Contents

Acknowledgements 4

Introduction 6

Making and spending money 6

 Lord Fairhaven at Anglesey Abbey 6
 A gentleman's establishment 8
 The uses of money 10
 The making of a squillionaire 11
 Enter the robber baron 13
 The millionaire's daughter 16
 From Manhattan to Mayfair 18
 Party services 20
 The shy peer 23
 Lady Fairhaven and her yacht 24
 Anglesey Abbey and the building campaign 25
 The collector at home 27

The Library at Anglesey Abbey 32

 Note on the provenance of
 books at Anglesey Abbey 38

Fifty treasures from
Lord Fairhaven's library 39

Bibliography 154

Notes 156

Index 158

Acknowledgements

Working on Lord Fairhaven's library at Anglesey Abbey has been more than usually enjoyable. The staff there, and especially the House Manager, Gareth Sandham, have been unfailingly kind and helpful, responding swiftly and generously to a series of complicated and tedious enquiries, as well as going way beyond the call of duty in kindly allowing us to study books and take photographs long after normal office hours.

Among many others, we would particularly like to thank the National Trust's Head Curator, David Adshead, who read the evolving text and commented on it, drawing in part on his experience in the 1980s and 1990s as the Trust's Historic Buildings Representative in East Anglia. Oliver Garnett was, as usual, an exemplary editor. Christopher Rowell advised on matters as various as silver and Windsor; Richard Wheeler on Stowe; Alastair Laing on pictures, collecting and art historical gossip; and Desmond Shawe-Taylor on pictures in the Royal Collection. In New York, Jennie L. McCahey of the Royal Oak Foundation (whose 1990s Campaign for Country House Libraries funds much of the National Trust's libraries programme) provided several valuable nuggets. Philip Warner, now in charge at Claydon House in Buckinghamshire but once based at Anglesey Abbey, spent an afternoon discussing Lord Fairhaven, and provided us with a copy of his unpublished MA thesis on the Fairhaven collection. Chris Lacey of the National Trust Photographic Library arranged the photo shoot, and John Hammond took most of the marvellous photographs, including all those in the catalogue section. Sarah Bakewell checked the catalogue descriptions with characteristic thoroughness; we,

daunted by the number of books of which reportedly 'no two copies are ever exactly alike', have double-checked some since: some errors may remain, and any blame will lie with us.

Much of the introduction was either written in (or with material unearthed in) the Upper Reading Room of Oxford's Bodleian Library, and I am grateful to Verity Westgate and her staff, and indeed to all the staff of the library, for providing such an exemplary service at a time when the library's mighty bookstack – built in the 1930s, when Lord Fairhaven was only recently installed at Anglesey Abbey – was being emptied and rebuilt. The staff at the Vere Harmsworth Library at Oxford's Rothermere Institute for American Studies, and the National Sound Archive at the British Library in London, also deserve my particular thanks. So too, do Norma Aubertin-Potter and Gaye Morgan, who kindly welcomed me to the Codrington Library at All Souls College, again in Oxford: it would be difficult to conceive of a more magnificent or appropriate setting to write about libraries, and Hawksmoor's great marbled room provided a haven of peace and quiet for writing, and a refuge from emails.

This is not a project which has drawn heavily on archival sources, but again we are grateful to those who answered queries, and especially to Mari Takayanagi of the Parliamentary Archives in London, and Jeremy McIlwaine of the Conservative Party Archives in Oxford. The Millicent Library at Fairhaven, Massachusetts, kindly supplied additional photographic material from its collections, and Christine Ferdinand at Magdalen College, Oxford, provided a helpful American

Treasures from Lord Fairhaven's Library at Anglesey Abbey

National Trust

Mark Purcell
William Hale
David Pearson
with photographs by
John Hammond

Books are the liberated spirits of men,
and should be bestowed in a heaven of
light and grace and harmonious color
and sumptuous comfort.

*Mark Twain, opening speech at the
inauguration of the Millicent Library,
Fairhaven, Massachusetts*

perspective and wise advice at an early stage in the project. Philippa Marks at the British Library was kind enough to help with David Pearson's description of one of Lord Fairhaven's finest bindings, and Nick Savage at the Royal Academy of Arts not only opened my eyes to the interest of colour-plate books, but kindly sent the text of the lecture on them which he had delivered at Arundel Castle during a conference sponsored by the Paul Mellon Centre for the Study of British Art. Sir Hugh Roberts commented on matters connected with Windsor, and to my delight and surprise told me about some youthful conversations with Lord Fairhaven. Robin Myers and Nicolas Poole-Wilson (Bernard Quaritch Ltd) shared memories of the kid-gloved customer who regularly visited Sawyer's bookshop, and John Saumarez Smith (now based at Maggs Bros.) kindly untangled confusion about Lord Fairhaven's connections with Heywood Hill Ltd.

Professor David McKitterick of Trinity College, Cambridge, and Professor Richard Guy Wilson of the University of Virginia at Charlottesville kindly read the text in draft, and their suggestions greatly improved it; Richard is also the Director of the Victorian Society in America's Summer School at Newport, Rhode Island, which I attended in 2003, funded by a generous donation from an anonymous benefactor.

Finally it seems appropriate to include a word of acknowledgement to Lord Fairhaven himself. It may seem like an empty formula to thank a man who has been dead for very nearly 50 years, but Huttleston (if that is not too familiar) is still very much within living memory. His legacy is too easy to mock and sometimes has been,

and he himself would perhaps have been puzzled – conceivably even offended – by the forensic zeal with which we have examined his life and his library, quoted sometimes unflattering comments, speculated on the motivation of his parents, and poked around in the murkier business dealings of a grandfather who died as long ago as 1909. But the fact remains that his bequest of Anglesey Abbey to the National Trust in 1966 was one of the most generous gifts in the Trust's history. It was all the more generous because – despite the fact that some major works of art came in lieu of death duties – it was just that: a gift, and one which was accompanied by the then enormous cash endowment of £300,000. If the poking around is justified, and we believe that it has been, it is because it helps to set the man and his collections in a more realistic context than has been the case so far.

On a war-time visit, James Lees-Milne was unimpressed with Anglesey Abbey, which he thought 'more a fake than not', its owner 'a slightly absurd, vain man… too much blessed with this world's goods', and its contents 'a desultory collection of good things that do not amount to a great collection'. Readers of this book must decide for themselves whether that was fair in 1943, and if it was, whether the characterisation remains apt, or has been overtaken by the succeeding 70 years. We hope this book succeeds in showing that – the occasional delighted groan notwithstanding – the library, one of the least-known parts of a great treasure house, has a real cohesion and integrity, and contains books of extraordinary splendour. Most of those books are seen here for the first time.

Mark Purcell

Introduction
Making and spending money

First and foremost this is the story of a library, but it is also an intriguing slice of Anglo-American history from a time of huge social and economic change on both sides of the Atlantic. The library at Anglesey Abbey is, as the contents of this book show, of great magnificence, a collection lovingly assembled between the 1920s and 1960s by Huttleston Broughton, 1st Lord Fairhaven (1896–1966). A shy but by no means reclusive bachelor, Huttleston spent most of the last 40 years of his life deep in the English countryside, but he was born in Gilded Age America and raised in the world described in the novels of Henry James and Edith Wharton, moving to London only when he was 16. To say that Huttleston grew up in considerable affluence rather understates things; his maternal grandfather, H.H. Rogers, was one of the richest men in the entire history of the United States, and his family circles included some of the wealthiest people, in real terms, who have ever walked the face of the earth.

Inevitably, therefore, much of what follows is about making and spending money. The making was largely done by his father and grandfather, while Huttleston himself did most of the spending; buying art, creating a garden, keeping an eye on his racehorses, and generally living in considerable style. But the story is also one about class and identity, and it raises some intriguing questions. Who was Huttleston Broughton? Were his family British or American, or both? Was he really a peer of the realm, or was he just the son of an oil man? In simple factual terms, the answers are straightforward: the Broughtons were British citizens, and Huttleston did indeed have a seat in the House of Lords, though he rarely attended. On the other hand, most of the money came from America, and so apparently did many of the aesthetic choices which underpinned the creation of his great collection and the building which houses it.

There is one final irony. Huttleston's magnificent library is just one part of the extraordinary house which he created at Anglesey Abbey - an American millionaire's palace miraculously transported from Long Island to the Cambridgeshire Fens. So opulent is the setting that the books have often been overlooked; most of the volumes illustrated here are seen in public for the first time. And yet all this polished and fastidious grandeur was ultimately funded, literally, and perhaps also metaphorically, by dirty business.

Lord Fairhaven at Anglesey Abbey

Apart from a brief hiatus in the 1940s, daily life at Anglesey Abbey followed the same unvarying routine for 34 years, from the departure of Huttleston's younger brother Henry in 1932 to his own death in 1966. Since it was a bachelor household, things were in some ways quite relaxed, with none of the elaborate gradations of the Edwardian servants' hall. With no lady of the house (and generally no female housekeeper either), Lord Fairhaven's orders were usually relayed to the staff via his valet or butler.[1] On the other hand his tastes were exacting and methodical. As his friend, the architect Sir Albert Richardson, put it, Anglesey Abbey was a house where things 'ran like clockwork and nobody was ever late for anything', and where small upsets could cause major consternation. Lord Fairhaven 'floated in unreality' through the lavishly carpeted interiors, a fresh gardenia in his buttonhole and dressed rather too grandly for the country, while 'menservants moved noiselessly about, gardeners continually changed blooms from the hot-houses, and it was reputed that guests had their shoe-laces ironed before breakfast'. This almost '*too* perfect' regime required a large staff for what was never an especially large house.[2] The details varied over the years, but the full complement included a butler (in tails), two footmen (in yellow waistcoats), a valet and three maids. Outdoors, in addition

LEFT Lord Fairhaven, photographed at Anglesey Abbey

RIGHT This elaborate gilt clock, set against an equally fine tapestry, exemplifies Lord Fairhaven's superb collection and the luxury that he enjoyed at Anglesey Abbey

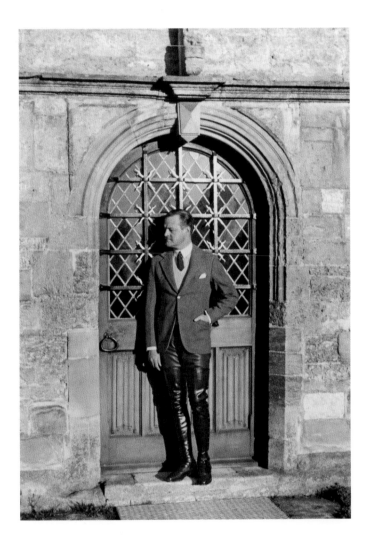

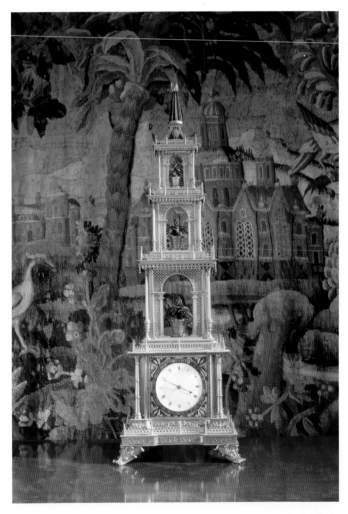

to the gardeners, there were a couple of chauffeurs, who dealt with the Fairhaven fleet of Rolls-Royces, and could be called on to deal with guests' vehicles when required. In the early days Lord Fairhaven employed a woman cook, but in time she was succeeded by a male chef, Allen, who had previously been in charge of onboard catering on the family yacht, *Sapphire*, and could be relied on to produce 'superb but plain English food'. Lord Fairhaven – like his American mother, who was delighted to be presented with homely southern fare in smart Palm Beach in 1926 – had firm views on food, and 'didn't like a lot of fancy things'.[3] Nonetheless he lived well, though a certain formality of style tended to prevail at mealtimes, with his lordship served first, before his guests, like a medieval baron, as the National Trust's James Lees-Milne (1908–97) noted in his diary with some amusement.[4] Wartime rations at Anglesey Abbey in 1943 included a generous lunch and a formal four-course dinner of soup,

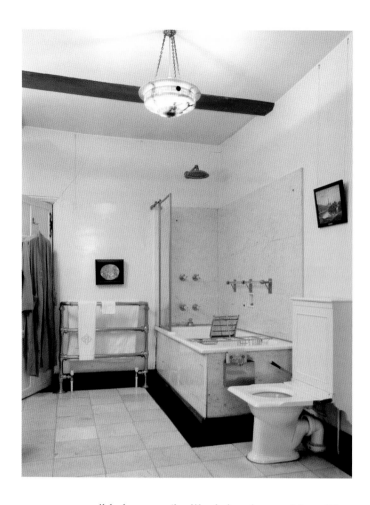

One of the bathrooms which Lord Fairhaven had installed at Anglesey Abbey; he brought American standards of luxury to the British bathroom

lobster, chicken and savoury, followed by 'lashings of port and brandy'.[5] Sardines were another special favourite, which Lord Fairhaven consumed with such enthusiasm that it is said a vast stock of tins had to be removed from the pantry and buried on the estate after his death.[6]

Visitors were struck by the fact that the house was so immaculately kept, and this was equally true of the garden, even in wartime. The head housemaid generally 'did' the Library and the other principal rooms every morning. Work started at 6.30 am, and the house was expected to be clear and ready for use by 8.00 am, with log fires lit in season. The Abbey had radiator central heating, a luxury which subsequent generations would learn to take for granted, but run with an extravagance which post-war British visitors found disconcerting (surprisingly, the books in the Library do not seem to have come to much harm from this). Mains electricity arrived only in 1948, but the house always had its own generator, and 'mod cons' were very much in evidence; Lord Fairhaven's smart chrome bathrooms were the first that one of the housemaids had ever seen. Occasionally, this luxurious regime slipped over into eccentricity: while Fairhaven had lunch, for example, housemaids with brooms would attend to the fitted carpets in the other rooms, and 'take out all the footmarks that visitors had made … so that when he came out of the dining room there was the room once again as if nobody had ever been in it'.[7] Another ritual was listening to the BBC news at 9.00 pm, with the wireless brought in on a silver salver.[8]

A gentleman's establishment

At the time of his death, newspapers described Fairhaven as 'the Shy Peer', a characterisation confirmed by one of his housemaids ('a very nice gentleman – a bit shy'), though she was also sensible enough to realise that this was very possibly because 'he liked the place to himself' and didn't want to have 'a lot of servants about'.[9] His obituarist, the historian Sir Arthur Bryant (1899–1985), confessed that his friend Lord Fairhaven could seem 'reserved and austere', but was equally keen to stress his devotion both to the arts and to his friends.[10] His nephew Ailwyn Broughton remembered him as 'quite a retiring person' with a small circle of close friends, 'who were invited very regularly to Anglesey Abbey', and indeed the guest books record the same limited range of names over and again. House guests tended to be fellow-bachelors, though married couples were also invited from time to time, except for shooting weekends, which were always all-male affairs.[11] It was, as one of the staff put it, a house with 'more gentlemen than ladies, shall I say – it was a gentleman's establishment', and though Lord Fairhaven apparently once contemplated marriage, he never took the plunge.[12] Unsurprisingly, he was regarded as fair game by man hunters. In 1942 the socialite romantic novelist Barbara Cartland described him and his friend Lord Inverclyde, heir to the Cunard shipping fortune,

as 'our most eligible bachelors' – a compliment which may explain his flight from matrimony.[13] Some idea of his circle of friends emerges in his Christmas list; in the last year of his life he gave presents to 23 people, including his friend and neighbour Soane Jenyns (1904–76), of the Department of Oriental Antiquities at the British Museum, Jenyns's wife Anne, the American-born landscape gardener Lanning Roper (1912–83), and Audrey Pauncefote, daughter of Britain's turn-of-the-century ambassador to Washington, who had also been friends with his mother and had accompanied the Broughtons on family cruises on their private yacht in the 1920s.[14] Other friends included Sir Albert Richardson and Sir Arthur Bryant, whose idealised agrarian view of England's past was in close accord with Lord Fairhaven's own. He also stayed in close contact with his extended American family, including his cousin Henry Rogers Benjamin (1892–1967) and his uncle William R. Coe (1869–1955).[15]

Nearer to home, Lord Fairhaven accepted the conventional honours and obligations for a man of his class and wealth: he was a deputy lieutenant of Cambridgeshire, a knight of St John, a governor of the King's School, Ely, a JP, a council member of the British Red Cross and a member of the executive committee of the Council for the Care of Churches.[16] On the other hand he was certainly not prominent in public life, and spoke in Parliament only once.[17] He became a well-known figure in his adoptive home town of Cambridge, and was regularly sighted at the Cambridge Arts Theatre, occasionally taking his cantankerous neighbour Elsie Bambridge (daughter of Rudyard Kipling, and eventual donor of Wimpole Hall to the National Trust) as a guest.[18] The Fairhaven Rolls was a common sight in the city, as his valet was driven into town each evening to pick up a copy of the *Cambridge Evening News*.

Despite his obvious affection for Cambridge, Huttleston did not attend the university, finishing his

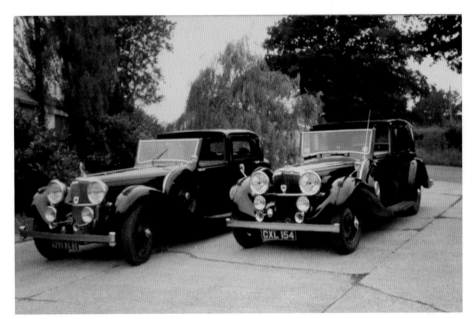

The Upper Picture
Gallery, created to display
Lord Fairhaven's
collection of paintings

education at the age of 18. His early schooling was at the elite St Paul's School, Concord, New Hampshire, where he would have received the nearest thing that turn-of-the-century America could offer to a British public school education. Arriving in London in 1912, he later spent two years at Harrow before going into the army in 1916. Unsurprisingly, his only published work, his privately-printed *Dress of the First Regiment of Life Guards* (1925), is slightly clumsy – not by any means illiterate, but certainly not the work of a young man used to drafting complex prose. Later letters to the National Trust, on the other hand, are businesslike and both fluent and good-humoured, if occasionally a little pedantic (many finish with a comment on the weather).[19] His surviving travel diaries are similarly laid-back and entertaining. It is possible to infer that, in both his writing and his collecting, Huttleston was not only self-educated, but also something of a late developer.

The uses of money

Although Lord Fairhaven was not wealthy on the same scale as his maternal grandfather, the oil baron Henry Huttleston Rogers, he was by any standards a very rich man. His total British estate in 1966 came to some £2,406,691, which included Anglesey Abbey and its marvellous contents; Kirtling Tower, a nearby medieval gatehouse which he bought in 1941; Thorney Abbey House, in the north of the county; and a large seaside house at Aldeburgh on the Suffolk coast. In accordance with family tradition, Lord Fairhaven was something of a philanthropist. He paid for a new village hall in the estate village of Lode in 1930, and refitted the lady chapel of Lode church in memory of his parents.[20] Like his father before him, he rallied round in times of national emergency, donating a Spitfire to the war effort in 1940; the

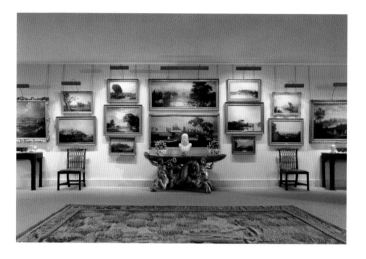

commemorative plaque is one of the more unexpected objects in the Library at Anglesey Abbey. He was also a regular and generous donor to charity sales, contributing a diamond and emerald ring to a Christie's auction in aid of the Red Cross in 1940, and a landscape by the eighteenth-century painter Joseph Farington in aid of Lord Baldwin's Fund for Refugees (it sold for 48 guineas).[21] In 1948 he gave £30,000 to the Fitzwilliam Museum, and after his death Cambridge was remembered in his will, not least in the suggestion that Anglesey Abbey might provide a suitable residence for a dignitary of the University if the National Trust ever needed a tenant. But of all his benefactions, the gift of Anglesey Abbey to the Trust, along with an endowment of £300,000, was the most generous.[22]

Lord Fairhaven's first real contact with the National Trust seems to have been in the summer of 1943, when he called at the London office. It may be no coincidence that he was, like James Lees-Milne, a member of Brooks's Club, and Lees-Milne made several wartime visits to Anglesey, during which the two men discussed the future of Thorney Abbey House, Kirtling Tower and Anglesey Abbey itself. Discussions continued after the

war, though the Trust's officials had some misgivings; Lees-Milne wrote to the Trust's chairman Lord Esher in 1950 that Anglesey Abbey was 'a rather typical case of a rich man's property … the house, apart from a 13th century undercroft, now the dining room and a room of undoubted importance, is not really a national monument'. But he also conceded that 'the contents are very remarkable indeed'.[23] Nor were the treasures confined to indoors, for the house was surrounded by the remarkable landscape garden which Huttleston had created in a flat and implausible setting. As one of his gardeners later explained, Huttleston had had little experience of gardens before he acquired Anglesey Abbey, and outdoors he was not a plantsman, but a 'single-minded chap' who liked 'grand effects' and was in a hurry.[24] And no doubt the garden, with its avenues, temples and superb statuary, encouraged the National Trust to take on a house which, despite its great collections, might otherwise not have been accepted.

Even as a young man in the 1920s, Huttleston had been conscious that he was living at a time when 'everything is changing and everyone is a reformer for better or worse'.[25] By the end of his life he seems to have been more aware that the world had altered beyond recognition since his youth, and his will (1964) set out very clearly that, if the National Trust accepted his bequest of Anglesey Abbey, the house should be preserved as 'a complete and furnished entity so that it retains as far as possible the character of an English Home'.[26] The wording is intriguing, implying not only a fierce pride in his own Englishness, but also perhaps some slight doubt on his part as to whether Anglesey Abbey really was so very English. For any contemporary visitor – or at least for one who has travelled in America – the debt to America is so very clear that it seems extraordinary that no-one commented on it at the time. The only possible explanation is, of course, the obvious one. Unlike their twenty-first century counterparts, National Trust staff of the pre-jet era had generally not travelled in America (James Lees-Milne, for example, visited the US for the first time in 1985, at the age of 77). Unlike Huttleston's mother, Cara, whose steam yacht *Sapphire* could ferry her across the Atlantic in effortless comfort to Planting Fields in Oyster Bay, the 65-room Long Island mansion built for her sister Mai Rogers Coe (1875–1924), they were entirely unfamiliar with the great mansions built for America's super-rich in the late nineteenth and early twentieth centuries. For Cara, Planting Fields, built in 1918–21 in the Tudor Revival style, with lavishly furnished period interiors, was the perfect house.[27] Anglesey Abbey can really only be understood in the context of this and similar American houses, some still standing and others, such as most of the great mansions which once lined New York City's Fifth Avenue, long gone. And this is perhaps what gives Lord Fairhaven's creation at Lode its very special savour: a full-scale American millionaire's mansion (or at least a mansion heavily influenced by America), a species of house now rare even in the United States, set down on the edge of the Fens.

The making of a squillionaire

Huttleston's father, Urban Hanlon Broughton (1857–1928), was born in Worcester and brought up in northeast Wales. When he became famous, the British press described him as a 'member of a well-known English family', but Urban's father John Broughton was in fact a railway manager and had worked for a time in India. Urban was educated at Park Grove School in Wrexham but left early, and by 1874 he too was an employee of the East India Railway in Bengal.[28] By 1882 he was back in England, studying engineering at Imperial College, London, and from 1882 to 1884 he worked on the

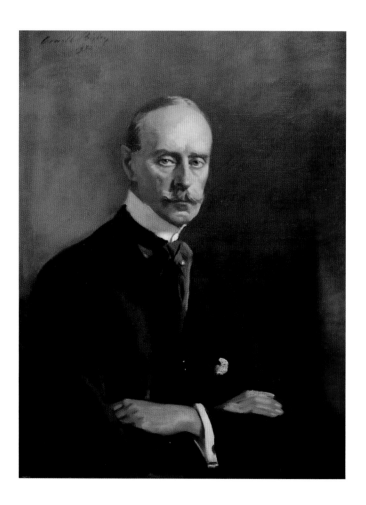

Lord Fairhaven's father, Urban Hanlon Broughton (1857–1929); a posthumous portrait by Sir Oswald Birley, 1932 (Ashridge Business School)

construction of the new docks at Felixstowe. At this stage in his life Urban was clearly a pretty impecunious young man, short of cash and familiar with the inside of the local pawnshop.[29] Despite this he managed to get himself invited to weekend shooting parties at the local country house, Orwell Park. This secured him his first lucky break, an introduction to the railway magnate Sir George Stephen (1829–1921), who promptly offered Urban a job on the Canadian Pacific Railroad.[30] A chance meeting in London with an old acquaintance, former mayor of Wrexham Isaac Shone, led to a more attractive offer. Shone's company was about to start work on a major project to reconstruct the drainage system underneath the Houses of Parliament, where the vast outfall built by Charles Barry in 1839 had never worked very well, a problem exacerbated by the construction of Joseph Bazalgette's new Metropolitan Board of Works sewerage network between 1858 and 1870.[31] Urban was to go to the United States to head up the firm's new American subsidiary, his brief to introduce transatlantic customers to the glories of Shone's new 'hydro-pneumatic' sewerage systems. It was a period of his life about which he was later perhaps slightly cagey, but by 1887 Urban had found his way to Chicago, then in the throes of a massive property boom following the rebuilding of the city after the Great Fire of 1871. There he set to work selling Shone's wares to eager American clients.[32] Other major sewerage projects followed, first in Winona, Minnesota, and then – back east – in Worcester, Massachusetts.[33] He also had business ventures of his own, including a profitable role as a contractor for the Chicago World Fair of 1892, whose extraordinary neoclassical buildings, designed by the great American architect Richard Morris Hunt (1827–95), were reckoned by some to be the equal of imperial Rome at its height. In the process Urban seems to have acquired a taste for the good life, lodging at the exclusive Chicago Club and grumbling about the lack of polo, tennis and golf in his adopted city: none of them, perhaps, popular pursuits in Wrexham and Felixstowe.[34]

Urban's next big break came in 1895, when he was engaged to install a new sewerage system at Fairhaven, Massachusetts, some 50 miles south of Boston.[35] Just across the mouth of the Acushnet River from the great whaling port of New Bedford, immortalised by Herman Melville in *Moby-Dick* (1851), Fairhaven in 1895 was still archetypal small-town America. But the sewerage project was just the start of a decade-long transformation, which saw the construction of a series of monumental

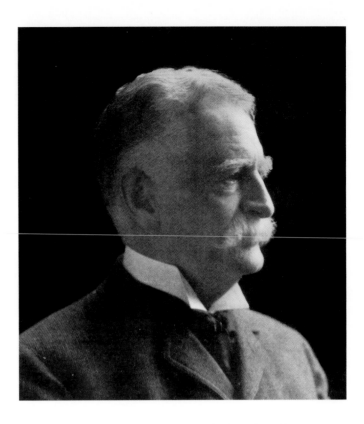

Lord Fairhaven's grandfather, H.H. Rogers (1840–1909), photographed by Spencer Arnold in 1890 (Schloss/ Spencer Arnold/Hulton Archive/Getty Images)

Gothic revival public buildings 'including a church, parish house, parsonage, town hall and library'. All of them were designed by the prominent Boston architect Charles Brigham (1841–1925), and all were paid for by the town's most famous son, the oil tycoon Henry Huttleston Rogers (1840–1909).[36]

✿ Enter the robber baron

Henry H. Rogers was proud of his New England antecedents and claimed descent from one of the original passengers on the *Mayflower*. As a young man he had worked in the family grocery store on Main Street, Fairhaven, but by 1895 he had long been one of the richest men in America. His father, Rowland Rogers, had once worked as a whaler, but Henry Huttleston made his fortune out of oil of another kind. He became a leading expert in the development of refining technology and, faced with relentless pressure from the oil monopolist John D. Rockefeller (1839–1937), he astutely sold up to Rockefeller's Standard Oil Company in 1874. Part paid in Standard stock and given a seat on the Standard board, Rogers soon became one of Rockefeller's most trusted lieutenants and a dominant figure in the affairs of America's largest oil company, which by 1878 controlled 95% of all the pipelines and refineries in the United States.[37] In an increasingly motorised world, his association with Standard brought huge profits and he invested his millions right across the country, expanding into every possible area of industry, high finance and market capitalism. In 1884 he founded the Consolidated Gas Company and in 1899 the Amalgamated Copper Company. Both firms exhibited the monopolistic aspirations so characteristic of Rockefeller and his acolytes, engaging in 'perpetual warfare' with competitors. Rogers became known as

the master of the hostile takeover bid, and rival tycoons who resisted were ruined or driven out of business by Standard's cartels. By the early twentieth century, Rogers had diversified still further, becoming a leading player in the Virginian Railway and reaping enormous profits by successfully linking the rich coal seams of West Virginia to the Atlantic seaboard. His financial interests continued to make money during the great crash of 1907, at a time when many others were going under.[38]

At the time of his death in 1909, when an ordinary American labourer might earn $1.70 for a 10-hour day, Henry Huttleston Rogers was reputedly worth between $50 and $75 million; by comparison, the banker J.P. Morgan (1837–1913) was said to be worth $75 million, while the New York property mogul John Jacob Astor (1864–1912) reportedly had about $40 million.[39] By 1909, Rogers had long since abandoned New England for New York City, and by the turn of the century he was living in a mansion at 3 East 78th Street, just off Fifth Avenue and looking out over Central Park. It was a dazzlingly smart address, surrounded by some of most expensive real estate in the world, and dominated by the palatial mansions of America's richest men and women, including the young financier Howard Gould (1871–1959), the coal magnate Henry Clay Frick (1849–1919) and the sugar

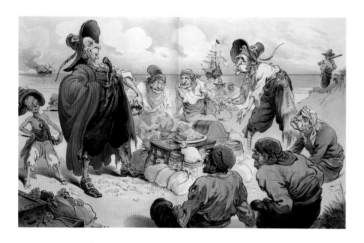

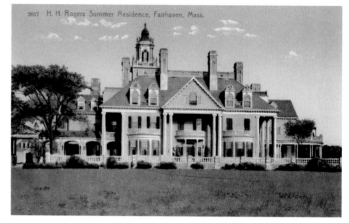

monopolist Henry Osborne Havemeyer (1847–1907), whose house included a library with a ceiling made of precious Japanese fabric shot through with gold and silver, and kitted out with polished furniture in the Celtic and Viking styles. By comparison, the Rogers house, though large and well appointed, was positively restrained.

Rogers remained a regular visitor to Fairhaven, a town whose affairs he dominated from afar. He generally made the 400-hundred mile round trip from New York on board his ocean-going steam yacht the *Kanawha*, employing a personal pilot to navigate him safely through the mansion-lined waters of Long Island Sound.

By 1895 he had already paid for the installation of a public water system in his home town, and it was he who decided it also needed a new sanitation system.[40] Millionaire families like the Vanderbilts, Astors and Berwinds traditionally escaped the oppressive summer heat of Manhattan by spending the season in their seaside 'cottages' down the coast at Newport, Rhode Island, but Rogers's New England seaside retreat was a large wooden house in Fairhaven, built in 1884. When this burned to the ground in February 1894, it was immediately replaced by an even more opulent summer residence.[41]

This house, nicely sited on the shores of Buzzard Bay, had 85 rooms; there were 18 bedrooms, playrooms for the grandchildren, a private bowling alley, and vast kitchens. Outdoors there were stables, hothouses, a private electrical plant, and magnificent gardens renowned for their chrysanthemums.[42]

In his public life, however, Rogers was subject to a constant barrage of criticism and accusations of sharp practice in the American press. 'Hell-Hound' Rogers and the 'Fiend' were among the more respectable of the derisive nicknames given to him and during a notorious legal dispute in 1906, the headline in the *New York Herald* read, 'Rogers calmly defiant of the Supreme Court – note of contempt in all his replies'.[43] His reputation was damaged still further when Thomas W. Lawson (1857–1925), a former colleague turned defeated business rival, published *Frenzied Finance* (1906), a mammoth denunciation of the excesses of the unregulated capitalism of the American robber barons. Rogers was clearly high on the list of targets when Lawson angrily asserted that 'unmeasured success and continued immunity from punishment have bred an insolent disregard of law, or common morality, and of public and private right'.[44] A year later, in February 1907, President Roosevelt himself launched

a stinging attack on 'malefactors of great wealth' at a formal dinner. Since Rogers was sitting opposite the president, with J.P. Morgan, the speech was widely interpreted as a direct attack on him.[45] Morgan, well-known for his buttoned-up Anglo-Saxon rectitude, seems to have shared Roosevelt's reservations. In conversation with the mining magnate and art collector Solomon R. Guggenheim (1861–1949), he deplored the damage he believed was being done to Wall Street by an interminable legal wrangle between Rogers and the copper baron F. Augustus Heinze (1869–1914). Guggenheim agreed, and added that he could not 'understand why Rogers keeps up such a dirty mess. He may get a few million out of it, but he'll only give it away to charity. Wouldn't you think he'd have had more sense than to sacrifice his name for that'.[46]

Today it is difficult to form any reliable judgement on Rogers's business affairs, not least because his lawyers systematically destroyed his papers after his death.[47] But a well-informed historian of a generation or so later – sympathetic to the 'robber barons', close to the events under discussion, and safely out of the reach of Rogers's lawyers – was in no doubt:

> His polished exterior concealed a gamester's recklessness and a total lack of scruple in financial affairs … Friends who knew him at his New York house or Fairhaven estate found him a prince of entertainers and an unmatchable raconteur. But everyday business acquaintances knew him as exacting, unsympathetic, and sharp; while his enemies dreaded him as a scheming, relentless and tyrannical foe.[48]

Like many of the robber barons, Rogers was also known as a philanthropist, although there was a certain inevitability to this. The most successful American practitioners of unrestrained free-market capitalism – men like Rockefeller, Rogers and Andrew Carnegie (1835–1919) – accumulated money on such a stupendous scale that they were almost obliged to give it away: they had so much that it was simply impossible for them ever to spend it.[49] Among other things, Rogers subsidised the African-American activist Booker T. Washington (1856–1915) and funded the college education of deaf-blind author Helen Keller (1880–1968), as well as underwriting various pet projects back home in Massachusetts. By 1905 his great friend Mark Twain – another recipient of his largesse – could plausibly claim in print that he had 'made Fairhaven, the home of his youth, an ideal town'.[50]

Despite his unlikely friendship with Twain, Rogers was clearly no cultural titan, but neither was he wholly ill-educated or devoid of cultural interests.[51] He did not assemble an art collection to match Frick's, and unlike J.P. Morgan and another Massachusetts millionaire, Henry Clay Folger (1857–1930), he did not collect rare books and manuscripts either.[52] But if he did not own Shakespeare First Folios, Rogers could to the end of his life still quote chunks of Shakespeare and various minor eighteenth- and nineteenth-century poets from memory. Clearly he had read around, and perhaps even as a grown man he continued to do so, as at the time of his death the house in East 78th Street contained 'bric-a-brac, works of art and furniture, china, plate, silverware, books and pictures'. Whether any of these books were acquired with the help of his son-in-law, the Boston collector and publisher William Evarts Benjamin (1859–1940), who had set up as a rare books dealer in 1884, is now impossible to say.[53] On balance it is unlikely, and when Edith Wharton, one of the great cultural arbiters of Gilded Age America, as well as one of its greatest novelists, addressed the issue of plutocrats and libraries in 1898, she felt able to pronounce with some confidence: 'few of the large houses lately built in America contain a library in the serious meaning of the term'.[54]

✣ The millionaire's daughter

By the time of the Fairhaven sewerage project in 1895, the plutocrat Henry H. Rogers and the up-and-coming Urban H. Broughton evidently knew one another quite well. As early as 1894, Urban Broughton was in charge of a Rogers enterprise in Chicago, a factory manufacturing the 'Paige automatic typesetting machine', a pioneering but risky speculative project which had lost Mark Twain some $200,000, and which Rogers had bailed out for the sake of his bankrupt friend.[55] But his residence in Fairhaven provided Broughton with the opportunity to get to know the Rogers family rather better. The *New-York Tribune* was later to tell the full story:

> After an inquiry which extended to Europe Rogers decided on a kind of sewer built by an English company, whose representative was Urban H. Broughton. He accordingly invited Mr Broughton to Fairhaven, and made him a guest at his home while the two inspected the town to determine where the trunk and where the tributary pipes should be laid. At the Rogers home Mr Broughton met the financier's daughter, Cara, and as the trenches deepened where Mr Broughton superintended the work his love for the heiress also grew deeper. In his courtship the Englishman made even greater progress than in finishing his task for the young woman's father, with the result that the engagement was announced first.[56]

Cara Leland Rogers (1867–1939) was the second of five Rogers children, four daughters and a son, Henry (Harry) Jr (1879–1935). When Urban Broughton arrived at Fairhaven in 1895, Cara was already a widow, her New York-born husband Bradford F. Duff having died two years previously, at the age of just 24. Photographs show a determined-looking but rather plain young woman, with strong features and the prominent jaw which would

be inherited by her son Huttleston. The couple were engaged in May 1895, and were married just six months later, on 12 November; an event which clearly came as something of a surprise in some quarters.[57] The year 1895 was, after all, the high noon of the 'dollar princess', the short period when the daughters of America's new plutocrats vied to marry into the British aristocracy, with the British scooping the money and the newly-rich Americans the prestige and social status that many craved. On 22 April the Chicago department store heiress Mary Leiter (1870–1906) married George Nathaniel Curzon, heir to Kedleston and future viceroy of India, in Washington.[58] The Curzon marriage may or may not have been a matter of money, but the marriage of Consuelo Vanderbilt (1877–1964) to the 9th Duke of Marlborough on 6 November 1895, just a week before the Broughton-Rogers wedding, most certainly was. The daughter of the railroad millionaire William Kissam Vanderbilt (1849–1920) and great-granddaughter of Commodore Cornelius Vanderbilt (1794–1877), the original founder of the family fortune, Consuelo was bullied and brow-beaten by her mother into a disastrous marriage of convenience. The Marlboroughs got the money to keep up Blenheim – a reputed $2.5 million in railway stock, as well as an annual allowance of $100,000 – while Alva Vanderbilt had the satisfaction of installing her daughter at the heart of the British Establishment. Consuelo spent the morning of her wedding in floods of tears, and separated from her husband after 11 years, finally obtaining a divorce in 1921.[59]

The surprise, then, was not that Cara should have married an Englishman, but that her millionaire father should have settled for a sanitation engineer rather than a peer of the realm. The take of the local newspaper in Urban Broughton's home town of Worcester was typical: 'Another American millionaire young lady is about to marry an Englishman, who is not a duke. He is not even

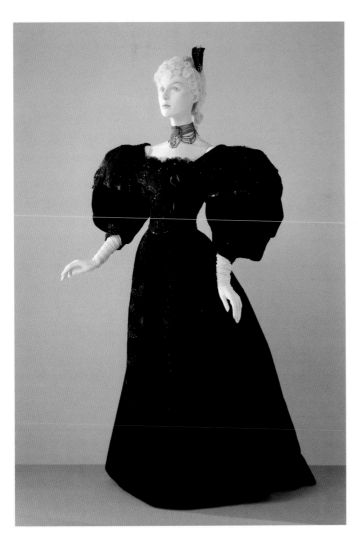

This black silk velvet couture gown was made in 1894 and was probably worn by Cara Leland Rogers during her brief widowhood, before she married Urban Broughton (Victoria & Albert Museum)

a baron, but a simple commoner. The lady is a widow, worth a million in her own right'.[60] Rogers's reasoning on the Broughton marriage is open to question, and it may simply have been the fact that Cara had already buried one husband that prevented her from being hawked around the courts of Europe. But a more likely explanation is that Rogers, for all his harsh reputation, loved his children and wanted them to be happy. Since he already knew and apparently trusted Urban Broughton, and Cara evidently liked him, that may have been enough. Perhaps, too, there was a dose of plain small-town New England common sense involved. By 1915 there were reportedly 454 titled Americans, but if H.H. Rogers was interested in money, he evidently had no particular desire to have a British aristocrat for a son-in-law.[61] For that matter he does not seem to have been much interested in American high society either, and none of his children was pushed into socialite marriages. Broughton, for his part, was

clearly a smooth operator and something of a charmer, a successful businessman who was 'a brilliant raconteur' but 'remained human', and a man calculated to appeal to both father and daughter. And indeed the Broughtons do appear to have been a devoted couple, and to have been genuinely happy together right down to Urban's death in 1929.[62]

After a brief honeymoon the new Mr and Mrs Broughton returned to Chicago, where they lived in 6 Tower Court, an exclusive address on Chicago's North Side, just off the city's main thoroughfare, Michigan Avenue, and a couple of doors down from Lord Curzon's father-in-law Levi Z. Leiter (1834–1904). They seem to have led a sociable sort of life, with a formal 'receiving day' each Wednesday, while Urban was a member of the Chicago Golf Club, the Chicago Culture Club, and the city's Washington Park Club.[63] In the early years of their marriage, Broughton continued to travel extensively on business, much as he had done as a bachelor. It is clear from his later memoirs that he was personally familiar with large parts of the United States, including Kansas, New Orleans, San Francisco, the states of Montana and Washington, and Salt Lake City, Utah. He also retained his connection with the Shone company and was still its vice-president in 1907, by which time its British origins had generally been forgotten; it was described in the US press as 'a Wisconsin Corporation which makes sanitary devices'.[64] Broughton also retained business contacts with some of the leading figures of the day, including Frick, managed a copper firm in New York from 1901 to 1911, and formed a 'National Copper Bank', making a killing in the process.[65] 'For many years' Broughton was also one of the directors of the huge Anaconda Mining Company, and since H.H. Rogers was widely suspected of wanting to set himself up as a 'copper czar' (cornering the world market so as to allow him to set the price), it seems clear that Urban was involved in his father-in-law's scheme.

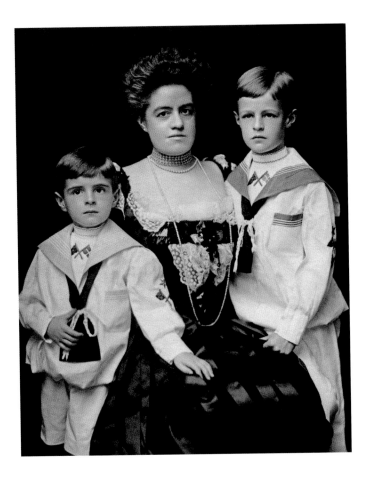

Cara Leland Rogers, Mrs Broughton, with her sons Huttleston (on the right) and Henry, photographed in the early 1900s (Millicent Library, Fairhaven)

He was certainly very familiar indeed with the details of Anaconda's operations in and around Butte, Montana in the 1890s and early 1900s.[66]

✿ From Manhattan to Mayfair

Urban and Cara's first son, Huttleston, was born at Fairhaven on 31 August 1896, and named after his 97-year-old great-grandmother Mary Eldridge Huttleston. Mark Twain described him early as 'the little fellow that got crippled', so it seems that the birth was a difficult one, although Huttleston appears not to have suffered any permanent ill-effects.[67] By November 1896, mother and son were living in Rogers's house at 26 East 57th Street in New York, while Urban Broughton had returned to Chicago 'to settle the house and arrange for the coming of his family', though the Broughtons were still in Chicago in 1898. Only in 1902 did they set up permanently in New York City, purchasing a five-storey house on East 78th Street, presumably to be near H.H. Rogers, who had recently moved into the same street.[68] They also owned a seaside retreat at Great Neck, on the north coast of Long Island, travelling to and fro 'by a small steam yacht'.

Rogers himself remained active into old age, and his last great scheme was the Virginian Railway. Urban Broughton was much involved in the project, and newspapers reported that he was regarded as his father-in-law's 'logical successor'. When old 'Hell-Hound' Rogers finally died after a stroke in 1909, his fortune was divided equally between his four surviving children, each of whom was provided with a separate family trust.[69] The old man was buried with great pomp in Fairhaven, in a mausoleum raised in his honour, and his 13-year-old grandson Huttleston walked in the funeral procession, along with other family members. After much speculation about its future, Standard Oil was dissolved in 1911. Rogers's great house in Fairhaven only survived another four years, before being sold for building salvage in 1915.[70] It was the end of an era.

By the terms of her father's will Cara Broughton did not come into full control of her inheritance until she was 40, but when Rogers died in 1909 she was already 42, and all at once the Broughtons became enormously wealthy. At the most conservative estimates, Cara inherited some $12.5 million from her father. Though only a fraction of his vast fortune, this was still nearly six times the sum the Willie K. Vanderbilts had paid to install their daughter as Duchess of Marlborough and mistress of Blenheim in 1895. To set it in context, an American visitor to Edwardian London could pick up a Savile Row suit for £3.10s (approximately $18), while back home in New York $200,000 would buy a 250-foot steam yacht.[71] But before long there were whispered hints in the press of some sort of power struggle brewing between Urban Broughton and his wife's brother Henry H. Rogers Jr. Whether or not this was true, within three years Urban and Cara Broughton had left

New York and set up home in London.[72] Despite more than two decades in America, Urban had never ceased to regard himself as an Englishman. He and his wife had honeymooned in Europe, and Cara and her sister Mai had stayed at Brown's Hotel in Mayfair and visited Switzerland in the spring of 1894, just after the death of her first husband.[73] Even old 'Hell-Hound' had been known to cross the Atlantic from time to time, and had set up Standard's British subsidiary, Anglo-American Oil, in 1888.[74] By 1912 the capital of the British Empire was very much part of the regular US social scene, frequently visited between the end of Lent and the annual summer exodus to Newport. The electric telegraph, the marriage of American heiresses into the British aristocracy, private steam yachts and, above all, a scheduled passenger service on luxurious ocean-going liners like the *Titanic*, had brought London and New York much closer together over the previous 20 years.[75] The world's most famous unsinkable ship had gone to the bottom of the Atlantic on 14 April 1912, taking with it (with some 1500 others) John Jacob Astor and the millionaire book collector Harry Elkins Widener (1885–1912), whose distraught mother built the world's largest university library at Harvard in his memory.[76] But just a week after these terrible events, a surprising report from London appeared in the social columns of the *New-York Tribune*:

> One or two American hostesses will come forward in London this season. One who already has a large circle of friends in tow is Mrs Urban H. Broughton, née Rogers, who, with her husband, will shortly arrive at no. 37 Park Street, which they have taken for the season. It is said that although Mrs Broughton is a prominent member of the New York Yacht and Garden City golf clubs, they contemplate giving up their estates in America and making their permanent headquarters in this country. Mr Broughton's American business interests, however, are so big that it is hardly likely that he will cut himself off altogether from his New York and Chicago associations, but Mrs Broughton probably will make her home in London, with perhaps occasional visits to America.[77]

There were encouraging precedents for American money 'making it' in London. When William Waldorf Astor had decanted to England in the 1890s, he had notoriously declared that England was 'a country fit for gentlemen to live in'. Renouncing his US citizenship in 1899, he attracted widespread ridicule by publishing an obviously bogus genealogy in the *Pall Mall Magazine* (which he also owned), and buying Hever Castle, which he embellished with a mock Tudor village for servants and guests. His other great house, the ducal mansion at Cliveden, was fitted out with antique French *boiserie* supplied by the interior designer Allard, a conceit which would have looked at home in any of the Newport 'cottages'.[78] A generous contributor to ostentatiously good causes, by 1916 Astor had arrived in the House of Lords, the first in a long line of imports who clawed their way to the apex of the British class system. Unsurprisingly most were citizens of the far-flung British Empire, with Max Aitken (1879–1964), who arrived in London from Canada in 1910 and became Lord Beaverbrook in 1917, perhaps the most famous example. Another Anglo-American plutocrat elevated years later to the red benches was the London Underground boss Albert Henry Stanley (1874–1948), who became Lord Ashfield in 1920. Born the son of a coachbuilder at the Pullman Works in Derby, Stanley had emigrated to Detroit in 1888, worked as an office boy, and progressed up through the ranks until he found himself in charge of 25,000 New Jersey railwaymen, returning to London in 1907. Among his more visible legacies were the extension of the Bakerloo Line and Northern Lines, and the construction of a giant new headquarters above the St James's Park Tube Station at 55 Broadway.[79]

Urban Broughton did not come from quite such humble stock as Lord Ashfield, but neither did he make any false claims to gentility: by the 1920s references to Broughton Castle, the medieval residence of the 19th Lord Saye and Sele and entirely unconnected with the Broughtons, had apparently assumed something of the nature of a family joke.[80] While Urban had attended a grammar school in Wrexham, however, Huttleston was packed off to Harrow, and when he joined up in 1916, his regiment was the 1st Life Guards, the most socially exclusive regiment in the British Army.[81] Another obvious foray into the very smartest part of the Establishment came with Urban Broughton's election to the august ranks of the Royal Yacht Squadron, an ultra-exclusive club which by the early twentieth century enjoyed an increasingly ambivalent attitude towards self-made money. When the ambitious Lord Birkenhead managed to get elected after lobbying by George V, an aggrieved member was heard to mutter, 'We do not want any more of his sort in the Squadron'.[82] It seems likely that Urban's membership would have provoked a similar reaction.

Paradoxically, however, the Broughtons may actually have found aristocratic London less socially restrictive than New York. One of the main themes of Henry James's early novella *The Europeans* (1878) is the disruptive influence of a pair of Old World visitors to America, who bring their racy and decidedly new-fangled ways of doing things, to the obvious consternation of their more fastidious and traditionally minded New England relations. New York high society, in particular, was known for its stuffy conservatism, dominated by a self-selecting elite, 'the four hundred', who regarded themselves as a cut above newer families. Well into the 1890s the city's self-appointed social arbiter was the southerner Ward McAllister (1827–95), who was notoriously hostile to the families of social-climbing industrialists and especially to anyone who had made their money in the mid-west

metropolis of Chicago.[83] By contrast, Edward VII's court in London welcomed plutocrats of all kinds, and the king was reportedly astonished to learn that Consuelo Vanderbilt was not always received in the best New York society until she married the Duke of Marlborough. By 1912 all this was starting to break down, but as late as the mid-1920s the patrician Mrs King van Rensselaer (1848–1925) was happy to tell anyone who would listen that *parvenus* like the Rockefellers and their ilk were decidedly below the salt.[84] A future British ambassador to Washington, James Bryce, spelt out the contrast between the two sides of the Atlantic with characteristic acuity in 1889:

> A millionaire has a better and easier social career open to him in England than in America. In America, if his private character be bad, if he be mean or openly immoral, or personally vulgar, or dishonest, the best society may keep its door closed against him. In England, great wealth skilfully deployed, will more readily force these doors open. For in England great wealth can by appropriate methods, practically buy rank from those who bestow it.[85]

The tycoon Andrew Carnegie went further. Americans knew how to work hard, he thought, but too many American millionaires ended up as greedy old men who wasted their 'last years grasping for more dollars'. Britain, on the other hand, was a place which could teach them 'not to lay up treasures, but to enjoy them day to day'.[86]

Party services

Initially the Broughtons' sole British residence was, as the *Tribune* had correctly reported, 37 Park Street, a lavishly appointed Mayfair town house, with opulent Louis XVI interiors and a roof garden, about 150 yards

west of Grosvenor Square.[87] The surrounding Grosvenor estate had traditionally been an aristocratic enclave, but by the end of the nineteenth century the area was increasingly being colonised by new money: J.P. Morgan had kept a house there, and so too had Edward VII's favourite Jewish financier, Sir Ernest Cassel (1852–1921).[88] Within a short time Urban and Cara had also acquired a country pad in Berkshire. Situated on the eastern side of Windsor Great Park, and surrounded by rhododendrons, Park Close, Englefield Green, was less a country house in the English sense, and more like the high-class suburban retreats of America's East Coast millionaires. The Broughtons presumably bought it as a replacement for their Long Island house at Great Neck. Like many American millionaires, they evidently preferred a new house. Park Close, 'a well-built picturesque modern house … in the style of an old manor house', had been built just over a decade earlier, in 1900, by the architect Huntly Gordon, and it fitted the bill perfectly.[89]

On arrival in England, Urban Broughton also embarked on a political career. Elected unopposed as Tory MP for Preston in 1915, he served until the Khaki Election of 1918, though in fact he spoke only twice in three and a half years in Parliament. Like many clever men, he clearly found the Commons boring, and was scathing about many of his colleagues:

> In my time the majority of members were of very ordinary calibre. The House can be very interesting to members who enter in early life, who have the power of oratory, or who intend to follow a public career, but to a man who enters late in life, either from a sense of duty or for an occupation, it is tedious listening for hours on end to dull people making dull speeches.

Urban seems to have owed his parliamentary career to the influence of his friend Lord Birkenhead (1872–1930),

who served in close succession as Solicitor General, Attorney General, and finally as Lord Chancellor, before party infighting and an insatiable appetite for drink led him to political oblivion and ultimately to an early grave. Urban served as his Parliamentary Private Secretary, the first step on the path to ministerial office. Given his disdain for politics, it perhaps seems surprising that a self-made millionaire in his late 50s should have chosen to become involved in it at all. One obvious motivation was patriotism, and Broughton marshalled his US connections in support of the war effort, publishing *The British Empire at War*, a thoughtful and persuasive propaganda tract addressed to neutral America in 1916. Another obvious motive was simple self-aggrandisement. As recently as the 1880s newly created peers had invariably come from a traditional landed background, and Queen Victoria had strongly resisted her prime ministers' attempts to elevate industrialists and entrepreneurs to the House of Lords. By the time of the First World War all this had changed, and in the 1920s and 1930s perhaps half of all new peers were from newly wealthy families. If Urban Broughton was already aspiring to a peerage, he would also have been well aware that wealth and philanthropy were not in themselves always enough, but that a period in the Commons could smooth the way to the ermine.[90]

The post-war era led to further political disillusion and, once out of the Commons, Urban came to regard himself as a former Tory, willing to help 'any party whose main objective is to restore the British Empire to something resembling its former estate'. Presumably he was alienated in 1922 by the ousting of Lloyd George and the end of the wartime Tory–Liberal coalition, of which his friend Birkenhead was a vehement supporter.[91] Whatever the cause, his fear of socialism and the election of the first Labour government in 1924 led him back into the Tory fold, and resulted in his final intervention in public

life. In 1923 the executors of the 3rd Earl Brownlow (1844–1921) had decided to sell his estate at Ashridge in Hertfordshire. The great house there, mostly by James Wyatt, stood in magnificent Chiltern countryside and was widely regarded as a national treasure, although there seemed to be no obvious future for it. After some debate, Urban Broughton was recruited as the chief financial backer of a scheme which resulted in much of the estate passing to the National Trust and the house being taken over as the 'Ashridge Bonar Law Memorial College', a 'College of Citizenship' intended to help the Tories reach out to potential supporters, and to overturn the generally perceived intellectual ascendancy of the Left. Broughton was drawn to the project because (as Conservative Central Office put it in the 1950s) 'he was deeply concerned at what was known in those days as "Bolshevism" and he believed that the best way to preserve liberty under a constitutional government was by educating the electorate in the responsibilities of citizenship'. Ashridge became a bastion of Conservative thought and Urban Broughton found himself nominated for a peerage, a title which he would not live to receive, but which would devolve on his son, Huttleston.[92]

The rescue of Ashridge was sold to the British public as a heritage project, but ironically Urban Broughton seems to have been something of a philistine. Unlike his son Huttleston, who loved sight-seeing, he had few real cultural interests. His hobbies were golf and yachting, and from quite early in his career he had his own boat, his steam yacht, *Visitor*, which made the headlines in 1902 as the consequence of an accident on New York City's East River.[93] Dragged around Europe in the 1920s on a series of sightseeing cruises on his wife's yacht *Sapphire*, Urban was evidently bored by cultural tourism, grumbling that 'when one has seen St Peter's, Milan, Cologne, Canterbury, and York Minster, I do not see any reason to

pursue cathedrals, and I propose if possible to avoid them in future'.[94] When on dry land, Cara Broughton's main interests revolved around her charities, although, like her father, she had a shrewd head for business. Both she and her husband retained substantial assets in the United States, and when Urban died in 1929, he left a mere £104,922 in his English will, presumably no more than a fraction of his true wealth.[95]

In the years just after the First World War, there was a widespread belief that peerages could be bought for cash. The going rate, it was alleged, was somewhere between £50,000 and £100,000, paid to Lloyd George's 'fixer', Maundy Gregory (1877–1941). The subject remains fairly murky but, while the 'cash for honours' affair did 'LG' a great deal of harm and was a significant factor in his fall from office in 1922, there is little real evidence that he was much more venal than any other prime minister of the era. By the time of the Ashridge benefaction Lloyd George was out of office, but even in the 1960s hints persisted that Urban Broughton had bought his peerage. Shortly after his son Huttleston's death in 1966, a columnist in the left-leaning *Observer* grumbled that he had been a relic of a vanished era, when titles and honours went by default to the rich (which the Broughtons certainly were) and the well-born (which they were not); carefully phrased though it was, it might have been read as an insinuation that a cruder transaction still had taken place.[96] In reality, of course, there was – and is – a fine line between the straight purchase of honours, and party supporters receiving titles for political services. It is worth bearing in mind that if Urban Broughton had been an American citizen, no US administration would have hesitated to offer him a plum ambassadorship in return for a munificent donation to party funds. *The Saturday Review* hit the nail on the head in 1934 when it said (referring to the Broughton peerage) that ennoblement was 'a usual form of rewarding party

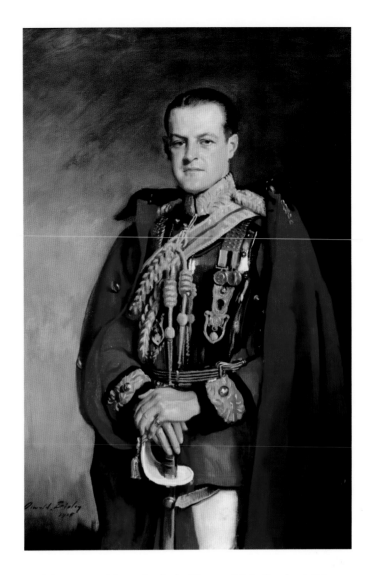

services', a fact which remained as true in 1966 as it had been in the 1920s.[97]

There is no evidence that Urban Broughton was nominated for a peerage in a way which was overtly corrupt, underhand, or illegal, and the other major contributors to the Ashridge appeal also received honours. At the same time it is an inescapable fact that, despite his other political and philanthropic services, Broughton got his peerage ultimately because he was very rich and able to afford 'party services' at a time when an ordinary Tory activist who was not in a position to buy Ashridge would certainly not have received one. But the final irony is that the Broughton peerage was gazetted in the New Years Honours for 1929, and Urban Broughton himself died less than a month later, some weeks before he was due to receive it. The title went by default to Huttleston, with a special remainder allowing Cara Broughton, who may have influenced the choice of title, to take the style and precedence of the widow of a baron. In the event, a peerage for political services went to a man who had no serious interest in politics.

❧ The shy peer

Huttleston Broughton's life was as quiet and self-contained as his grandfather's and parents' had been action-packed and dramatic. Named after his American grandmother and ennobled in acknowledgement of his father's 'public, political and philanthropic services', he took the title of Lord Fairhaven of Lode in 1929, four years after he and his younger brother Henry Broughton (1900–73) had bought Anglesey Abbey. Situated about eight miles north-east of Cambridge, the flat Fenland landscape at Lode seems on the face of it an unpromising location for a great house and garden, but in fact the area had been attracting new money since the 1870s. Current

and former residents included Leopold de Rothschild (1845–1917) at Palace House, Newmarket, the Canadian-born whisky peer Lord Woolavington (1849–1935) at nearby Grove House, the diamond tycoon Solly Barnato Joel (1865–1931) at Sefton Lodge, and the financier Sir Ernest Cassel at Moulton Paddocks.[98] All were drawn by one thing, horse-racing, and initially that was the attraction for Huttleston and Henry as well. In 1924 the two brothers had bought a stud at Barton, north-east of Bury St Edmunds. Anglesey Abbey was convenient for it, and was also easily accessible from London. Besides, the surrounding countryside provided excellent partridge shooting, and devoted as they were to their parents, the two young men were by then 29 and 25. They perhaps felt it was time to set up on their own, and wisely it was agreed that whoever married first would sell up and leave the other in sole occupancy.[99]

This print, published in 1925, shows the family steam yacht, the *Sapphire*, leaving Cowes Roads

One of the chief influences on Lord Fairhaven's artistic tastes was the architect Sir Albert Richardson (1880–1964), who liked to think of Huttleston as 'a man completely dedicated to the arts'.[100] That was perhaps pushing things a little far, and Huttleston's nephew was probably closer to the mark, when he suggested his uncle's life had actually been based around four principal preoccupations: collecting, shooting, racing and gardening (with 'good food and wine' thrown in).[101] As the years went on, the garden and the collection seem to have become increasingly important to him, and Lord Fairhaven spent more and more of his time at Anglesey Abbey, although he also had a flat and an office in London, and a seaside house on the Suffolk coast at Aldeburgh, generally used only in August.

In Sir Oswald Birley's portrait, the 29-year-old Huttleston is a tall, broad-shouldered man, with a heavy jaw and a rather florid complexion. In his youth he was a natty dresser with (as a close friend put it) a talent for 'smoothing over delicate situations'. He was deeply proud of his regiment, a great lover of monarchy and tradition, and decades later he still treasured photographs of friends who had been killed in action in the First World War. He smoked cigars and cigarettes, loved playing golf, and very nearly got himself killed doing the Cresta Run in 1923.[102] A senior steward with the Jockey Club, he was, according to some, 'very shy and introverted' and as a young man he affected to 'pose as a misogynist', though he could also sparkle in company and, at least with friends, displayed 'an ability to discourse on any subject'.[103] He worked for the Red Cross during the Second World War, had 'a good eye', loved antiquing and car tours, disliked hitting 40, enjoyed doing tapestry work, and thought it was 'rather foolish to keep a diary'.[104] Writing in *his* now famous wartime diary, the National Trust's James Lees-Milne thought Lord Fairhaven 'a slightly absurd, vain man, egocentric, pontifical, and too much blessed

with this world's goods', and when he visited Anglesey Abbey in the 1940s, he privately smirked at his host's curious habit of 'flicking invisible specks of fluff off his suit'. Inordinately proud of his own trim figure and with a well-honed eye for the male physique, Lees-Milne thought Fairhaven was, at 47, getting rather paunchy. 'He lives too well and smokes endless cigars'. But he also conceded that 'although aloof and pleased with his noble position', Fairhaven could also be friendly and communicative, and the two men certainly enjoyed grumbling that the country was going to the dogs in the aftermath of the 1945 election.[105]

Lady Fairhaven and her yacht

Lord Fairhaven was devoted to his widowed mother, who after her husband's death in 1929 continued to divide her time between 37 Park Street, and Park House, Englefield Green. She also spent a good deal of time each year on her yacht, the *Sapphire*.[106] By the 1930s Cara had become a very *grande dame*. She dabbled in expensive collecting and particularly liked spectacular jewels but, true to family tradition, she also indulged in suitably public philanthropy, most notably in her gift of Runnymede to the National Trust in 1929, made in memory of her husband, who was commemorated there by a set of

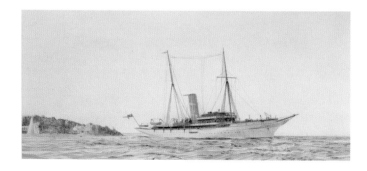

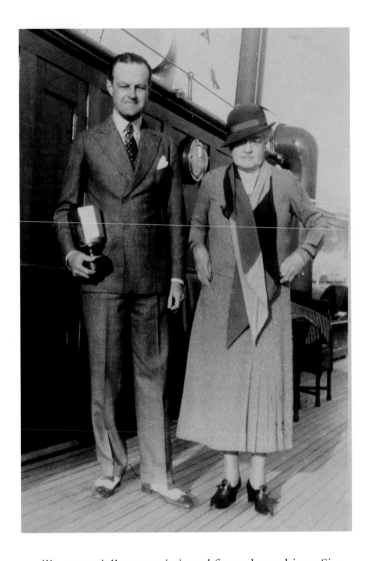

a floating library, each book with a special *Sapphire* bookplate. (Many of the books eventually ended up on the shelves at Anglesey Abbey.)[108]

Photographs of both the *Sapphire* and her houses reveal how much Cara's taste influenced that of her elder son, and she was clearly a powerful force in other ways as well. Publicly devoted to the memory of her father H.H. Rogers, it was presumably through her influence that Huttleston became Lord Fairhaven rather than Lord Broughton or Lord Lode, reputedly the only British peer to take his title from a town in the United States. But Cara's influence was, if anything, even more direct; when Huttleston and his brother wanted servants for the newly acquired Anglesey Abbey in 1926, they were recruited via an agency in London, and interviewed for the post by his mother's housekeeper-companion at 37 Park Close.[109] Her British estate came to some £725,050 in 1939, probably only a fraction of what she was really worth.[110]

Anglesey Abbey and the building campaign

Huttleston grew to love Anglesey Abbey but at the time of the original purchase, in 1926, he and his brother seem to have envisaged the place as no more than a convenient country bachelor pad, and the idea of creating a garden, extending the house, and filling it with treasures was something which emerged only gradually. Originally established as a hospital and refounded as an Augustinian priory in 1212, Anglesey passed through many hands after the dissolution of the monasteries in the sixteenth century, gradually going down in the world until it was little more than a farmhouse wrapped around a few decayed medieval fragments.[111] By the time the Broughton brothers came on the scene the house was

pavilions specially commissioned from the architect Sir Edwin Lutyens. She made a nostalgic visit to America in 1926, attending a dinner at her father's old house on East 78th Street and noting with interest the vast changes afoot in New York, which she found 'so changed that one would not know it'. In Fairhaven she was feted, and since she had not visited since 1910, she made a series of lavish gifts to the town.[107] Like her father before her, Cara travelled in style. *Sapphire*, which she and her husband had purchased in 1924, was, at 1421 tons, one of the largest British-registered yachts, and it had a crew of more than 60. At over 76m (251ft) long, it was only marginally smaller than Cornelius Vanderbilt's *North Star*, the very first American millionaire's yacht, described by contemporaries as a floating palace. *Sapphire* was hardly less palatial, and was frequently seen at Cowes, but more importantly it was ideal for luxurious winter cruises. Among other refinements, the Fairhaven yacht contained

Anglesey Abbey as it appeared
before it was restored and
extended by Lord Fairhaven

pretty dilapidated, but it was gradually transformed
in the following decades, in three distinct phases.
The first was described in *Country Life* in 1930, and
meticulously recorded in a 'before and after' photograph
album preserved in the house. Intended to 'make the old
medieval buildings thoroughly habitable', it involved a
certain amount of re-planning, converting the vaulted
thirteenth-century calefactory from an entrance hall to
a dining room, moving the front porch, creating a com-
pletely new stone newel staircase, tweaking dormers and
installing fireplaces, antique panelling and other period
details.[112] The work was carried out by Sidney Parvin, the
in-house architect of the Mayfair retailers and interior
designers W. Turner Lord & Co. Based in Mount Street,
just yards from the Broughton town house at 37 Park
Street, Turner Lord had been known since the 1890s as
purveyors of grand furniture, architectural details, and
period rooms. They numbered long-established landed
families among their clients, but most of their work was
fitting up grand London houses for the new rich, offer-
ing the same sort of integrated service that the Parisian
firm Allard had provided for wealthy American clients
on Fifth Avenue or on Ocean Drive, Newport, in Cara's
youth.[113] If, as seems likely, Lady Fairhaven was involved,
she seems to have approached Anglesey Abbey in much
the same way that she might have fitted up a yacht or
a New York townhouse in the 1890s. The result was a
house which was, for its date, curiously old-fashioned

(by the 1920s 'period rooms' were becoming decidedly
passé) but it was an approach which Huttleston evidently
felt comfortable with. At any event the project was tack-
led with some vigour, and 60 years later a retired house-
maid still had vivid memories of the gangs of workmen
who were billeted on the villagers in nearby Lode, and
the delivery of Turner Lord's then very fashionable fit-
ted carpets from London.[114] Although the architectural
establishment tended to be rather sniffy about Turner
Lord, regarding the company as decorators rather than
architects, *Country Life* was not unimpressed, commend-
ing the firm for carrying out the alterations at Anglesey
Abbey with 'the greatest taste and discretion'. Huttleston
and his mother were evidently impressed, too, and
shortly afterwards Parvin was commissioned to repair
and restore Ashridge for its new role as a college for the
Tory party.[115]

When Henry Broughton married in 1932, his elder
brother stayed on at Anglesey as the sole proprietor.[116]
The Abbey was still comparatively small, and Lord
Fairhaven's rapidly expanding collection provided the
impetus for its progressive enlargement. First came the
new Library wing, completed in 1937, and then in 1939
the Tapestry Hall, a double-height staircase hall which
provided more display space. The final addition to the
house had to wait until after the war: a two-storey
Picture Gallery – essentially gallery space rather than liv-
ing space – added to designs by Sir Albert Richardson,
which was completed in 1956, just ten years before Lord
Fairhaven died.

The Library wing, again designed by Parvin, provided
additional service space on the ground floor, together
with a large first-floor reception room with ample shelv-
ing space for Lord Fairhaven's books, many of which had
previously been squeezed into alcoves in the ground-floor
Sitting Room. Parvin's final scheme was fairly similar to
an earlier unexecuted scheme commissioned from the

The two-storey Tapestry Hall
was added in 1939

Lewes architects Wratten and Godfrey, but there were key differences. Wratten and Godfrey were familiar with medieval buildings, and were doing work for Sir Paul Latham at the fifteenth-century Herstmonceux Castle at much the same time as they were consulted on Anglesey Abbey. In their designs for Lord Fairhaven they proposed a Library with an open timber roof, a room which closely resembled a monastic hall. Parvin's rather less Gothic winning design, on the other hand, was barrel-vaulted, and lit by huge oriel windows at either end. These windows made it possible to shelve the long side walls from floor to ceiling, with ten decks of shelving to Wratten and Godfrey's three, providing enough space for 7000–8000 volumes.[117]

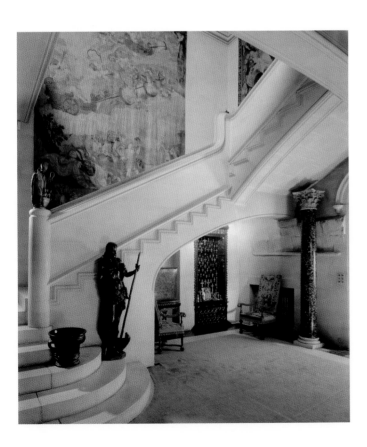

❧ The collector at home

By then Anglesey Abbey was a veritable treasure house, with every available space crammed with an extraordinary and eclectic medley: pictures, furniture, bronzes, tapestries, silver, books and clocks. All these were carefully arranged by Lord Fairhaven, who enjoyed doing 'a lot of changing round', to the evident puzzlement of the servants, some of whom were specially trained in handling precious objects.[118] His personal involvement no doubt explains his clearly expressed wish that the house and collection should remain arranged as it was at the time of his death, a request that the National Trust did not entirely honour in the late 1960s, although there have been considerable efforts in more recent times to turn the clock back. Fairhaven's collection developed over nearly 50 years and his taste changed and developed over time. Lack of surviving documentation makes it difficult to construct a precise chronology but it seems clear that he started off with an enthusiasm for the Jacobean and medieval, and gradually became interested in the neoclassical, probably under the influence of his friend Albert Richardson, a key figure in the Regency revival of the mid-twentieth century. In common with Richardson, he had no interest whatever in Modernism, and his tastes were deeply conservative (when he gave £30,000 to the Fitzwilliam Museum in Cambridge in 1948, for example, he carefully stipulated that it should be used to buy British School landscapes, and specifically excluded contemporary art).[119] Parts of his own collection, among them the large collection of jewelled crucifixes in the Tapestry Hall, the Constable *Embarkation of George IV from Whitehall* in the Library and the soapstone animals, were inherited from his mother and moved to Anglesey Abbey after her death, but the contents of the house very largely reflect Fairhaven's own personal, and sometimes rather idiosyncratic, tastes.[120]

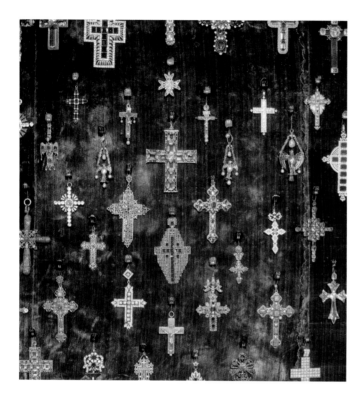

His early purchases included sporting and military pictures – Sir Alfred Munnings (1878–1959) was and remained a favourite – but in the post-war period he also bought Old Masters, and his greatest coup as a collector was his acquisition of the two marvellous 'Altieri Claudes' (two paintings by Claude Lorrain, 1600–82, once in the possession of the Altieri family in Rome) which had belonged to William Beckford, and which he purchased at the Duke of Kent's sale in 1947. British art was also a major preoccupation (though interestingly American pieces were not), and Lord Fairhaven's purchases ranged from important Tudor panel portraits through to landscape painter Richard Parkes Bonington's *Coastal Scene of Northern France*, and sculptor John Flaxman's *Shield of Achilles*, one of the masterpieces of Regency silversmithing. Another particular favourite was William

Etty (1787–1849). Although Lord Fairhaven was a vocal advocate of British art in general and Etty's nudes in particular, James Lees-Milne noticed that his 16 Ettys were discreetly hung in the corridor which led to his own bedroom.[121]

Other obvious themes include ceremony and tradition, royalty and, above all, Windsor Castle, a building which had fascinated Huttleston since he was stationed at Windsor during the First World War.[122] More generally the collection, and especially the pictures, prints, books and drawings, often serves some sort of documentary, biographical or associational function, recording a place or an event, or reflecting something of the life and interests of a former owner. Many of the items refer in some way to other objects in the same room, or elsewhere in the house. The Lower Gallery houses many of the Windsor pictures, for example, while the Flaxman *Shield of Achilles*, shown in the Upper Gallery, was bought by George IV in 1821 and displayed at his coronation banquet in 1821. The same king substantially remodelled Windsor Castle and, as Prince Regent, had been the recipient of the despatch drafted by the Duke of Wellington at Waterloo in 1815, a document which Lord Fairhaven bought for his library. Napoleon, Wellington's defeated opponent, was imprisoned on St Helena, which is illustrated in meticulous detail in one of Lord Fairhaven's finest colour-plate books, George Hutchins Bellasis's *Views of Saint Helena* (London, 1815) (no. 25), and he also bought a mahogany circular table of about 1810, said to have been used by the exiled emperor.

To draw out another connecting thread, a Georgian heraldic tabard hangs on the wall of the Windsor Corridor, a garment which might have been worn by one of the heralds who officiated at the ceremonies for the foundation of the Order of the Bath in 1725. These are depicted in glorious detail in Joseph Highmore's original coloured drawings for John Pine's *Procession*

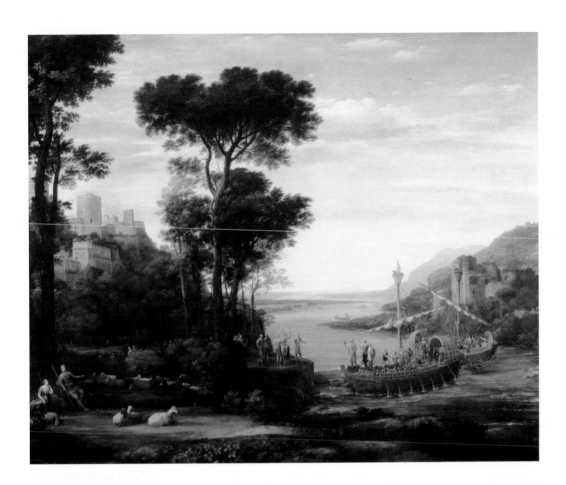

LEFT *The Landing of Aeneas at Palanteum*, by Claude Lorrain, one of two paintings by Claude which were the masterpieces of the Fairhaven picture collection

BELOW *Windsor Castle*, by William Marlow; Lord Fairhaven's collection of painted views of the royal castle are displayed in the Upper Picture Gallery

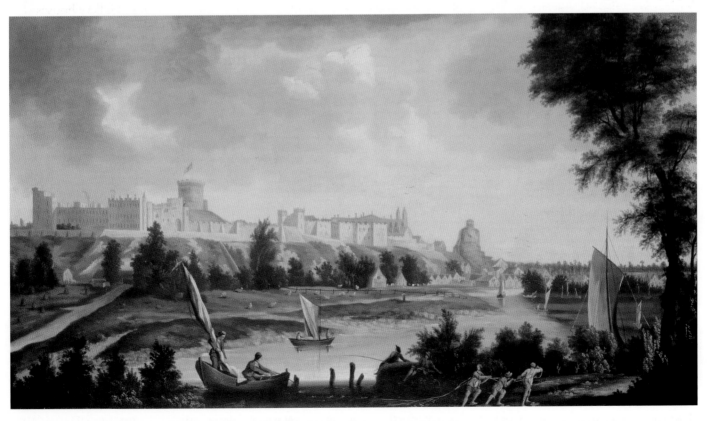

*and Ceremonies Observed at the Time of the Installation of
the Knights Companion of the Most Honourable Military
Order of the Bath* (London, 1730), drawings which
Lord Fairhaven bought at some date after 1934.[123] In addi-
tion to the drawings, Fairhaven owned a fine copy of the
ensuing book, and he also had a copy of its obvious pre-
cursor, Elias Ashmole's *Institution, Laws and Ceremonies
of the Order of the Garter* (London, 1672) (no. 6), a history
of the senior British order of chivalry. Inevitably much of
this relates to Windsor, and Wenceslaus Hollar's magnifi-
cent engravings of the castle then point us to the unsur-
prising fact that Fairhaven also bought Hollar drawings

of Windsor. He cannot have been unaware that the plate
opposite page 404 in the Ashmole volume depicts the
investiture of the Emperor Maximilian with the Garter in
1490. This must have given him considerable satisfaction,
since he himself owned the actual Garter sent by Henry
VII to the emperor. Finally, in the context of the Pine
and the Ashmole volumes – both of them fine examples
of early books on royal ceremonial – we can close the cir-
cle and return to George IV and the Duke of Wellington;
one of the most remarkable items in the library is a set
of coloured proofs of Ackermann's panoramic roll of the
Iron Duke's state funeral in 1852 (no. 39).

When James Lees-Milne visited Anglesey Abbey in
the middle of the Second World War, he characterised its
contents as 'a desultory collection of fine things which
does not amount to a great collection'.[124] It is a remark
which, more than any other, has tended to be wheeled
out whenever the Fairhaven collection is discussed, but
it is worthwhile asking how fair this is. It is certainly
uneven, and for every aesthete who coveted the Claudes
and every bibliophile who drooled over one of the
Geometrical Compartment Binder's finest bindings
(no. 9), there have no doubt been others who have shud-
dered at the Ettys and the Cosway bindings (no. 46).
In part, this is a reflection of how the collection evolved
during its owner's lifetime, and it is difficult to avoid
the suspicion that Huttleston, who was essentially self-
taught, got better at collecting as he got older. But it is
also perhaps based on a misunderstanding of what he
was trying to achieve. Since there is little documentary
evidence, this can only be inferred, but several points
seem clear. The first is that, whatever one thinks of the
underlying taste, the collection cannot be regarded as
desultory, if by that we mean that Huttleston was simply
a rich dupe who pottered around dealers' shops buying
expensive things at random. Clearly he liked shopping,
and he liked doing it in person, as both his nephew and

various long-established members of the London trade still recall. Equally he was happy to lay out large sums of money to get the things that he really wanted. But he also had an eye for a bargain: the Altieri Claudes, for example, were bought for £170 in 1947, an astute buy when the market was at rock bottom. It is quite clear that there was an underlying logic and order to the collection, and that this increased as time went on. This logic was substantially Lord Fairhaven's own, since there is no evidence of a cultural adviser pulling strings (though Richardson and others certainly commented from time to time), and no individual dealer specialising in a single category of object could have provided guidance that would have resulted in the pictures, prints, books, furniture, silver and so on cross-referring to one another in the way that they clearly do.

Part of the problem has perhaps been that, when it has been considered at all, the Fairhaven collection has been regarded primarily as an assemblage of pictures and expensive furniture, and secondarily as interior design. In the process, two of its most important components – books and works on paper – have been almost entirely overlooked. Yet these help to reinforce the line taken by more astute commentators: that Huttleston was as much interested in historical, antiquarian and topographical pursuits as in art with a capital A. Had he wanted to assemble a comprehensive, encyclopaedic and representative collection of 'great' works he could easily have done so, but he clearly preferred to follow his own interests and trains of thought. It is instructive that, when he commissioned a catalogue of his collection, it described not the things which the pundits would have liked to know about, but the pictures, prints, books and drawings in the Windsor collection.

Ultimately, to find Anglesey Abbey wanting for not being something it was never intended to be is perhaps slightly sterile, even if that was an understandable reaction for National Trust staff called upon to assess its merits in the late 1960s. Speaking in 1992, the 11th Duke of Grafton (1919–2011), Honorary Representative and later East Anglian regional Chairman, and one of the National Trust's most influential grandees, was openly scathing: 'We ought never to have taken Anglesey Abbey ... but it was too late by the time I was landed with it.'[125] A former Deputy Chairman of the Society for the Protection of Ancient Buildings and, like Lees-Milne and many other National Trust aesthetes, a prominent member of the Georgian Group, Grafton came from the generation brought up on books such as Geoffrey Scott's *Architecture of Humanism* (1914), which had attacked the 'wholly false aesthetic' of the Romantic movement.[126] Trained to think of cultural history as a progression from one form of high style to another (from Gothic to classical, from Arts and Crafts to Modernism, and so on), it would have been surprising if they had judged the expensive historicist eclecticism of Anglesey Abbey any differently. It would be several decades before architectural and social historians in both Britain and the US began to take the great mansions of the *nouveaux riches* seriously, and by that stage many of them had already been demolished. An expensive collection of fine things, bought by a man who had arrived from the US aged 16, whose tastes were formed in the Gilded Age of his youth, whose suits were too grand for the country, and whose pile-carpeted house was heated and furnished with a level of comfort and technological sophistication all but unknown in British houses of the period: it was always bound to be a puzzle.[127] Only with the benefit of 50 years of hindsight is it now easier to see that Anglesey Abbey can, and perhaps should, be looked at on two distinct levels; not only as an assembly of magnificent and occasionally really wonderful things, but also as an intriguing social document.

The Library at Anglesey Abbey

Sidney Parvin's barrel-vaulted Library at Anglesey Abbey is by any standards a dramatic and rather extraordinary room. A slightly modernised 1930s take on the historicist style in vogue in Britain and America in the late nineteenth and early twentieth centuries – with just a hint of Gotham City and the Bat Cave – it provides an appropriately dramatic setting for one of the National Trust's most grandiose collections of books. But books are not the only treasures. At either end of the room, huge sheets of mirror glass reflect into infinity the floor-to-ceiling bookcases made from the piles of John Rennie's Waterloo Bridge, demolished in 1934. Constable's *Embarkation of George IV from Whitehall: The Opening of Waterloo Bridge 1817*, a picture purchased by Lord Fairhaven's mother in 1923, hangs on one of the long side walls.[128] Other treasures include seventeenth-century bronzes, a set of panel paintings of royalty (including perhaps the earliest portrait of Henry VIII), sculpture by Frederic Leighton and Alfred Gilbert, wooden soldier figures from sixteenth-century Swabia, framed miniatures after the antiquarian George Vertue (1684–1756), and a pair of extraordinarily lavish clocks, one French and one English. Two large chintz sofas are set around the Tuscan-columned fireplace, and there are two massive library tables, one perhaps by the Regency cabinet-makers Marsh and Tatham, and the other traditionally said to have been made for Sir Robert Walpole at Houghton Hall, Norfolk. Most spectacular of all are two solid silver chandeliers, part of a set of five made by Balthasar Friedrich Behrens (1701–60) to designs by William Kent (*c.* 1685–1748), and intended for the Hanoverian summer palace at Herrenhausen.

The whole ensemble is, to say the least, eclectic, and given Lord Fairhaven's American antecedents, it

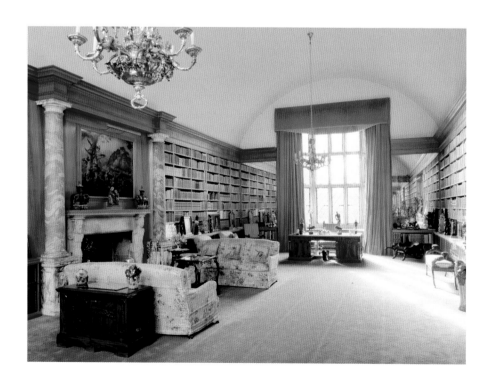

The Library at Anglesey Abbey, looking towards the mullioned window

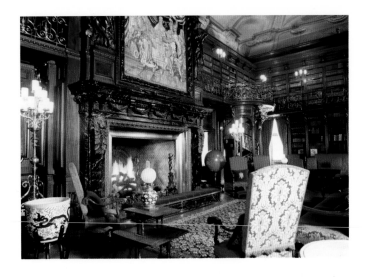

The Library at Biltmore, the Vanderbilts' palatial mansion in North Carolina (Gamma-Rapho via Getty Images)

is striking at first sight how little it conforms to the Frenchified tastes beloved of the novelist and cultural arbiter Edith Wharton, or indeed to the preferences of the Vanderbilts and their favoured architect Richard Morris Hunt. By the 1920s Lord Fairhaven, with his British title and his fondness for British art, evidently did not entirely share the tastes of his mother's youth. The Trianon-inspired architecture of the Vanderbilts' Marble House in Newport, the monumental classicism of New York's Metropolitan Museum of Art, or even the French Gothic of many of the great mansions which once lined Fifth Avenue, were clearly not for him. Nonetheless, the Library at Anglesey Abbey in fact largely conforms to the *beau ideal* of a private library as set out in Wharton's *The Decoration of Period Rooms* (1898), the interior design bible of the Gilded Age. Wharton had recommended that 'plain wood bookcases' 'in natural oak or walnut' should be set into the walls and should line the room from floor to ceiling. The bookcases should be open, without heavy doors or lavish ornamentation, and the preferred form was the 'bookcase à deux corps – that is made in two separate parts, the lower a cupboard to contain prints and folios'. Above all, the books themselves should be beautifully bound, as 'bindings of half morocco or vellum form an expanse of warm lustrous colours'.[129] Apart from the change in visual vocabulary – Tudorbethan Gothic with neo-Georgian touches rather than *Louis Seize* classicism – Parvin's designs for Lord Fairhaven follow the Wharton recipe in all the essentials. As a piece of architecture and interior design, the room is a fusion not just of classical with Gothic, but of Gilded Age planning and opulence with Lord Fairhaven's own romantic longing for Olde England. Even given its opulence and eclecticism (Mrs Wharton would have liked one but not the other), no-one could be left in any doubt that it was a library, dominated not by furniture, pictures or *objets d'art*, but by row upon row of books in gold-tooled crushed morocco bindings,

with the Fairhaven crest on their spines. Ironically, however, despite – or perhaps because of – this magnificence, the books on the shelves have either been ignored, or treated primarily as interior design.

There are nearly 5200 books on the shelves of the Library at Anglesey Abbey – more if one counts volumes rather than imprints – and a couple of thousand more elsewhere in the house. Of these, the great majority – well over 80 per cent – were acquired by Lord Fairhaven not as collector's items, but as reading copies of standard late nineteenth- and early twentieth-century books. They cover a great range of subjects: politics, literature (both high-brow and less elevated leisure reading), travel, country sports, racing, art, architecture and so on. The overwhelming majority of these books are in English; many were bought by Lord Fairhaven himself, though others belonged to his father and mother, and a fair few seem once to have been kept on board the S.Y. *Sapphire*. A few of the reading copies – for example Lord Fairhaven's first edition of Ian Fleming's *You Only Live Twice* (no. 50) – have acquired a desirability and collectability which Fairhaven probably never envisaged. But most were and remain perfectly ordinary books, chiefly remarkable for their extraordinary bindings. Interviewed in the 1980s, Lord Fairhaven's nephew commented on 'the large collection of books that have all been bound in leather with the family crest on them', explaining that 'in those days we went out to Heffers [in Cambridge] and bought a novel for 2/6 or 1/3 or whatever it was, and took it off to Gray's [Cambridge's premier bookbinders] and you had the whole thing bound in leather and it cost a pound'. In fact Lord Fairhaven's bindings seem mostly to have

copy of the 1502 Aldine Catullus, but this is very untypical of Lord Fairhaven's books and was presumably bought because it had once belonged to his father's friend, Lord Birkenhead, rather than because of any particular interest in Catullus, or indeed in the great Venetian printer Aldo Manuzio (1449–1515). Apart from this, there are very few editions of the Greek and Latin classics, and indeed comparatively few books of any kind in languages other than English. Of the seventeenth-century books, most clearly appealed to Lord Fairhaven for quite specific reasons, including his copy of Elias Ashmole's 1672 history of the Order of the Garter (no. 6), which is mostly about Windsor, his 1690 Loggan *Cantabrigia Illustrata* (no. 7), and – of even more obvious interest to an adoptive Fenlander – Sir Jonas Moore's *The History or Narrative of the Great Level of the Fenns, called Bedford Level* (London, 1685). By comparison there are considerably more (over 100) eighteenth-century books, the great majority fine copies of illustrated or iconic books of one kind or another; these are well-represented here and it would not have been difficult to select more for inclusion. Nineteenth-century books are still more numerous (nearly 1000), many of them obviously bought quite deliberately as collectibles, and 24 of the most remarkable are illustrated here. From the twentieth century the grille books include a few private press publications, notably Lord Fairhaven's copy of T.E. Lawrence's *The Seven Pillars of Wisdom* (1926) (no. 44) and the Gregynog Press *Eros and Psyche* (1935) (no. 49), as well as two sumptuous but rather saccharine illuminated manuscripts (nos. 45 and 47), almost certainly early acquisitions and probably not the sort of books which Lord Fairhaven would have bought later in life.

Far more notable and vastly more numerous, however, and dominating the selection illustrated here, are Lord Fairhaven's collections of fine bindings and colour-plate

been done in London, but the point is unarguable. That said, the sight of rows of Fairhaven livery bindings is often taken by National Trust visitors as evidence that Huttleston bought his books 'by the yard'. This is one of the most pervasive of all country house myths, and one which is almost never true. In fact Huttleston liked to note the date he had read a particular book on the flyleaf, and it seems clear that his binding campaign was still in progress when he died unexpectedly in 1966 – corners of the Library were never finished. In other words, in many cases the books came first, then the room, and the fine bindings came last of all.

So much for the 80 per cent, the reading copies, but what of the remaining 20 per cent, Lord Fairhaven's collection of fine books, mostly stowed away in the grilles in the lower part of each of the library bookcases? There are comparatively few early books here: no medieval manuscripts (perhaps rather surprisingly), no incunabula and only a few dozen sixteenth- and seventeenth-century books, several of them illustrated in the following pages (nos. 1–7). The earliest book is a slightly unremarkable

books. Binding historians are often quick to point out the anomaly inherent in focusing on fine or fancy bindings when books of all kinds have a physical structure whose study can yield sometimes startling insights into their history. But bibliophiles have long coveted curious or lavishly decorated books, and to that extent the history of fine bindings is an important part of the history of bibliophilia. Lord Fairhaven was certainly an enthusiast, and was sufficiently interested in the subject to buy reference books on it – for example G.D. Hobson's magnificent illustrated catalogue (1940) of early English bindings in the library of the English bibliophile J.R. Abbey (1896–1969). While there are thousands of expensive twentieth-century bindings on books in Fairhaven's reading collection (in their own way, *en masse*, a rather extraordinary piece of bookbinding history), the bindings in the grille collection are comparatively few in number. Most of the more striking examples are illustrated here (nos. 1, 9, 13, 42, 43, 45, 46 and 47), although there are many other books which were obviously collected primarily for other reasons which are also in fine, lavish or simply interesting bindings (nos. 3, 4, 14 and 44 are good examples). Although there are a few earlier examples, most of Lord Fairhaven's grander bindings date from the late eighteenth, nineteenth and early twentieth centuries. Some of the very finest examples (for example no. 47) are obviously the product of the revival of English binding inspired by William Morris, and more particularly by the great craft binder T.J. Cobden-Sanderson (1840–1922), and are both sophisticated and extremely beautiful. Even those which later tastes have tended to find ostentatious and aesthetically clumsy (the most extreme example shown here is perhaps the first of the two 'Cosway' bindings illustrated (no. 46), are, as David Pearson remarks, impressive examples of the craft of their era, and striking and well-preserved examples of a very particular sort of millionaire taste. These too were probably early acquisitions, and it would be interesting

Two examples of the specially-designed bookplates which Lord Fairhaven commissioned for his book collection

to know whether the rather fastidious collector that Lord Fairhaven had become by the 1950s might have regretted these youthful excesses.

If the binding collection is comparatively small (and commensurately quite well represented in this selection), Lord Fairhaven's collection of illustrated books is very much larger, with well over 80 of the very first rank, some rare or unusual and others of the greatest possible magnificence. Many of the finest are included here, but it is perhaps worth emphasising that, while this survey includes many of Lord Fairhaven's finest bindings, it represents only quite a small proportion of his plate books; if space had permitted, several dozen more would certainly have made the shortlist. The majority of these books are superb copies in mint condition, either finely bound or, occasionally, carefully preserved (often in specially made boxes) in their original boards, as issued. Many are on large paper, or have other refinements or adornments calculated to whet the appetite of a millionaire book

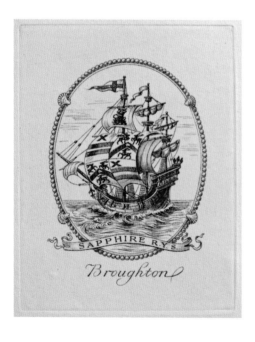

collector. Again, while it is difficult to map a precise chronology, it is clear that Lord Fairhaven's tastes developed over time, and that what began as a young army officer's collection of prints and books about military uniforms gradually developed to encompass costume books and books on pageantry and ceremonial; flower books (Huttleston's younger brother Henry Broughton also collected flower paintings, and subsequently presented many to the Fitzwilliam Museum in Cambridge); books on travel and topography; and, finally, colour-plate books of all types and a substantial number of illustrated books. The colour-plate books, in particular, are very striking. These were enormously desirable in Regency England, because they could reproduce many of the nuances of watercolour, but for many years after that they were despised by sophisticated bibliophiles. In the years since Lord Fairhaven's death, however, they have once again come to be regarded as remarkable, beautiful and desirable.

Given the loss of most of the acquisitions records (see p. 38), it is now very difficult to reconstruct a precise chronology, and only occasionally is it possible to say where Lord Fairhaven bought particular books. He was certainly well known in many of the smarter West End bookshops, though Charles Sawyer of Grafton Street seems to have been a particular favourite. As Lord Fairhaven's nephew recalled in 1986, 'he and my father were two of the very few people in the country who were actually collecting' in the immediate post-war period, and 'dealers in London would rub their hands with glee when they saw either the 1st Lord Fairhaven or Major Henry Broughton walking down the street'.[130] There are still people who remember dealing with the exacting customer in the kid gloves, and Lord Fairhaven is not by any means beyond living memory.[131]

The result was, and is, a library which is by no means easy to categorise. Writing in 1948 (the year after Lord

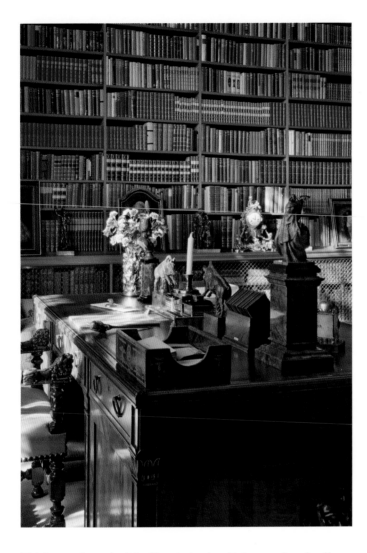

It is true that Lord Fairhaven's library does not contain the stupendous treasures assembled by his grandfather's American contemporaries; none of the marvellous manuscripts in J.P. Morgan's library in New York, and not even one Shakespeare First Folio to set against Mr Folger's hoard in Washington DC. It is clear that Lord Fairhaven was not especially interested in either, but his library certainly does not compare badly with other American private collections of the era, including the large library assembled by George Washington Vanderbilt (1862–1914) at Biltmore, his palatial country retreat in South Carolina. A better point of comparison might be the great library assembled by Sir Paul Getty (1932–2003) at Wormsley in Buckinghamshire – a collection and a family with a rather similar pedigree to Lord Fairhaven and Anglesey Abbey, although admittedly the Wormsley library is both grander and considerably more varied, with a far wider range of manuscripts and earlier printed books in particular (and assembled with a substantial element of help and guidance from the great London dealer Maggs Bros.).[133] Perhaps more comparable still is the even larger library assembled by Lord Fairhaven's near contemporary, Major J.R. Abbey, not least for its wonderful collection of plate books. Fairhaven was clearly aware of it, owned several of Abbey's splendid catalogues (an essential reference source in the compilation of this catalogue of Fairhaven treasures), and cannot have failed to be pleased by the number of his own books which he and favoured dealers were able to inscribe 'Not in Abbey'.

Fairhaven bought his Claudes), the diplomat, bookseller and bibliophile guru John Carter (1905–75) was rather sniffy about Fairhaven-type collectors with long purses who were attracted to 'colour plate books and handsome (often showy rather that strictly fine) bindings'.[132] But whether this was fair in 1948, and – still more – whether it is helpful today, is debatable. Carter, after all, was an Eton and Cambridge classicist with very different tastes from Lord Fairhaven, and he was active in an era which had barely discovered the Regency, which saw the demolition of architectural masterpieces like Sir John Soane's Bank of England, and which was often puzzled by the odd enthusiasms of eccentrics like Sir Albert Richardson. Perhaps, with the benefit of hindsight, it is possible to take seriously things which Carter did not, and rather easier, six decades later, to judge the library on its own terms, rather than measuring it against some externally validated canon of taste.

Three points are worth making in conclusion. The first is that Fairhaven's shelves are incontestably packed with magnificent books, books which time and again compel the viewer to draw breath and gasp with admiration. The National Trust has many fine libraries, and many marvellous books, but for sheer concentrated magnificence few can match Anglesey Abbey. As Nicolas Barker rightly observed in the preface to a catalogue

issued to commemorate a National Trust fundraising exhibition at New York's Grolier Club in 1999 (an appropriate venue for the sort of Anglo-American philanthropy of which Lord Fairhaven would surely have approved), the Fairhaven collection includes 'some of the grandest books that the Trust owns'.[134] Second, as this book shows, there is a considerable logic and coherence underlying Lord Fairhaven's choice of books, and to a large extent he himself seems to have determined what to buy and what not to buy. No-one was pulling his strings, and his was a very personal collection; nearly 50 years after his death, it seems remarkable for that reason alone. Finally, and just as important, the library is a fascinating exemplar of the tastes (and indeed some of the foibles) of its era. Lord Fairhaven clearly saw it as an integral and very important part of his collection, and the library makes undeniable sense both in that context, and in the extraordinarily opulent setting which he contrived for it. What is more, it is a collection which makes more sense not only when it is examined – as it has been here, for the first time – in the context of Huttleston's life at Anglesey Abbey, but, equally, in the light of the lives of his parents and his American grandfather, the oil baron Henry Huttleston Rogers.

Ultimately, readers must draw their own conclusions about the range, sophistication and success of Huttleston's connoisseurship. Visitors can also decide for themselves what to make of Anglesey Abbey; whether it is a sublime memorial to the tastes of one man, an unmissable opportunity to snoop round a millionaire's mansion, or an example of conspicuous consumption – a term coined by the Gilded Age sociologist Thorstein Veblen in his *Theory of the Leisure Class* (1899) – on a truly heroic scale. For some, perhaps, it may be all of these. What is incontestable is that Lord Fairhaven was an extremely generous benefactor of the National Trust, and that his house and garden have been enjoyed by millions in the nearly half century since he died. That, perhaps, is conclusion enough, but it is pleasing indeed that the library which clearly meant so much to him is now on show for the very first time.

❧ Note on the provenance of books at Anglesey Abbey

Very few of the 1st Lord Fairhaven's personal papers have survived. There are a variety of possible reasons for this state of affairs. Speaking in 1986, Fairhaven's nephew, the 3rd Lord Fairhaven (b. 1936), was sure that his uncle had maintained detailed acquisition lists for his entire collection, and that these were kept in the library desk at Anglesey Abbey. These, however, seem not to survive. Whether this is because (as Lord Fairhaven believed) the papers were removed to allow Robin Fedden to write the first National Trust guidebook to Anglesey Abbey (1968), and subsequently lost, or whether these papers were included among those which other sources suggest were deliberately destroyed on his uncle's instructions in 1966, is, after nearly 50 years, now impossible to say. The two stories are clearly not mutually exclusive. At any event, we now know regrettably little about the provenance of many of the books in the Fairhaven collection. Lord Fairhaven is known to have been a regular customer at several West End bookshops, and a handful of bills also survive from youthful book-buying in Eton in the 1920s; these remain at Anglesey Abbey. The information on the provenance of the books described below is derived either from these bills, from ownership marks on the books themselves or, occasionally, from bills and cuttings from catalogues pasted or inserted into the copies. In some cases these, too, are incomplete, Lord Fairhaven having removed either the price, or any mention of the dealer or auction house concerned, or both.

Fifty Treasures from Lord Fairhaven's Library

1. A sixteenth-century Cambridge armorial binding

John Caius, *De Antiquitate Cantabrigiensis Academiæ Libri Duo*
Londini: in ædibus Iohannis Daij, An. Dom. 1574

For many centuries, the defining characteristic of luxurious and upmarket bookbindings was the use of gold tooling, achieved by applying a thin layer of gold leaf between a heated tool and the leather surface. The technique was invented by Islamic bookbinders in the Near East during the Middle Ages, and first practised in Europe in the late fifteenth century. The earliest known English gold-tooled binding dates from around 1520, and during the sixteenth century the practice gradually spread across English binding workshops and their customers. Initially restricted to a few London binders with royal or aristocratic patrons, gold tooling had, by the end of the century, become a standard offering not only in the capital, but also in the other major English binding centres in Oxford and Cambridge.

This elaborately decorated Cambridge binding is noteworthy on several counts. Its central ornament, incorporating the arms of Cambridge University, is evidence of one of a family of similar tools used in Cambridge in the 1570s and 1580s. They are well known to binding historians and the most recently published account of them mentions 60 surviving examples. The great majority of these, however, are much simpler, being blind-tooled without the use of gold leaf, and this is the most spectacular known example. It was also, until recently, lost to view; an account of these bindings written in

1968 noted the existence of this binding from its mention in a 1936 dealer's catalogue, but after that the trail went cold. Its rediscovery at Anglesey Abbey means that we can now close the circle and record that the unknown customer was Lord Fairhaven.

The binding's interest, and the appropriateness of its decoration, is enhanced by the fact that it covers a copy of *De Antiquitate Cantabrigiensis Academiæ* by John Caius, the sixteenth-century London physician who endowed Gonville Hall in Cambridge, recreating it as Gonville and Caius College. First published in 1568, this is the first printed history of Cambridge University; it was written to counter a contemporary account of Oxford University, with the aim of proving Cambridge to be the older and superior foundation. Its contents, including the assertion that the university was founded by ancient Athenian philosophers, are largely erroneous and discredited, but the book is a significant milestone in Cambridge bibliography. This book stands out on Fairhaven's shelves as a particularly early fine binding; there are relatively few sixteenth-century books at Anglesey Abbey, and no other bindings of the period of comparable quality. It seems likely that Fairhaven was interested in the Cambridge association, as his library includes a section of material of Cambridge antiquarian interest, of which this is a particularly significant representative.

BINDING
Gilt-tooled dark brown calfskin, *c.* 1575, decorated in centre and cornerpiece style with tool CAM3 in cartouche F3, following the classification in David Pearson, 'Bookbinding in Cambridge in the second half of the sixteenth century', in David Pearson (ed.), *For the*

Love of the Binding: Studies in Bookbinding History Presented to Mirjam Foot (London: British Library, 2000), pp. 169–96, 181–2.

REFERENCES
ESTC S107133; STC 4345; John Morris, 'Thomas Thomas, Printer to the University of

Cambridge 1583–8, Part II', *Transactions of the Cambridge Bibliographical Society* 4 (1968), pp. 339–62; H.R. Plomer, 'The 1574 Edition of Dr John Caius's *De Antiquitate Cantabrigiensis*', *The Library,* 4th ser. 7 (1926), pp. 253–68.

DP

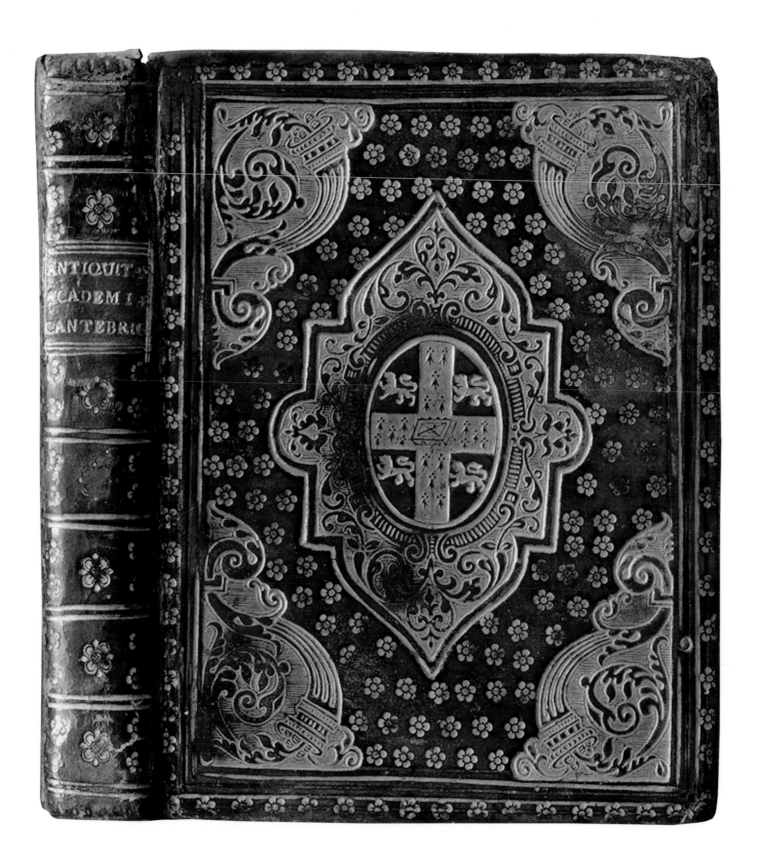

2. Don John's stables

Jan van der Straet, *Equile Ioannis Austriaci Caroli V Imp. F.*
[Haarlem?, 1578?]

'Un bellissimo libro di Cavalli .. tanto ben' osservato che veramenti è una maraviglia.' ('A very beautiful book of Horses … so well observed that truly it's a marvel.') This was the estimate of the Italian art historian Filippo Baldinucci, writing in 1681, a century after the appearance of van der Straet's *Equile Ioannis Austriaci.* It was the first such series of horse illustrations to be printed, and its reputation ensured that it continued to be issued under various titles until around 1700.

The owner of the horses was Don John of Austria (1547–78), the victor of the battle of Lepanto, and it was doubtless he who originally commissioned the engravings. The artist, Jan van der Straet (1523–1605), often referred to in Latinised form as Johannes Stradanus, had followed his patron to the Low Countries when Don John became regent there in 1576. Van der Straet was in fact a native of Bruges, but spent much of his career in Italy, working with Vasari on the Palazzo Vecchio in Florence. Initially most active as a designer of tapestries, he took advantage of the relatively new medium of engraving to make his work more widely known, using engravers and publishers in his native country, at that time the greatest centre for the medium. His association with the engraver and publisher Philips Galle (1537–1612) began in 1574.

Work probably started on the *Equile* in 1578, with Hieronymus Wierix (1553–1619) providing the engravings after van der Straet's designs. Two unlooked-for events, however, temporarily put the project into abeyance. The first was the untimely death of Don John on 1 October, 1578; the second was the imprisonment of Wierix, a brilliant engraver but tempestuous personality, for accidentally killing a barmaid in 1579 in a brawl. A new patron was needed, and the one whose name appears on the title-page is Alphonso Felice d'Avalos y Aragon (1556–1619), a descendant both of Margaret of Palma, a former regent of the Low Countries, and of Federico II Gonzaga, who had immortalised his own stable on the walls of the Palazzo Te in Mantua, providing a possible model for Don John's undertaking.

Work could now resume with a different group of engravers. The title-page is signed by Adriaen Collaert (*c.* 1560–1618), probably a pupil of Galle and who was to become his son-in-law a few years later. Other plates were executed by Hendrick Goltzius (1558–1617), an engraver of such fame in Europe that when he travelled to Italy at the age of 32 he went incognito to avoid being mobbed by fans, and Hans Collaert I (*c.* 1525/30–80), Adriaen's father, to whom 'Dacus' and four other unsigned plates are attributed. The complete work probably appeared shortly after 1580.

In the Sala dei Cavalli in the Palazzo Te, the horses were depicted standing in profile against architectural backgrounds. In the *Equile* they appear in natural landscapes, riderless in all but one plate, but portrayed in poses (rearing, trotting, galloping) which suggest the exercises of the riding school. These poses often feature in the grand equestrian portraits of the ensuing century by Velázquez, Rubens and others, suggesting that the work of van der Straet was admired and taken for a model by greater artists.

BINDING
Half-goatskin, twentieth
century.

REFERENCES
Alessandra Baroni Vannucci,
*Jan van der Straet detto Giovanni
Stradano* (Milan: Jandi Sapi,
1997), p. 692; Ann Diels and
Marjolein Leesburg, *The
Collaert Dynasty* (Ouderkerk
aan den Ijssel: Sound & Vision,
2005), pp. 1482–90; Marjolein
Leesburg, *Johannes Stradanus*
(Ouderkerk aan den Ijssel:
Sound & Vision, 2008), pp.
527–66; Walter Liedtke, *The
Royal Horse and Rider* (New
York: Abaris Books, 1989);
Zsuzsanna Ruyven-Zeman,
The Wierix Family (Rotterdam:
Sound & Vision, 2003–4) pp.
2196–2209; Manfred Sellinck
and Marjolein Leesberg, *Philips
Galle* (Rotterdam: Sound &
Vision, 2001); Walter L.
Strauss, *Hendrik Goltzius*
(New York: Abaris Books,
1977), pp. 91–105.

WH

3. The first English county atlas, from Chichester Cathedral

Christopher Saxton, *Atlas of the Counties of England and Wales*
[London, 1590?]

Saxton's *Atlas* was the first complete county atlas of England and Wales, and the first national survey of its kind to be published in any European country. Obviously inspired by *Theatrum Orbis Terrarum* (Antwerp, 1570), the first modern atlas, compiled by the Flemish geographer Abraham Ortelius (1527–98), Saxton's great work was an official project, sponsored and supported by the government of Queen Elizabeth I. It seems to have been carried forward under the personal protection of her Lord Treasurer, William Cecil, Lord Burghley (1520–98), who was well aware of the political and military uses of accurate maps.

In March 1576 – when the cartographer was somewhere between 32 and 34 years old – the Privy Council had issued a warrant ordering that:

> Saxton servant to Mr. Sackeford M[aster]r. of the Requests to be assisted in all plac[e]s where he shall come for the view of mete plac[e]s to describe certen counties in carts [maps] thereunto appointed by her Mai[es]t[ie]s bill under her signet.

By then Saxton had already been at work for two years, though the whole project was only completed in 1579. The finished atlas, which included a preliminary map of England and Wales and a frontispiece showing Queen Elizabeth enthroned, was issued in that year, though plates were subsequently reissued on three separate occasions in the years that followed. The arms and motto of the lawyer Thomas Seckford (1515–88), Master of the Court of Requests and a friend and associate of Burghley, appear on each of the county maps. The scale varies from county to county, so that each map fits the double page allocated to it. All but one map was printed from a single copper plate, the work of Flemish engravers working in London. The exception was Yorkshire, perhaps because it was Saxton's native county, or perhaps simply because it was the biggest.

The Fairhaven copy is particularly splendid, and still in its original gold-tooled centrepiece binding, re-backed in the twentieth century. It was purchased in 1947, having been in the library of Chichester Cathedral for at least the previous 200 years, the victim of one of a series of secretive post-war sales from the cathedral library which stirred up a hornets' nest of clerical infighting, worthy of Barchester. When the news first broke in November 1947, the Bishop of Chichester, George Bell, who thought the sales 'really scandalous', left his dinner unfinished at his club, the Athenaeum, and rushed back to Chichester to confront the Dean, Arthur Duncan-Jones. By then, this copy of the Saxton *Atlas*, together with a *Hortus Sanitatis* printed in Mainz in 1491, had already been sold on the orders of Canon Basil Lowther Clarke, who was, as Bell rather grimly noted, simultaneously the cathedral's Librarian (responsible for its books) and its Communar (responsible for the Chapter's finances). Although Clarke was apparently pleased that together the two books had made £260, the Archdeacon of Chichester, who had not been consulted, wrote to a friend in Canterbury that 'nothing on earth would induce me to give consent to the sale of these books', while Bell's suffragen, the Bishop of Horsham, thought the whole affair 'a little sordid'. Meanwhile the ecclesiastical historian G.R. Owst had already written to *The Times* from Cambridge to express his 'dismay', not just at the sales but at the poor manners of the Dean and Chapter of Chichester, who, he said, had never expressed a word of thanks to his college, Emmanuel, for storing the cathedral's books during the war. Lord Fairhaven was evidently monitoring the affair, as it was presumably he who pasted a clipping of Professor Owst's letter into the front of the Saxton when he had bought it.

Having failed to stop the sales, Bell insisted that some of the finest books be bought in by the cathedral, reducing the notional value of the sales from an impressive

Clemens et Regni moderatrix iusta Britani
Hac forma insigni conspicienda nitet.

Tristia dum gentes circum omnes bella fatigant,
Cæciq; errores toto grassantur in orbe.
pace beas longa, Vera et pietate Britannos:
An. Dm. Iustitia moderans miti sapienter habenas. 1579
Chara domi, celebrisq; foris, longæuaq; regnu
Hic teneas, regno tandem fruitura perenni.

£1,516*s* 0*d* to a rather paltry £419 1*s* 5*d*. He then undertook a formal Visitation of the cathedral, in which he rebuked the Chapter in person and in print for selling 'over 100' books which had been 'a glory to the cathedral', and instituted a series of administrative reforms to prevent further books being sold without widespread consultation. In a final twist, it is said that when the Bishop and Mrs Bell sallied forth to the Deanery to proffer a seasonal olive branch to Dean and Mrs Duncan-Jones at Christmas 1948, the door was slammed in their faces.

PROVENANCE
In the library at Chichester Cathedral by 1735 (catalogue of that year at Chichester); Sotheby's, 21 February 1947, lot 402.

BINDING
Gilt-tooled dark brown calfskin, *c.* 1590, decorated in centrepiece style, re-backed and heavily repaired.

REFERENCES
ESTC S123137; STC 21805.5; George Bell, *The Function of Chichester Cathedral* ([Hove]: Printed for Private Circulation, 1948), pp. 19–23; Catherine Delano-Smith and Roger J.P. Kain, *English Maps: A History* (London: British Library, 1999), pp. 66–71; Sarah Tyacke and John Huddy, *Christopher Saxton and Tudor Map-Making* (London: British Library, 1980); Mary Hobbs, 'Books in Crisis at Barchester', *The Book Collector*, 44 (1995), pp. 37–50.

MP

4. A flower book from Peiresc's library

Crispijn de Passe the Younger, *Hortus Floridus*
Arnhem: J. Jansson, 1614

The earliest illustrated botanical books were herbals, chiefly concerned with the identification of plants and their use in medicine. Their woodcut illustrations tended at first to the stylized and diagrammatic, but by the mid-sixteenth century could display considerable artistry. Wider use of copperplate engraving in book illustration at the end of the century allowed for still more natural-ism, and works began to be produced in which pictures of flowers were the central feature, with the text relegated to a subordinate position or even absent altogether. These

books were termed *florilegia*, and their appearance coincided with a growth of interest in horticulture, itself stimulated by the introduction of plants, including the tulip, from outside Europe.

The *Hortus Floridus*, or 'Flower Garden', is the most celebrated *florilegium* of the period. Divided into four main sections, each corresponding to one season of the year, the book consists of naturalistic engravings of plants shown growing in the earth, with insects and beetles adding interest in the background, and in one instance a mouse gnawing at a tuber. In the words of the *Hunt Botanical Catalogue*, 'there are few books of the period that more utterly enchant'. Though most copies include instructions as to how the pictures might be coloured, the quality of the engravings is such that few early owners apparently felt it necessary. A remark-able achievement for anyone, this becomes still more so when we learn that the artist responsible was no more than 20 years old.

Although estimates of the date of his birth have varied widely, Crispijn de Passe is now believed to have been born in 1594 in Cologne. His father, Crispijn the Elder, was also an engraver, who had sought refuge in Germany after the expulsion of Protestants from Antwerp. By the time the *Hortus Floridus* was published, the family had been forced to move again, and since 1611 had been resi-dent in Utrecht. There Crispijn the Younger had attended a drawing school run by Paulus Moreelse and Abraham Bloemart. His *florilegium* is in some respects a calling card by a young artist anxious to establish himself, 'hav-ing until now,' he wrote in the foreword to 'Autumn' 'concealed myself behind my father's fame'. It was none-theless something of a family affair, published jointly by his father and Jan Janszoon of Arnhem, and including work by his younger brothers Simon and Willem who, together with his sister Magdalena, were also to publish engravings under their own names.

Tulipa Cromhaudi alba
rubris flammis Elegan:
uti plum: Ornata

Tulipa Remmerlandi Elegan
fondo alba oriz purpurz
rubent: ornata

The Latin commentaries were written by Aernout van Buchel, a lawyer and close associate of the family, who provided verse inscriptions for many of their prints.

No two copies of the *Hortus Floridus* are alike. The earliest issued copies have prefatory matter in Latin and van Buchel's commentaries printed in letterpress on the back of the plates. Slightly later issues have no Latin texts and appear with additional letterpress titles and introductory matter in Dutch, French or English. Most of these also have 12 extra plates of tulips, and a few include a short treatise on these in French or Dutch. Still later issues have the Latin commentaries partly or entirely re-set. To add to the confusion, the plates to 'Spring' and 'Summer' were apparently executed first, and initially without the insects and other background details. These were then added to later impressions, but plates with or without these details appear in various combinations in both early and later copies of the complete collection. The bibliographical inconsistencies of this work have baffled collectors and scholars ever since, and were perhaps a result of its youthful author's inexperience with such a large undertaking.

Four years after the publication of the *Hortus Floridus,* de Passe was sent to Paris by Prince Maurits of Nassau to teach drawing in the equestrian academy for noblemen's sons run by Antoine de Pluvinel. He seems to have begun work almost immediately on what was to become one of the finest illustrated equestrian books of the period, de Pluvinel's *Le Maneige royal* (1623). Other illustrated books followed, but de Passe's youthful brilliance gradually faded. In his middle years, by now relocated to Amsterdam, he suffered financial problems and also bouts of insanity, and his later work shows a sharp falling off in quality. In 1666 he was condemned by the authorities after publishing a political broadside overly sympathetic to the Orangist cause, and he died in relatively modest circumstances in 1670.

Lord Fairhaven's copy is in a fine contemporary binding in red morocco, with the Greek monogram of the French humanist Nicolas-Claude Fabri de Peiresc (1580–1637). De Peiresc, whose voluminous correspondence with the foremost scholars of the period led to him being dubbed 'the Attorney-General of the Republic of Letters', was active in many learned fields, among them astronomy, antiquities and botany. Three years before the publication of the *Hortus Floridus,* de Peiresc had planted the first tulips grown in Provence, in his famous garden at Belgentier.

PROVENANCE
From the library of Nicolas Claude Fabri de Peiresc (1580–1637). Bookplates of Marie Jacques Philippe Mouton-Fontenille de La Clotte (1769–1837), naturalist, and Jean-Louis Beraud (fl. 1760–1813), bibliophile, both of Lyon.

BINDING
Gilt-tooled goatskin with cipher stamp of Nicolas-Claude Fabri de Peiresc, seventeenth century.

REFERENCES
Nissen BBI 1494; Pritzel, 7796; Daniel Franken, *L'Oeuvre gravé des Van de Passe* (Amsterdam: F. Muller & Co., 1881); Rachel McMasters Miller Hunt, *Catalogue of Botanical Books in the Collection of Rachel McMasters Miller Hunt* (Pittsburgh: Hunt Botanical Library, 1958–61), 199; S. Savage, 'The *Hortus Floridus* of Crispijn Vande Pas the Younger', *The Library*, 4th ser., vol. 4, no. 3 (1 Dec. 1923), pp. 181–206; Ilja M. Veldman, *Crispijn de Passe and His Progeny* (Rotterdam: Sound & Vision, 2001).

W H

5. Manège at the Rubens house

William Cavendish, Marquess of Newcastle, *Methode et Invention Nouvelle de Dresser les Chevaux*
Antwerp: Jacques van Meurs, 1658

William Cavendish (1593–1676), successively Earl, Marquess, and finally Duke of Newcastle, was a grandson of Bess of Hardwick and was brought up at Welbeck Abbey in Nottinghamshire with his brother, the mathematician Charles Cavendish. A patron of Ben Jonson and governor to the future Charles II, he became one of the leading Royalist commanders in the Civil War (1642–51). With the Royalist defeat at the Battle of Marston Moor in 1644, Newcastle fled to the Continent, and was eventually condemned to death *in absentia* by the parliamentary authorities on 14 March 1649. He spent his exile in Antwerp, where he rented the magnificent town house and studio created between 1616 and 1640 by Peter Paul Rubens, from the artist's widow.

Back in England, one of Newcastle's great passions had been horsemanship. In his youth, along with the short-lived Henry, Prince of Wales, he had been trained in the art of *manège* by the great French riding master M. de St. Antoine. He commissioned a magnificent riding school from the architect John Smythson at Welbeck, and another at Bolsover Castle in Derbyshire. Newcastle pursued his passion still further in Antwerp, according to some converting Rubens's studio into yet another riding school, and publishing this magnificent folio guide to equestrian pursuits in 1658. The project cost some £1,300, beyond the pocket of an exiled marquess, and had to be underwritten by friends. The text, originally written in English, was professionally translated

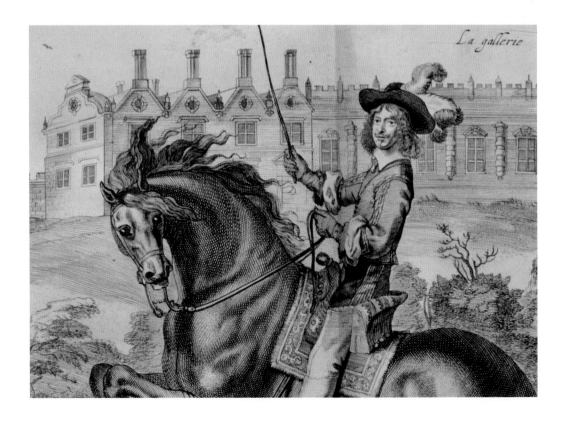

into French so as to appeal to an international audience, and the 33 splendid plates were engraved after designs by Abraham van Diepenbeeck (*c.* 1596–1675), the son of an Antwerp glass painter who became one of Rubens's most esteemed pupils. Despite his devout Catholicism and his connections with the Jesuits, Diepenbeeck was already well known to his English patron, and had designed frontispieces for several books published by Newcastle's wife Margaret, Marchioness (and eventually Duchess) of Newcastle.

PROVENANCE
'From the Earl of Pembroke's library' – pencilled note.

BINDING
Gilt-tooled calfskin, *c.* 1740, re-backed and repaired.

REFERENCES
Bénézit, IV, pp. 900–1; ODNB; *Royalist Refugees: William and Margaret Cavendish in the Rubens House, 1648–1660* (Antwerp: Rubenshuis, 2006); David W. Steadman, *Abraham van Diepenbeeck: Seventeenth-Century Flemish Painter* (Epping: Bowker, 1982); Geoffrey Trease, *Portrait of a Cavalier* (London: Macmillan, 1979).

MP

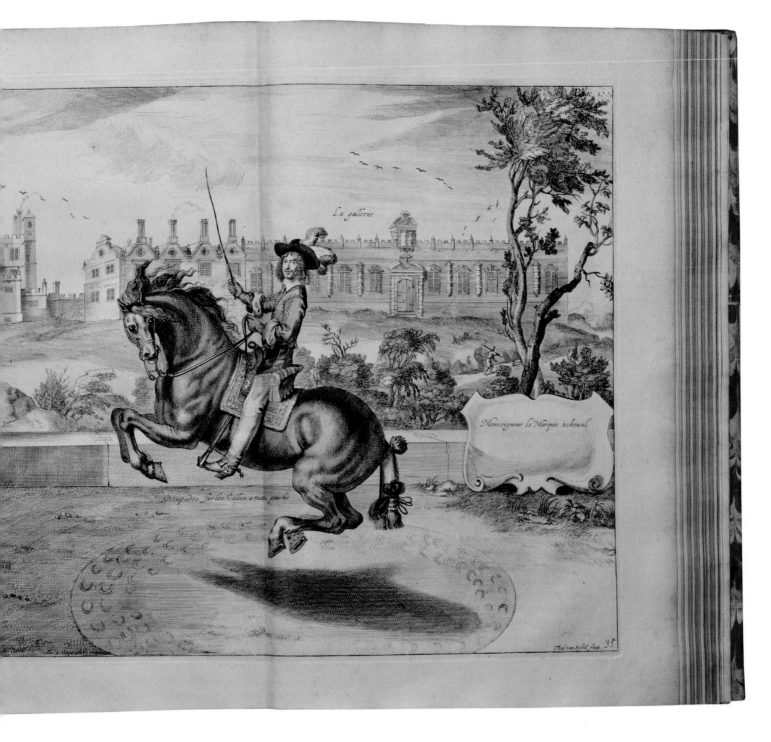

La galerie

Monseigneur le Marquis à cheual.

Groupades Jur les Voltes a main gauche

Ind. van velde fece 35

6. Ashmole and the Emperor Maximilian's Garter

Elias Ashmole, *The Institution of the Order of the Garter*
London: printed by J. Macock for Nathanael Brooke, 1672

Shortly after they returned to England in 1912, the future Lord Fairhaven's parents purchased a large modern house at Englefield Green, a handsome but even then rather suburbanised village on the edge of Windsor Great Park. It was the beginning of a lifelong fascination, and the impetus for the creation of what was to become the largest collection of works of art about Windsor to be found anywhere outside the Royal Collection. The fact that the then Huttleston Broughton was stationed in the town during his time in the Life Guards through the First World War can only have heightened the attraction. The Windsor collection seems originally to have been kept in the Englefield Green house, which was retained until his mother's death in 1939, apparently only later being shifted to Anglesey Abbey. Sometimes criticised for his failure to sponsor proper catalogues of his collections – the mark of a really serious connoisseur – Fairhaven was sufficiently enthused by Windsor to commission a description of the Windsor pictures, prints, drawings and books in his collection in 1949, written by the popular art historian Cyril Bunt.

Elias Ashmole's *Institution of the Order of the Garter* was almost inevitably a book which captured Lord Fairhaven's imagination. His pristine copy, in a smart nineteenth-century binding by Francis Bedford (1799–1883), with gilded edges, the pages crisp and thoroughly washed, is typical of many of the earlier books in his library. Heavily done over, and effectively stripped of much of its own history, it is undeniably slightly unappealing to current tastes. On opening it, however, the splendid engravings by Wenceslaus Hollar (1607–77) are revealed. Born in Prague, Hollar first arrived in London in 1636 in the retinue of Thomas Howard, 2nd Earl of Arundel, originally to make copies of paintings and drawings in the great collection at Arundel House. In addition to his numerous topographical and fine art engravings, Hollar established a considerable reputation as a book illustrator, and was involved in several important antiquarian projects, notably William Dugdale's *Monasticon Anglicanum* (1655) and his marvellous *History of St Paul's Cathedral*, published, in the nick of time, in 1658 (the old cathedral was destroyed in the 1666 fire

PROVENANCE
In the library of Sir Joseph
Hawley, of Leybourne Grange,
West Malling, Kent, by *c.* 1875
(see: *Catalogue of the Library at
Leybourne Grange* (London:
Ellis and White, [*c.* 1875] and
Sotheby's, 1906); purchased
by Lord Fairhaven from

Brown's Antiquarian
Bookshop, Eton, 17 September
1934, for £8 10*s*.

BINDING
Gilt-tooled brown goatskin,
signed by Francis Bedford,
nineteenth century.

REFERENCES
Bunt, pp. 11, 12, 18, 107, nos.
143–5; plates 12–14; ESTC
R16288; ODNB; Wing A3983;
Richard Marks and Paul
Williamson (ed.), *Gothic: Art for
England 1400–1547* (London:
V&A Publications, 2003), 81.

MP

of London). Interestingly enough, the
Fairhaven collection also includes three
pen-and-pencil drawings of Windsor by
Hollar, as well as three contemporary
oil paintings of the castle by Hendrick
Danckerts (1630–78), Jan Wijck (1640–
1702) and Gerard Edema (1652–1700).

There is, however, a further connec-
tion; both Ashmole's book and, espe-
cially, this plate have a special resonance
at Anglesey Abbey, which also houses the
Garter of the Emperor Maximilian (1459–
1519). The emperor was created a Stranger
Knight, a member of the Order of the
Garter, by Henry VII in 1489, and Garter
insignia were delivered to him in 1490,
and again in 1503. It was conventional for
the insignia to be returned to the sover-
eign on the death of each knight, but at
least one of Maximilian's became an heir-
loom of the Hungarian Counts Festetics,
remaining in their possession into the
twentieth century. It is the earliest surviv-
ing Garter, the next earliest being that
sent by Edward VI to Frederick II of
Denmark (1534–88), which is now in the
Danish royal collection at the Rosenborg
Castle in Copenhagen.

The Manner of sitting at Dinner of Maximilian king of the Romans, on the day
of his Investiture.

The Manner of sitting at Dinner of Ferdinand Prince of Spanie,
on the day of his Investiture.

7. *Cantabrigia Illustrata*

David Loggan, *Cantabrigia Illustrata*
[Cambridge]: [s.n.], [1690]

Born of Scots descent in the Baltic port city of Danzig (now Gdańsk), David Loggan (1635–1700) was a pupil of the Dutch engraver Willem Hondius, and subsequently of Crispijn de Passe in Amsterdam. He moved from Holland to London between 1656 and 1658, and eventually found his way to Oxford. Appointed engraver to the university in 1669, he worked extensively for the university press, which had recently been refounded by the indefatigable John Fell (1625–86), Dean of Christ Church and (from 1676) concurrently Bishop of Oxford. Loggan produced many illustrations for Oxford books of the period, but his most famous and iconic publication was *Oxonia Illustrata* (1675), a splendid picture book of views of the colleges and principal university buildings. By 1676 Loggan was in Cambridge, working on plates of Wren's designs for Trinity College Library, and he seems to have started work on the companion *Cantabrigia Illustrata* at about the same time, and certainly by 1679.

Fell's model in setting up the Oxford press had been the Imprimerie royale, the official French print-works, whose grandest books frequently had engraved title-pages and frontispieces, the preferred artist often being Poussin, just as Rubens had previously worked for the Plantin Press in early seventeenth-century Antwerp. Loggan's sometimes rather stiff draughtsmanship clearly did not compare to the work of these two great masters; unsurprisingly, his models were the Dutch engravers of his youth. But for all this, the publications of the Oxford press in the later seventeenth century are notable examples in their own right of the use of illustrations in scholarly books. The splendid copperplates in both *Oxonia* and *Cantabrigia Illustrata* were clearly popular, and copies were retained by both universities for presentation to benefactors and distinguished visitors.

This popularity is reflected in the fine bindings which adorn a good number of surviving copies (the National Trust owns an especially beautiful copy of *Oxonia Illustrata* at Saltram in Devon, bound in London by the anonymous Queen's Binder B). Sensibly, while Lord Fairhaven owned only one copy of *Oxonia Illustrata*, he had two copies of the companion volume on nearby Cambridge – one elegantly bound and the other more obviously a reading copy.

PROVENANCE
Purchased by the future Lord Fairhaven from Brown's Antiquarian Book Shop, Eton, 21 September 1928, together with the companion *Oxonia Illustrata*, for £25. Previously in the library of Gaddesden Park, Hertfordshire, home of the Halsey family (gutted by fire, 1905; abandoned, 1950) with its bookplate, and the shelfmark C.1.2.

BINDING
Half-red goatskin with marbled paper boards, nineteenth century.

REFERENCES
BAL 1913; Barker, 56; ESTC R180011; Wing L2837 (Wing has two editions, L2836 [1688] and L 2337 [1690?], but this is, according to BAL, an error: the two are identical, and both are [1690]); Nicolas Barker, *The Oxford University Press and the Spread of Learning, 1478–1978* (Oxford: at the Clarendon Press, 1978), pp. 22–3.

MP

8. 'Gross mistakes committed by coach-painters, carvers, &c.'

William Parsons, *A New Book of Cyphers*
London: printed for the author, 1704

Ciphers, in this context meaning initial letters superimposed and intertwined to make an intricate tendril-like design, became popular in England in the late seventeenth century. Like crests or arms, they were a way of denoting identity and ownership; distinctive, but intelligible only to the *cognoscenti*. They had the additional advantage that, whereas arms and crests were only available to the elite, anyone with access to pen and paper could make a cipher out of their initials.

Parsons's *New Book of Cyphers*, the fourth such book printed in England, contains engravings of 600 two-letter ciphers, and instructions as to how to use them to compose longer examples of three or four letters. Parsons comments severely in his preliminary 'Advertisement' that the earlier works on the subject only contained half the number of ciphers necessary to complete their alphabets. The inclusion of plates illustrating the various coronets used with the crests or arms of the nobility demonstrates the cipher's close link with heraldry. Parsons's strictures on the 'Gross Mistakes Committed by Coach-Painters, Carvers, &c.' in 'the Coronets (which amongst the Nobility are always Used with Cyphers, Crests, &c.)' give

a hint as to how and where these designs were employed.

The younger son of a baronet and an alumnus of Christ Church, Oxford, Parsons entered the army in 1682 and took part in the Glorious Revolution (1688). Returning to civilian life for a period, he turned to publishing, and seems to have taken a particular interest in popular works of learning. His translation of Guillaume Marcel's *Tablettes chronologiques* (chronological tables listing the dates of kings, popes and emperors) was a great success and ran through many editions. He also entered into a partnership to produce a new set of globes (though none survive) and was hailed (by his partner) as 'the Great Encourager of Artists'. He commissioned Michel Tauvel, an engraver based in the Strand, to begin work on his cipher designs in 1698. Work proceeded slowly over the following years, and permission to print the complete work was finally given in 1703. The finished book, engraved throughout, includes a fine frontispiece, engraved by Simon Gribelin to Parsons's design, and a title-page and text leaves, in both English and French, by Joseph Nutting. Parsons's own cipher is visible in the bottom left-hand corner of each leaf.

BINDING
Gilt-tooled blue goatskin; with
armorial stamp of the Clifton
family, twentieth century.

REFERENCES
ESTC T116152; ODNB.

WH

Book of Cyphers. Composed by Col°. Parsons. Imprimatur Carlisle, E.M. 1703

9. A binding by the Geometrical Compartment Binder

The Book of
Common Prayer
London, 1713

The Holy Bible
London, 1712

The Whole Book
of Psalms
London, 1712

The half-century or so immediately following the accession of Charles II at the Restoration in 1660 is often seen as a particular high point of English bookbinding. A number of craftsmen in London and elsewhere developed great skill in producing beautifully decorated bindings, using a variety of small tools laid out in elaborate gilded patterns. Gold tooling was a well established technique by then, as was the use of tanned goatskin, imported from the Near East, as a top-quality binding material. The tool shapes then in vogue were typically small, delicate designs based on stylised flowers and foliage, which lent themselves well to the building up of complex patterns.

This Prayer Book, Bible and Psalter from the early eighteenth century is a fine and particularly well preserved example of a luxury binding from this period. Covered in dark red goatskin, the boards and spine have been decorated to a striking symmetrical design inspired by the fine 'Fanfare' bindings made in France a century earlier. The contents comprise not only the texts, but also a large number of contemporary engravings illustrating

the biblical narrative – this was a popular way of enhancing early Bibles and devotional books, and sets of prints were made and sold for the purpose.

The binding has been attributed to the workshop of a London binder active during the first two decades of the eighteenth century, known as the 'Geometrical Compartment Binder'; a number of other bindings of his survive, all characterised by layouts with a strongly symmetrical framework. We do not know his name, which is not unusual, even for upmarket binders of this time, as bookbinding was a relatively humble occupation and bindings were not signed by their makers. Samuel Pepys, an acknowledged bibliophile who a few decades earlier was patronising London binders, never referred to them in his diary by name; he would go to 'the bookbinder' but it did not occur to him to individualise them.

Howard Nixon, the modern authority on English Restoration period binding, regarded this as the finest extant example of the Geometrical Compartment Binder's work.

PROVENANCE
With the bookplate of John S. Packington, nineteenth century. Subsequently sold from the collection of Sir Charles Chadwyck-Healey in 1942, and shortly afterwards bought by Lord Fairhaven from the London bookseller Charles Sawyer, for £175.

BINDING
Gilt-tooled red goatskin; marbled-paper endleaves.

REFERENCES
Barker 62; M.M. Foot, 'A binding by the Geometrical Compartment Binder', in M.M. Foot, *Studies in the History of Bookbinding* (Aldershot: Scolar Press, 1993), 30, pp. 210–11; H.M. Nixon, *Five Centuries of English Bookbinding* (Aldershot: Scolar Press, 1978), 56, pp. 128–9; Charles Sawyer, Catalogue 168 (1942), 24.

DP

10. *The Beauties of Stow*

George Bickham, *The Beauties of Stow, or a Description of the Most Noble House, Gardens, & Magnificent Buildings therein, of the Right Honble Earl Temple*
London: sold by G. Bickham in London, M. Hoskins at the New Inn, [1753]

Lord Cobham's gardens at Stowe had been attracting visitors since the 1720s, but the first guidebook was issued by the Buckingham writing master Benton Seeley in 1744. The venture was a great success and by 1750 Seeley was offering three parallel publications to tourists, his original *Description of the Gardens of Lord Viscount Cobham at Stow* (1744), Gilpin's *Dialogue on the Gardens at Stow* (1748), and *Views of the Temples and other Ornamental Buildings in the Gardens* (1750). These could be bought separately for 2s 6d each, or all three bound together, with an added title-page, at 5s. Together, they provided the well-heeled visitor with a practical description, an aesthetic critique and an illustrated souvenir.

At this point competition came on the scene in the form of two London booksellers and publishers, the George Bickhams, father and son. Like Seeley, the elder George Bickham (1684?–1758?) was a writing master, but George Bickham Junior (1706?–1771) rather grandly described himself as 'drawing master to the Academy at Greenwich'. The Bickhams had already made a name for themselves by issuing a wide variety of writing and dancing manuals, as well as a guidebook to Hampton Court and Windsor (1742), and George Bickham Junior's *General Rules for Painting in Oil and Water-Colours* (1747). Stowe was clearly too enticing – and lucrative – an opportunity to miss. In 1749 Seeley's patron Viscount Cobham had died, and in 1750 the Bickhams issued their own guidebook, *The Beauties of Stow*, an octavo of 64 pages, with plates by George Bickham Junior, priced at 5s. It contained all the material offered by Seeley in his compendium, but with more attractive illustrations and a better-organised text, set out in the form of a guided tour of the garden. But at least 98 per cent of this text was simply lifted from existing publications, roughly a third each from Seeley's *Description* and Gilpin's *Dialogue*, with further material derived from the French language guide *Les Charmes de Stow* (1748)

and from Defoe's *Tour thro' the Whole Island of Great Britain* (1724–6).

Unsurprisingly Benton Seeley was unhappy at this unexpected competition and there followed a protracted and acrimonious tussle, as he and the Bickhams competed to produce ever more refined and appealing guidebooks, adding at various times further illustrations, new text, and a 'Curious General Plan of the Whole Gardens'.

An Equestrian Statue of George I.

The Garden Fro

The Park Front

Seeley cannot have been happy to discover Bickham's guides on sale 'at the New Inn, going into ye Gardens'. But Bickham made his contempt for the local competition abundantly clear by replacing the Cobham epitaph in his plate of the Egyptian pyramid with a carefully blurred 'SEELEY IS A ****'. Finally, in 1763, Bickham retired from the fray, leaving the field open to the Seeley family, who continued to issue Stowe guidebooks well into the nineteenth century. But the battle of the guidebooks at Stowe marked a turning point in the development of tourist literature in eighteenth-century England, and it is not difficult to see why Lord Fairhaven – the creator of one of the great landscape gardens of the twentieth century – might have been attracted to one of Bickham's latest and most refined guides.

PROVENANCE
Purchased by Lord Fairhaven from an anonymous bookseller for £12 12s.

BINDING
Gilt-tooled calfskin, eighteenth century.

REFERENCES
ESTC T222659; George Bickham, *The Beauties of Stow (1750): Introduction by George B. Clarke*. Augustan Reprint Society, 185–6 (Los Angeles: William Andrews Clark Memorial Library, University of California, 1971), pp. i–xiv; George B. Clarke (ed.), *Descriptions of Lord Cobham's Gardens at Stowe (1700–1750)* ([Dorchester]: Buckinghamshire Record Society, 1990), pp. 174–5; John Harris, *A Country House Index* (rev. edn, London: Pinhorns, 1980).

MP

11. Bentley's *Gray*

Designs by Mr. R. Bentley for Six Poems by Mr. T. Gray
London: printed for J. Dodsley, 1766

Richard Bentley (1708–82) first met Horace Walpole in 1750, and swiftly became a member of the Committee of Taste which helped the former prime minister's son to develop Strawberry Hill, his Gothic fantasy house on the banks of the Thames near Twickenham. Bentley, himself another Twickenham resident, was the son of Dr Richard Bentley (1662–1742), Master of Trinity College, Cambridge, one of the most distinguished classical scholars of Georgian England, and also Master of the King's Libraries – a post which he surrendered to his 16-year-old son in 1725, in one of the more glaring examples of nepotism of the era. Bentley Junior was forced to resign from the sinecure in the aftermath of the disastrous Ashburnham House fire of 1731, which resulted in the destruction of many of the priceless manuscripts assembled by the Jacobean antiquarian Sir Robert Cotton, bequeathed to the nation by his grandson in 1700.

This celebrated book – often described as the most sophisticated piece of book illustration produced in Georgian England – was very much a joint project, with the poet Gray dragooned into co-operating by the enthusiasm of his two friends. It was originally to have been entitled *Poems by Thomas Gray, with Designs by Richard Bentley*, but Gray objected to this, writing to the original publisher Robert Dodsley in February 1753: 'I am not at all satisfied with

PROVENANCE
Armorial bookplate of John
Waterhouse Halifax, nineteenth
century; with a collation note
of Bernard Quaritch Ltd.

BINDING
Grey paper-covered
boards with paper spine,
nineteenth century.

REFERENCE
ESTC N9933; ODNB; John
Harthan, *The History of the
Illustrated Book* (London:
Thames & Hudson, 1981),
pp. 154–5; A.T. Hazen, *A
Bibliography of Horace Walpole*
(Folkestone: Dawson, 1973) 42;
Wyndham Ketton-Cremer,
Horace Walpole: A Biography

(3rd edn, London: Methuen,
1964), pp. 145–9; Margaret
Powell, 'The "Curious Books" in
the Library at Strawberry Hill',
in Michael Snodin (ed.), *Horace
Walpole's Strawberry Hill* ([New
Haven]: Yale University Press,
2009), pp. 235–41 (p. 241).

MP

the title. To have conceived that I publish
a Collection of *Poems* (half a dozen little
matters …) thus pompously adorned
would make me appear very justly ridicu-
lous.' Walpole, in turn, was grumpy
about the compromise title which was
eventually agreed on, taking particular
umbrage at the use of the word 'Mr'
('one of the Gothicisims I abominate').
But for all that, he kept the original
drawings with his most prized treasures
in the Glass Closet at Strawberry Hill.

Bentley seems to have been at work
on these drawings by June 1751 and had
finished them by the summer of the
following year, although the first issue
of the original edition did not appear
until May 1753. The exquisite copper-
plate engravings were done by Johann
Sebastian Müller and Charles Grignion;
there were three different issues in 1753,
and further editions using the same plates
followed in 1765, 1766, 1775 and 1789.
The six poems were the 'Ode of the
Spring', the mock-elegy 'Ode on the
Death of a Favourite Cat, Drowned in
a Tub of Gold Fishes', the 'Ode on a
Distant Prospect of Eton College',
'An Elegy Written in a Country
Churchyard', 'A Long Story' and the
'Hymn to Adversity'. Fittingly, Bentley's
illustrations for the 'Elegy' have always
been the most famous of the set, and the
only ones wholly in the Gothic taste.

12. The Garden of Eden

Pierre-Joseph Buc'hoz, *Le Jardin d'Eden, le Paradis Terrestre renouvellé dans le Jardin de la Reine à Trianon*
Paris: chez l'auteur, 1783–5

The second half of the eighteenth century saw a boom in natural history publication in France, fuelled by such works as Buffon's *Histoire naturelle* and Brisson's *Ornithologie*. The accession of Louis XVI in 1774 was followed by a relaxation in the regulation of the book trade, making it easier for authors to publish their own works. No other writer was to take such copious advantage of these two developments as Pierre-Joseph Buc'hoz.

Born in Metz in 1731, Buc'hoz initially trained as a lawyer, but later changed to medicine. He developed a particular interest in botany, collecting plants for the botanical garden of the exiled King Stanislas I of Poland in Nancy, and becoming 'démonstrateur royal en botanique'. His first botanical work, *Traité historique des Plantes qui croissent dans la Lorraine et les trois Évêchés* appeared in 10 volumes from 1762 to 1770; it was originally projected to run to 20.

Forced out of his position by hostile criticism after Stanislas's death, Buc'hoz moved to Paris and began publishing in earnest. A work on political economy was admired by the mathematician d'Alembert, but Buc'hoz is best remembered, though not generally revered, for his botanical works. In this field his output was prodigious. 'Il compilait, compilait, compilait', the lexicographer Larousse complained in 1867. 'Il écrit sur toutes les parties de l'histoire naturelle, sans y rien comprendre' ('he writes on every type of natural history, without understanding any of them'). The nineteenth-century German botanist Georg August Pritzel, employing a quality of invective probably only achievable in the days when scholars communicated in Latin, called him 'fraude ac ignorantia aeque eminens scriptor ... [qui] per semiseculum ultra 500 volumina consarcinavit' ('a writer as well known for his fraudulence as for his ignorance, who over half a century

cobbled together more than 500 volumes'). Nonetheless his *Histoire naturelle du Règne végétal* was approved by the Académie des Sciences, which, however, twice rejected its author for membership. An encyclopedic work arranged alphabetically, the *Histoire* ran to 13 volumes of text and 12 of plates, and stopped at the letter P, following the bankruptcy of two of its publishers. Henceforth Buc'hoz was generally to publish his own works.

The unctuously titled *Jardin d'Eden* is typical of the books Buc'hoz published in the 1780s. It consists of 200 hand-coloured plates in two volumes. There is no text, apart from the title-pages, captions to the plates in Latin and French and two pages of index. Buc'hoz habitually drew on other works to maintain his rate of production, and here he borrows illustrations from Nicolaas Meerburgh's *Afbeeldingen van zeldzaame gewassen* (1775), Christoph Jakob Trew's *Plantæ selectæ* (1750–73) and others. There is no discernible system to the order in which the plates appear, and the compiler, following his usual practice, names several plants after his patrons or potential patrons. (His contemporaries in the field of botany responded by naming two particularly foul-smelling plants after him.)

Buc'hoz's formula does not appear to have been particularly successful in gaining him either respect or wealth. In 1788 he had to sell his library, and he was awarded a pension (on the second application) by the Assemblée nationale in 1794, two years after the gardens of the Petit Trianon had been dispersed. As a work of scholarship *Le Jardin d'Eden* may be negligible but it is undeniably impressive as a collection of botanical illustrations, and now serves as a record of a lost garden and a testimony to the botanical interests of wealthy amateurs outside the circles of the learned.

Pl. XCII.

BINDING
Marbled sheepskin with
gilt-tooled spine, *c.* 1783.

REFERENCES
DBF; Pritzel 1478; Gabriela
Lamy, '*Le Jardin d'Éden, le
Paradis terrestre Renouvellé dans
le Jardin de la Reine à Trianon*
de Pierre-Joseph Buc'hoz',
*Bulletin du Centre de Recherche
du Château de Versailles* [online]
(20 Sept. 2010) http://crcv.
revues.org/10300.

W H

Bromella Ananas *.Linn. Ananas à feuilles rougeatres.*

13. An Etruscan binding by Edwards of Halifax

Horace Walpole, *The Castle of Otranto*
Parma: Giovanni Battista Bodoni, for James Edwards, London, 1791

All the decorative arts in England during the later part of the eighteenth century were influenced by neoclassicism – the rediscovery of ornamental ideas from ancient Greece and Rome, which began in continental Europe and spread to Britain through the work of architects like James ('Athenian') Stuart and Robert Adam. In bookbinding, this was expressed in designs incorporating patterns inspired by classical models. The 'Etruscan' style is one example, and was invented by one of the leading binding firms of the day, Edwards of Halifax, and characterised by the decoration of stained calfskin with drawings and tools which drew their inspiration from classical forms.

Edwards was a family business, founded by William Edwards (1723–1808) in Halifax, and subsequently flourishing as binders and booksellers both there and in London, under the direction of his sons. They were celebrated not only for their Etruscan bindings, but also for a trademark style of bindings with paintings seen through translucent vellum covers.

This handsome and characteristic example of the Etruscan style covers a copy of Horace Walpole's *Castle of Otranto*, the prototype for Gothic novels, which ran through numerous editions after its first publication in 1764. This luxury edition was published by John Edwards, one of William's sons and manager of the London arm of the firm, but it was printed in Italy at the Bodoni press, noted for the quality of its typography.

Etruscan bindings often had, as their central decoration, a relatively simple picture of a Greek vase or a classical figure, but here the covers are dominated by an oval ink drawing of the imaginary castle of the title. The narrow gilt-tooled roll around the outer border, and the ink-stained broader frame of acanthus-leaf palmettes within it, are both typical motifs for Etruscan bindings.

The decoration does not end with the covers. The Edwards firm also made a speciality of fore-edge painting, a technique which was invented in England around the middle of the seventeenth century and which enjoyed sporadic periods in vogue thereafter. Binders had been colouring leaf edges with dye or ink for centuries, but fore-edge painting takes the idea to a different level of ingenuity. Instead of merely staining the edges of the closed book, the fore-edge painter fans the leaves slightly, holds them in a clamp, and paints a scene on the resulting surface. When the book is closed, the picture disappears, but fanning the leaves brings it back into view. Fore-edge paintings are not always contemporaneous with the books on which they are found; their collectability has sometimes led dealers to embellish old bindings with supposedly authentic paintings, which are actually later additions. The Edwards firm is, however, known to have undertaken fore-edge painting regularly and there is no cause to doubt the authenticity of the two scenes painted on this book, made visible by fanning the leaves in opposite directions and depicting scenes from the novel.

BINDING
Mid-brown marbled calfskin, *c.* 1791, decorated with gilt tooling and ink drawings, in the Etruscan style.

REFERENCES
Barker 92; ESTC T131070; Nixon and Foot, p. 91; Jan Storm van Leeuwen, 'It Glitters and is More than Gold: Fore-Edge Paintings in the Dutch Royal Library', in Pearson (ed.),

For the Love of the Binding: Studies in Bookbinding History Presented to Mirjam Foot (London: British Library, 2000); pp. 221–39.

DP

14. Lewin's *Birds*, on vellum

William Lewin, *The Birds of Great-Britain, with their Eggs, Accurately Figured*
London, 1789–94

Bird books were popular in eighteenth-century England, both as works of scholarship and as splendid collectables for the libraries of wealthy connoisseurs. The naturalist Mark Catesby (1683–1749), born in Essex, originally made his name with a series of voyages to North America, publishing the magnificent *Natural History of Carolina, Florida and the Bahama Islands* in folio between 1729 and 1747. A second edition followed in 1754, edited by the ornithologist George Edwards (1694–1773), who had himself published *A Natural History of Uncommon Birds* (1743), and was a Fellow of the Royal Society and a correspondent of Linnaeus.

Lewin's *Birds of Great-Britain* surpassed any of these. Begun in the late 1780s, after more than 20 years of research, it was issued between 1789 and 1794. A pupil of the Irish flower painter Edward Hodgson, William Lewin (1747–95) was born and brought up in the East End of London, and as a young man scraped a living as a book illustrator and natural history painter. *Birds of Great-Britain* is sometimes described as the rarest of all English bird books; the first edition was limited to just 60 copies, as – unlike Catesby and Edwards, whose books were illustrated with hand-coloured copperplates – Lewin painted each plate of every single copy himself, a grand total of 19,380 illustrations for the whole print run.

The Fairhaven copy, on vellum, is a spectacular one, in a magnificent neoclassical binding. Originally in the possession of Richard Wellesley, Governor-General of Bengal, and elder brother of the Duke of Wellington (see no. 39), it later belonged to the book collectors Henry Huth and his son Henry Alfred Huth, first treasurer of the Bibliographical Society and a member of the Roxburghe Club from 1883 until his death. Fifty of the Huth books were bequeathed to the British Museum, which issued a catalogue of them in 1912; the rest were sold at Sotheby's between 1911 and 1920.

PROVENANCE
Originally in the collection of Richard Wellesley (1760–1842); later in the library of Henry Huth (1815–78) and Henry Alfred Huth (1850–1910).

BINDING
Gilt-tooled red diced goatskin, with elaborately gilt-tooled spine, green watered-silk endleaves, *c.* 1790.

REFERENCES
ESTC T128334; ODNB; H. Huth, W.C. Hazlitt and

F.S. Ellis, *The Huth Library: A Catalogue of the Printed Books, Manuscripts, Autograph Letters, and Engravings, Collected by Henry Huth* (London: Ellis & White, 1880); *Catalogue of the Famous Library of Printed Books, Illuminated Manuscripts, Autograph Letters, and Engravings, Collected by Henry Huth and Augmented by his son Alfred H. Huth* (London: Sotheby, Wilkinson and Hodge, 1911–20).

M P

15. The Imperial and Royal Army

Josef Georg Mansfeld, *Abbildung der Neuen Adjustirung der K.K. Armee*
Vienna: bey T. Mollo, [*c.* 1796–8]

Military uniforms became a popular topic for plate books towards the end of the eighteenth century. These found a ready market in an age increasingly concerned with military glory, and the colourful subjects showed off the new techniques of illustration to great advantage. Nearly every European country capable of raising an army produced books illustrating their uniforms, though few countries could match France in its enthusiasm for the genre. In Hilaire and Meyer Hiler's standard *Bibliography of Costume* (1939), the list of books of French military uniforms published in the eighteenth and nineteenth century runs to 13 columns, as opposed to 10 for the constituent states of Germany and four for England.

This was an area in which Lord Fairhaven, a former officer in the Life Guards, had a particular interest: indeed it seems possible that his interest in colour-plate books was sparked by books on military uniforms. His one published work, *The Dress of the First Regiment of Life Guards in Three Centuries* (London, 1925), drew heavily on printed books for its illustrations, and in the same year he had himself painted in full-dress uniform by Oswald Birley. His book collection predictably concentrated on English works, including a rare copy of *Military Costume of the British Cavalry* (London, 1820) by the caricaturist William Heath, but he also ventured further afield, and the *Abbildung der Neuen Adjustirung der K.K. Armee* is one of several Austrian works he possessed on the topic.

The title-page dedication is signed by the engraver, Josef Georg Mansfeld (1764–1817), and the publisher, Tranquillo Mollo, but the original illustrations are by Vincenz Georg Kininger (1767–1851), a highly versatile artist who, after a brilliant career as a student in the Vienna Academy of Fine Arts, worked variously as watercolourist, miniaturist and engraver, becoming professor in the mezzotint school at the Academy in 1807. Both he and Mansfeld were also later to become pioneers of lithography. Mansfeld founded a school of the new technique as early as 1815, and Kininger is credited with producing some of the first examples published in Vienna between 1819 and 1825. Their publisher, Tranquillo Mollo (1767–1837), came from Bellinzona in the Italian-speaking Swiss canton of Ticino. He is now remembered chiefly as a music publisher, issuing some of the early works of Beethoven, but he was also a successful publisher of illustrated works, introducing the technique of aquatint engraving from England, and of maps.

The present work appeared between 1796 and 1798, at which time Mollo, formerly a partner in the long-established music publisher Artaria, was setting up his own firm, which was finally established in July of the latter year. The *Abbildung* therefore represents something of a pioneering enterprise by three relatively young newcomers to the field. It was issued in parts, and a complete copy, a rare find, contains 44 aquatint plates of uniforms and a stipple-engraved portrait of the dedicatee.

PROVENANCE
Note signed 'F.H.B.' on front fly leaf.

BINDING
Half-calfskin with marbled paper boards, nineteenth century.

REFERENCES
Bénézit, VI, p. 1259; IX, p. 180; René Colas, *Bibliographie générale du Costume et de la Mode* (Paris: Colas 1933), 1609; Hilaire and Meyer Hiler, *Bibliography of Costume* (New York: H.W. Wilson, 1939), p. 499.

WH

16. Thomson's *The Seasons*, in colour

James Thomson, *The Seasons*
London: printed for P.W. Tomkins, 1797

Thomson's *The Seasons*, originally published between 1726 and 1730, and extensively revised between 1743 and 1746, was one of the most frequently printed eighteenth-century poems. A blank-verse description, in four books, of the natural world and man's place in it, it had appeared in over 400 editions by the 1870s. It was the model for much topographical verse in the second half of the century, as well as the source for Haydn's last oratorio *Die Jahreszeiten,* and was admired (with reservations) by Wordsworth and Coleridge. The first complete edition was illustrated with engravings after William Kent; the poem also provided inspiration for a wide variety of artists, including Gainsborough, Fuseli and Turner. This fine edition dates from 50 years after the poem appeared in its final form, and combines the talents of some of the foremost book artists of the period.

The edition includes 20 illustrations, including five full-page plates, by William Hamilton (1751–1801). Hamilton trained in Italy in his youth, and was afterwards employed by Robert Adam as a decorative painter at Kedleston Hall, Derbyshire, and Highcliffe. He later became established as a painter of historical subjects and portraits. In the latter capacity his sitters included Sarah Siddons and other figures from the stage, and his work as a whole has a noticeably theatrical quality. Hamilton's designs for *The Seasons* were executed in oils, and engraved by Peltro William Tomkins (1759–1840) and Francesco Bartolozzi (1728–1815). Born in Florence, Bartolozzi had worked for Piranesi before being lured to Britain by the promise of the position of engraver to the king. He soon became one of the most successful

engravers in Britain and maintained a large workshop. Tomkins was a former pupil who had produced stipple engravings for a wide variety of publishers before setting up in business with his brother on the Strand. (In stipple engraving, chiefly in fact an etching process, the image was built up from from dots rather than lines, a technique which allowed for delicate gradations of tone.) *The Seasons,* published by subscription (as were many largescale works of the period), was Tomkins's enterprise.

The letterpress was executed by Thomas Bensley (1759–1835), the printer of the first edition of Gilbert White's *Natural History of Selborne.* Bensley produced fine printing for a large variety of publishers, including Ackermann, Macklin and Paul Colnaghi, and was later responsible for several of the early books issued for the bibliophile Roxburghe Club. He was also something of a typographic innovator, devising an early system of printing in gold, and financing and trialling early experiments in running presses by steam. For this edition, he worked with specially commissioned type from Vincent Figgins (1766–1844), later notable as the designer of Ionic type, much used in newspapers.

The result, dedicated to Queen Caroline, has been described as 'arguably the most magnificent book to be illustrated with stippled engravings' (ODNB). The subscribers' list included William Beckford and six members of the royal family. Lord Fairhaven's copy is one of a very few copies printed in colour. It is bound, probably for presentation to a wealthy subscriber, in gold-tooled red morocco by Staggermeier and Welcher.

PROVENANCE
Bought from Charles Sawyer, London.

BINDING
Gilt-tooled straight-grained red goatskin, with binder's ticket of Staggermeier and Welcher.

REFERENCES
Abbey, *Life* 252; Barker 94; ESTC T146637; ODNB; Henry Cohen and Seymour de Ricci, *Guide de l'Amateur de Livres à Gravures du XVIII Siècle* (Paris: A Rouquette, 1912), p. 992; John Harthan, *The History of the Illustrated Book* (London: Thames & Hudson, 1981), pp. 157–8.

WH

Painted by Wm Hamilton, R.A. London, Pub.d as the Act directs, Sep.r 8, 1798, by F.W. Perkins, N.o 49 New Bond Street. Engraved by F. Bartolozzi, R.A. Engraver to his Majesty.

SUMMER.

FROM brightening fields of ether fair difclos'd,
Child of the fun, refulgent Summer comes,
In pride of youth, and felt thro' Nature's depth:
He comes attended by the fultry Hours,
And ever-fanning Breezes, on his way;
While, from his ardent look, the turning Spring
Averts her blufhful face; and earth, and fkies,
All-fmiling, to his hot dominion leaves.

17. The Temple of Flora

Robert John Thornton, *New Illustration of the Sexual System of Carolus von Linnaeus … The Temple of Flora, or Garden of Nature*
London: [for the author], [1799–1807]

The Temple of Flora is the most magnificent flower book ever published in England. Its spectacular and dramatic plates were commissioned by Robert John Thornton (1768–1837), a London physician from a moneyed family, whose father, Burrell Thornton (d. 1768), was well known as a doctor, wit and fop. His son, educated at Cambridge and at Guy's Hospital, invested and lost a large fortune in the project. Originally billed as the concluding part of his projected *New Illustration of the Sexual System of Linnaeus*, the work was announced to prospective subscribers in 1797. It was issued in parts, each one in smart green covers with pink labels; these sold initially at 12s 6d each, rising to 25s as the project progressed. In parallel to its publication, Thornton also showed the prints and drawings he had commissioned for his book in 'Dr Thornton's Linnaean Gallery' in New Bond Street. Admission was by catalogue, priced 1s, and the enterprise was clearly inspired by Alderman Boydell's 'Shakespeare Gallery', which had first opened in 1789 and was also a combination of prestige illustrated book and public exhibition. Like Boydell's Gallery, the whole operation was a commercial catastrophe and like the alderman before him, Thornton was forced to obtain a private Act of Parliament (1811) to authorise a lottery to recoup his losses: 20,000 tickets were offered at two guineas each, but despite a glittering array of prizes, ranging from a large and varied number of copies of the book through to the entire contents of the Linnaean Gallery, this, too, was a disaster, and Thornton was utterly ruined.

Botany and botanical books were the height of fashion in late Georgian London and William Curtis, demonstrator of plants and *Praefectus Horti* at the Chelsea Physic Garden, had already published his magnificent (and coloured) *Flora Londiniensis* between 1777 and 1787. Thornton himself had been interested in natural history since childhood, and the *European Magazine* reported in 1803 that his grandmother had once grumbled that 'he was always catching of insects and butterflies in her garden, instead of minding his books. Hence all his weekly allowance went to maintain his garden and menagerie.' But for all the splendour of its plates, *The Temple of Flora* contained nothing very original for the man (or indeed the woman) of science, and it was marred by Thornton's oddly grandiloquent prose. On the other hand, it was certainly magnificent, and the illustrations – of exotic, wondrous and sometimes rather sinister-looking plants in suitably exotic settings – were undeniably impressive. At their most striking, they incontestably have something of the 'romanticism of horror' detected by the poet and critic Geoffrey Grigson in his 1951 facsimile, a book which Lord Fairhaven also owned (the technical bibliography appended to it was by Handasyde Buchanan, of the London bookseller Heywood Hill, where Fairhaven and particularly his brother Henry Broughton were regular customers).

Thornton made much of the fact that his great work was 'a *national undertaking*', dedicating it to Queen Charlotte ('the Bright Example of Conjugal Fidelity and Maternal Tenderness, Patroness of Botany and Fine Arts', as Thornton described her with characteristic enthusiasm). He also pointed out to his subscribers that each flower was painted and engraved by 'the most eminent British artists', and this was true enough. The 31 plates are a mixture of aquatints, mezzotints, stipple and line engravings after original material by Peter Henderson, Philip Reinagle (1749–1833), Abraham Pether (1756–1812) and Sydenham Edwards (1768–1819; see no. 18) they were printed in colour but finished by hand. Unsurprisingly, therefore, *The Temple of Flora* is bibliographically unusually complex, and few copies are exactly alike. Lord Fairhaven owned three.

BINDING
Paper-covered boards, with
printed label pasted to front
cover, as issued, *c.* 1807.

REFERENCES
ODNB; Gordon Dunthorne,
*Flower and Fruit Prints of the
18th and Early 19th Centuries:
Their History, Makers, and Uses,
with a Catalogue Raisonné of the
Works of the 18th and early 19th
Centuries in Which They are
Found* (London: Dulau & Co.,
1938), 301; Sacheverell Sitwell,
Great Flower Books, 1700–1900
(London: Collins, 1956),
p. 77; *Thornton's Temple of
Flora with Plates: Faithfully
Reproduced from the Original
Engravings and the Work
Described by Geoffrey Grigson,
with Bibliographical Notes
by Handasyde Buchanan*
(London: Collins, 1951).

MP

Syd. Edwards fecit.

THE SETTER

18. *Coloured Engravings of the Various Breeds of Dogs*

Sydenham Edwards, *Cynographia Britannica: Consisting of Coloured Engravings of the Various Breeds of Dogs*
London: printed by C. Whittingham for the author, 1800[–1805]

Manuals such as *The Book of Hawking, Hunting and Heraldry* (1486) included passages on the care of dogs, but the first English book concerned with them exclusively was *De Canibus Britannicis*, by the physician and Cambridge college head John Caius (see no. 1). Originally compiled for inclusion in Conrad Gesner's *Historia Animalium*, the work was published separately in 1570 and freely translated into English in 1576. Although Caius's work was reprinted several times, no comparable work followed until the publication of Sydenham Edwards's *Cynographia Britannica* over two centuries later.

Sydenham Edwards (1768–1819) was born in Usk, Monmouthshire, and brought up in Abergavenny. The son of a schoolmaster and church organist, he showed early artistic talent and in his teens was brought to London to work for the botanical writer and publisher William Curtis. His first signed work appeared in Curtis's *Botanical Magazine* in 1788 and he produced most of the plates for the journal until 1815, also

contributing to Curtis's *Flora Londinensis* (1777–87) and R.W. Dickson's *A Complete Dictionary of Practical Gardening* (1807).

Although chiefly identified with botanical illustrations, Edwards also worked on animal subjects in such publications as Abraham Rees's revision of Chambers's *Cyclopaedia*. Nonetheless his *Cynographia Britannica* was something of a departure, and likely to appeal to Lord Fairhaven, who reportedly kept black labradors. Not only does it consist of images of dogs rather than plants, but Edwards wrote the text and published the work himself. Six parts were published at irregular intervals between 1800 and 1805, each apparently containing illustrations of two breeds 'drawn from the Life' by Edwards 'and coloured under his immediate inspection'. Despite the charm of the illustrations, the book does not appear to have been a success; publication stopped after the sixth number, the text breaking off abruptly in the middle of the section on the mastiff, and very few copies survive.

BINDING
Half-goatskin with marbled paper boards, twentieth century.

REFERENCES
Barker 95; ESTC T100612; ODNB; Tooley 192; Howard M. Chapin, *The Peter Chapin Collection of Books on Dogs* (Williamsburg: College of William and Mary, 1938); Clifford L.B. Hubbard, *An Introduction to the Literature of British Dogs* (Ponterwyd: C.L.B. Hubbard, 1949) pp. 25–6; E. Gwynne Jones, *A Bibliography of the Dog* (London: Library Association, 1971) 2815.

WH

19. Orientalism in Egypt

Luigi Mayer, *Views in Egypt from the Original Drawings in the Possession of Sir Robert Ainslie, Taken During his Embassy to Constantinople*
London: printed by T. Bensley for R. Bowyer, 1801–4

The Scots diplomat Sir Robert Ainslie (1729/30–1812) became British ambassador in Constantinople in 1775. It was a sensitive time for Anglo-Turkish relations. Just five years previously, in 1770, Catherine the Great's Baltic fleet had sailed round Europe to annihilate the Ottoman navy at the Battle of Çeşme Bay, and the Sublime Porte was well aware that the Russian ships had revictualled in England during the course of their epic voyage from St Petersburg to the Aegean. But Ainslie enjoyed good relations with his Turkish hosts; in time, as London's *St. James's Chronicle* noted in 1790, he became 'strongly attached to the manner of the people'. 'In his house, his garden, and his table', it explained, 'he assumed the style and fashion of a Musselman of rank; in fine, he lived *en Turk*.'

While in Constantinople, Ainslie combined his official duties with collecting Byzantine and Ottoman coins and antiquities, and he also commissioned a collection of drawings from Italian artist Luigi Mayer (1755–1803). Mayer was a painter and watercolourist, now mostly remembered for his association with Ainslie, though he also produced oils and gouaches, chiefly of scenes in southern Italy and the Levant, monuments to what a later generation would call – with varying degrees of approbation – Orientalism.

BINDING
Half-calf, marbled paper boards, nineteenth century.

REFERENCES
Abbey, *Travel* 369; Bénézit, IX, p. 614; ODNB; A.I. Bagis, *Britain and the Struggle for the Integrity of the Ottoman Empire: Sir Robert Ainslie's Embassy to Istanbul, 1776–1794* (Istanbul: Isis, 1984); Domenico Sestini, *Lettere e Dissertazioni Numismatiche Sopra Alcune Medaglie Rare della Collezione Ainslieana* (Livorno: Nella Stamperia di Tommaso Masi, [1789–1821]).

MP

20. Nelson's funeral

Orme's Graphic History of the Life, Exploits, and Death of Horatio Nelson
London: printed for, published and sold by Edward Orme, [1806]

The death of Nelson in 1805 at the moment of his greatest victory called forth an unprecedented outpouring of national grief. Huge crowds came to pay their respects to the body as it lay in state in Greenwich Hospital, and an even greater throng watched the funeral procession as it wound its way to St Paul's on 9 January 1806, the hero carried in an elaborate carriage designed by Rudoph Ackermann, now best remembered for his activities in the field of publishing (see nos. 23, 26, 27 and 36).

It was inevitable that so great a national event should also stimulate a response from the book trade. Poems, songs, pamphlets and biographies were soon issuing from the presses. *Orme's Graphic History* must have appealed to the higher end of the market, a handsome folio retailing on its first appearance for four guineas, and including 12 engravings, of which four are coloured. The text presents Nelson the hero, rather than the flawed human being; the introduction refers to his 'extraordinary and brilliant career', comparing him to Hannibal and Epaminondas. The less edifying aspects of his life, though well enough known to his contemporaries, are dismissed briefly at the end of the book with the single sentence, 'Of his private conduct it is not necessary to enter into any further particulars'.

Born in Manchester, Edward Orme became printseller by appointment to two successive kings, and was second only to Ackermann as a publisher of illustrated books. These cover the full range of subjects typical of such productions at the time, from drawing manuals, through travel and costume, to field sports and military and naval victories. Like Ackermann, he employed miscellaneous writers to provide the text for his books. The biography of Nelson was furnished by Francis William Blagdon (1777–1819), who, from humble beginnings as a newspaper boy, had risen to earn a living as author and (unsuccessful) journalist. The book appears to have been completed around 4 July, on which date a codicil to Nelson's will concerning Lady Hamilton was proved. The final sheet of the work was hurriedly re-set to include a transcript, the only time Emma Hamilton is mentioned. Copies survive with or without the codicil; it is present in Lord Fairhaven's copy.

BINDING
Quarter-goatskin,
nineteenth century.

REFERENCES
Abbey, *Life* 327; Tooley 351.

WH

21. 'A number of children have been employed to enrich this volume'

Humphry Repton, *Observations on the Theory and Practice of Landscape Gardening*
London: printed by T. Bensley for J. Taylor, 1805

Born in Suffolk in 1752, Repton become one of the most famous exponents of that most English of art forms, landscape gardening. As he explained in the preface to this, his longest and most important work, his task was not to apply 'Rules of Art to the Works of Nature', but to refine and improve them by applying two general principles, which he summarised as '*relative fitness* or UTILITY and *comparative proportion* or SCALE'. *Observations on the Theory and Practice of Landscape Gardening* was designed, at least in part, to answer criticisms levelled at Repton by Sir Uvedale Price (1747–1829) and Richard Payne Knight (1750–1824), who both wrote in support of the picturesque. But it was also a reflection of a lifetime's work travelling around England advising clients, and typically supplying them with a beautifully illustrated 'Red Book' designed to highlight the potential of their estates. As Repton himself explained in print, 'my opinions have been diffused over the Kingdom in nearly five hundred such manuscript volumes', and many of them still survive.

The Red Books were, of course, a clever marketing device, but by publishing hand-coloured aquatints of facsimiles of his famous 'before and after' sketches in a single volume, Repton was able to circulate very widely material which would otherwise have been accessible only to his original patrons. And though many of his designs were indeed issued in the pages of periodicals like *Peacock's Polite Repository*, an expensive colour-plate book – this one sold for four guineas to subscribers in the original edition of 1803 – was clearly a much more effective way of evoking the appearance of the original watercolours. In the case illustrated here, showing the 'after' sketch above, Repton's customer was Sir Peter Burrell, of Langley Park, near Beckenham, in Kent. The Langley Red Book, submitted in 1790, is today in the British Architectural Library in London. In a footnote to the text, Repton himself anticipated the likely reaction of his customers in lauding the fact that 'the Art of colouring plates in imitation of drawings has so far improved of late'; but in an important (and to modern sensibilities perhaps slightly salutary) aside, in the same breath he also thanked his colourist, 'Mr. Clarke, under whose direction a number of children have been employed to enrich this volume'.

BINDING
Gilt-tooled straight-grained red goatskin, with gilt armorial stamp of Lord Fairhaven, twentieth century.

REFERENCES
Abbey, *Scenery* 390; BAL 2734; Tooley, pp. 209–10; John Archer, *The Literature of British Domestic Architecture* (Cambridge, Mass.: MIT Press, 1985), p. 279; Stephen Daniels, *Humphry Repton: Landscape Gardening and the Geography of Georgian England* (New Haven: Yale, 2000), pp. 14–15, 46–7, 300.

MP

22. Birds of Paradise

François Le Vaillant, *Histoire Naturelle des Oiseaux de Paradis*
Paris: Denne, 1806

The vogue in France for illustrated works of natural history continued into the post-revolutionary years, fuelled by the emergence of a newly prosperous middle-class market, and by a number of technical innovations. The new technique of stipple engraving (see no. 16) became the basis for a method of colour printing claimed as his invention by the botanical painter Pierre-Joseph Redouté (1759–1840), in which each colour was applied individually to the engraved plate with a *poupée* or rag dabber, and a single impression made, after which the process was repeated. Although slow and laborious the method produced impressive results, and François Le Vaillant was among the first to employ it in a series of bird books, beginning in 1796.

Le Vaillant was born in 1753 in Surinam, where his father was consul, moving to Europe at the age of ten. He had already begun collecting natural history specimens, having a particular interest in birds, and went to Paris as a young man in 1777 to further his studies. The study of natural history at that time necessarily focused on stuffed specimens, collected in the cabinets of learned societies. Le Vaillant, though an expert taxidermist himself, found this unsatisfactory. He was as much interested in the behaviour as the appearance of the creatures he studied, and resolved to travel to Africa to observe them in their natural habitat. He arrived at the Cape of Good Hope in 1781, almost immediately losing his possessions when the Dutch merchant fleet with which he was travelling was destroyed in the Battle of Saldanha Bay. Undaunted, Le Vaillant made two hazardous trips into the interior before returning to Paris laden with specimens, including the skin of a giraffe he claimed to have shot. This, when stuffed and mounted, became such a prized possession of the Musée d'Histoire naturelle that they had it painted almost life-size in oils.

His first two books were lively, if not entirely reliable, accounts of his adventures, written with the assistance of ghost writers, since Le Vaillant's wandering youth as the son of a diplomat had not enabled him to acquire the art of writing correct literary French. With his exotic place of birth, daring exploits and history of consorting amicably with savage tribes, the author was able to present himself almost as a child of nature to an age awash with the ideas of Rousseau, and his accounts were widely read and translated. His series of bird books began with *Histoire naturelle des Oiseaux d'Afrique*, issued in 50 parts over more than a decade. Four other books followed, of which *Oiseaux de Paradis* was the third. Each drew largely on Le Vaillant's own collections of specimens, painted by Jacques Barraban (1767–1809) and Jean-Gabriel Prêtre and engraved under the direction of Louis Bouquet (1765–1814). The capital outlay for such lavishly illustrated works was considerable, and more than many in the book trade could bear; *Oiseaux d'Afrique* changed publisher three times over its long gestation, and each of its successors was issued under a different imprint. Although there was some disagreement over the accuracy of his ornithology, Le Vaillant's works remained highly collectable; he himself died in modest circumstances in 1824.

PROVENANCE
Purchased by the future Lord Fairhaven from Brown's Antiquarian Bookshop, Eton, 14 November 1927, for £20. Nineteenth-century bookplate of George Sowerby.

BINDING
Half-goatskin with marbled paper boards, nineteenth century.

REFERENCES
Barker 97; L. C. Rookmaaker, *François Levaillant and the Birds of Africa* (Johannesburg: Brenthurst Press, 2004)

W H

Le Pignancoin. N:7.

Barraband pinx. De l'Imprimerie de Rousset. Pérée sculp.

23. Ackermann's *Microcosm of London*

The Microcosm of London
London: printed by R. Ackermann, [1808–10]

Rudolph Ackermann was born in Saxony in 1764 into a family of saddlers. After a short apprenticeship in the family business he left for Dresden at the age of 18 to begin his career as a carriage designer. It was in this capacity that he arrived in London in 1787; 18 years later he would design the funeral car for Lord Nelson (see no. 20). In a varied career he also ran a drawing school, invented a system for waterproofing leather, cloth and paper, and devised a machine for distributing anti-Napoleonic propaganda across Europe by balloon. The drawing school soon became 'The Repository of Arts' in the Strand, selling prints, fancy goods (made in the early days by high-ranking refugees from the French Revolution) and art books. An illustration of this establishment in Ackermann's magazine of the same name (vol. 1, 1809) suggests that his wares appealed strongly to the growing middle classes of the time, especially to women. From 1813 the Repository was also the venue for weekly *conversazione* for artists, writers, patrons and distinguished visitors to London. But Ackermann's name is now most closely associated with colour-plate books, owing to the magnificent series of topographical works with coloured aquatints which he produced from 1808.

The Microcosm of London was the first of these, appearing in 26 monthly parts from 1808. The book seems to have had its origin in a scheme by the architectural draughtsman A.C. Pugin (1762–1832) and his wife for a book entitled *Views of London and Westminster*. In the finished work the text was by professional writers W.H.

Pyne and William Combe, but it is doubtful whether anyone has ever bought the book for the text. The chief interest lies in the illustrations, which combine the talents of two very different artists, Pugin himself and the caricaturist Thomas Rowlandson (1756–1827). Ackermann explained his reasoning in the preface to the first volume:

> The great objection that men fond of the fine arts have hitherto made to engravings on architectural subjects, has been, that the buildings and figures have almost invariably been designed by the same artist. In consequence of this, the figures have been generally neglected, or are of a very inferior cast, and totally unconnected with the other part of the print...

Rowlandson added his vigorous drawings of figures in contemporary dress to Pugin's renditions of famous London sights, and the illustrations were engraved by five different craftsmen and coloured in Ackermann's own workshop. The total cost of the 104 engravings was around £2600; the complete work in three volumes retailed for the considerable sum of 13 guineas. The result was described by R.V. Tooley as 'one of the great colour-plate books ... a carefully selected copy should form the corner-stone of any collection of books on this subject'. Lord Fairhaven's copy, previously owned by the industrialist Henry Harvey Frost (1873–1969), could not have been more carefully selected; Tooley described it as 'the finest copy ... I have seen', noting the presence at the back of the original part-wrappers, a rare survival.

PROVENANCE
H. Harvey Frost, industrialist and collector of fine books and manuscripts. Probably the copy sold at Sotheby's on 21 April 1958.

BINDING
Gilt-tooled goatskin, signed by Rivière, with the original printed wrappers bound in.

REFERENCES
Abbey, *Scenery* 212; Ford, pp. 39–41; Hardie, pp. 100–3; Tooley 7; S.T. Prideaux,

Aquatint Engraving: A Chapter in the History of Book Illustration (London: Foyle, 1968) pp. 121–4.

W H

24. Crossing the Alps

Jean-Frédéric d'Ostervald, *Voyage Pittoresque de Genève à Milan par le Simplon*
Paris, 1811

The notion of the 'picturesque', formulated by the English clergyman William Gilpin in a series of travel books beginning with his *Observations on the River Wye* in 1782, spread abroad with remarkable speed. Books with titles beginning 'Voyage pittoresque' were in fact appearing in France in the 1750s, and a *Viaggio pittoresco* by Italian painter and printmaker Giacomo Barri appeared in Italy as early as 1671, with an English translation following eight years later. These, however, were not tours in search of picturesque scenery, but tours in search of actual pictures, as the English title of Barri's work, *The Painter's Voyage of Italy*, makes clear. From the beginning of the 1780s, however, books by such writers as Jean-Claude Richard de Saint-Non (*Voyage pittoresque ou Description des Royaumes de Naples et de Sicile*, 1781–6) and Jean-François Albanis Beaumont (*Voyage historique et pittoresque du Comté de Nice* and *Voyage pittoresque aux Alpes pennines,* both 1787), begin to use the word in something approaching its later sense, and by the turn of the century lavishly illustrated books of picturesque tours were being issued at least as profusely by French publishers as by their counterparts across the Channel.

The new transalpine route over the Simplon Pass, constructed between 1800 and 1809 on the orders of Napoleon, was a particularly suitable route for a picturesque tour. Its spectacular and forbidding scenery, impressively realised in this volume by the father and son team of Gabriel Ludwig Lory (1763–1840) and Mathias Gabriel Lory (1784–1846), was well suited to excite pleasing terror in the breast of the sensitive book collector. The anonymous text is by Jean-Frédéric d'Ostervald (1773–1850), a cartographer and descendant of the theologian and Bible translator of the same name, and it was he who invited the elder Lory to Neuchâtel in 1805 to produce the illustrations of the new route.

The Lorys were natives of Berne. Gabriel senior had produced four series of coloured engravings of scenery in Switzerland and France in the 1780s and 1790s, before being invited to Neuchâtel by d'Ostervald. His son, also known as Gabriel, was later to acquire an international reputation as a watercolour painter, engraver and publisher of views and costume plates. The Lorys collaborated with d'Ostervald on a similar work in 1816 on the Chamonix district in the French Alps. The taste for the picturesque was so universal by this time that both books were later republished in England by Rudolph Ackermann (see no. 23) as part of his own series of similar works. One of Ackermann's house writers, Frederick Shoberl, provided an English translation for the Simplon volume; since d'Ostervald was not named on the French language edition, Shoberl felt able to pass his version off as an original work.

BINDING
Quarter-calfskin with paper boards imitating leather, *c.* 1811.

REFERENCES
Bénézit, VIII, p. 1256; *Dictionnaire historique et biographique de la Suisse* (Neuchâtel: Administration du Dictionnaire historique et biographique de la Suisse, 1921–).

WH

25. Napoleon's last exile

George Hutchins Bellasis, *Views of Saint Helena*
London: printed by John Taylor, 1815

The South Atlantic island of St Helena lies some 1200 miles off the west coast of Angola, and rather further from Brazil. A British colony since the seventeenth century, it was of great strategic importance before the opening of the Suez Canel, especially for the ships of the East India Company making the lengthy voyage to the Indian subcontinent. The island remains one of the most isolated places on the surface of the globe, still accessible only by boat, the mail ship *St Helena* ferrying inhabitants ('Saints') and visitors alike to and from Portland and Cape Town.

An earlier visitor was George Hutchins Bellasis (1778–1822), who, as he explained in the preface to this splendid book, had spent 'a residence of eight months on the Island of St. Helena', enabling him 'to gain the local knowledge essential to his subject'. His extended holiday was in essence no more than an accident; Bellasis's father was in command of the British garrison at Bombay, and his son was forced by illness to stop off on the island in 1804, on the return leg of a voyage to see his family in India. But it clearly allowed him time to explore and sketch St Helena, which has an area of barely 47 square miles.

This plate shows the island's capital, Jamestown, still little altered since Bellasis visited, with the rocky volcanic shore 'very bold and majestic'. In his day it was the custom for every ship to pause at the entrance to the roads 'until a signal is made to advance', only then being allowed to approach the island more closely. Within a short time the question of security became yet more important, for reasons which Bellasis himself explained when describing the scene:

> Near the opening between the two mountains, Ladder Hill on the right, and Rupert's Hill on the left, is a small knoll, or conical hill, at the foot of which is a house called the Briars, marked in this View, though not seen from the Roads; this situation is the more interesting, as it is said to be the place intended for the residence of Buonaparte.

And indeed Napoleon, recently defeated at Waterloo, was to land on St Helena in October 1815 (Bellasis's book was issued a month later), and died there six years later, in May 1821, still under heavy guard. Bellasis's eight months in the South Atlantic in 1804 – together with a further visit in 1812 – proved fortuitous, allowing him to produce this impressive book. The plates were engraved by Robert Havell (1769–1832), and the book is dedicated to the Duke of Wellington, a friend of the author in his youth in Bombay, 'by whose distinguished and eminent service, in restoring the peace and liberties of Europe the Island of Saint Helena is at this time an object of interest to the whole world'.

BINDING
Half-blue morocco binding,
twentieth century.

REFERENCES
Abbey, *Travel* 309; Tooley 87;
Margaret Bellasis, *Honourable Company* (London: Hollis & Carter, 1952).

M P

26. Ackermann's *Cambridge* on large paper

William Combe, *A History of the University of Cambridge*
London: printed for R. Ackermann, 1815

Among the most celebrated of the topographical publications with which Ackermann followed his *Microcosm of London* (see no. 23), published in 1808–10, was a trilogy of works on the English universities and public schools. The *History of the University of Cambridge* was the second of these, appearing in 20 monthly parts from May 1814.

The text of most of Ackermann's books was provided by William Combe (1741–1823) who, after a youth largely spent squandering his father's fortune, had embarked in the 1770s on a career as a writer, supporting himself by penning works in every genre, from satire to sermons. More or less permanently confined for debt within the rules of the King's Bench Prison from the early 1800s, Combe had effectively become Ackermann's house writer after authoring the final volume of *The Microcosm of London*. In this capacity he produced a steady stream of verse and prose for Ackermann's books and illustrated magazines, most famously the text for the three *Tours of Dr Syntax*, which were illustrated by Thomas Rowlandson.

Ackermann's books were issued in relatively limited editions of around 1000, but the production of such copiously illustrated works called for an extensive network of artists and craftsmen as well as a workshop of some size. The drawings and engravings were produced on a commission basis, and the letterpress executed by a firm of printers with premises near to Ackermann's establishment in the Strand. Only the printing and colouring of the illustrations themselves was done in Ackermann's workshop. There the plates were printed, generally in two colours, blue for the sky and brown for buildings, with local colour added subsequently by hand. The labour and expense of all this was considerable; the total number of images printed for Ackermann's major topographical works up to the *History of the Colleges* (see no. 27) was no less than 372,000. It is not surprising that these books, then as now, were priced as luxury items; both *Oxford and Cambridge* sold for £16 when completed and bound in two volumes, and the 50 copies of each produced on 'large paper' (lavishly proportioned and with wider margins than other copies) sold for the then considerable sum of £27. Of these copies, R.V. Tooley wrote: 'they gave a gloss, an incomparably rich glow absent from small-paper copies, fine as these are in early impressions; their text is also on thick Whatman paper and the portrait of the Duke of Gloucester on India paper'. It goes almost without saying that the Fairhaven copy is on large paper.

BINDING
Gilt-tooled blue goatskin, twentieth century.

REFERENCES
Abbey, *Scenery* 79; Hardie, pp. 104–5; Tooley 4; John Ford, 'Ackermann Imprints and Publications', in Robin Myers & Michael Harris (eds), *Maps and Prints* (Oxford: Oxford Polytechnic Press [1984]), pp. 109–22; S.T. Prideaux, *Aquatint Engraving: A Chapter in the History of Book Illustration* (London: Foyle, 1968), pp. 125–6.

W H

27. Ackermann's public schools

Rudolph Ackermann, *The History of the Colleges of Winchester, Eton and Westminster....*
London: printed for and published by R. Ackermann, 1816

The *History of the Colleges* was the last of Ackermann's great series of English topographical works, also closing his trilogy on English educational institutions. In his preface, Ackermann wrote that the great public schools followed on naturally as they were:

> ... the nurseries of the Universities, and may consequently be said to be so connected with them, that the history of the former cannot be considered as altogether perfect without that of the latter.

The scheme appears to have been hatched around the beginning of 1815 and originally encompassed just the four most famous of the public schools, Winchester, Eton, Westminster and Harrow. As this would have made a rather slim volume, Charterhouse was soon added, and finally Rugby, St Paul's, Merchant Taylors' and Christ's Hospital, making nine in all. The complete work was to be issued in 12 parts, as opposed to the 20 parts each of *Oxford* and *Cambridge*, each part containing four plates with accompanying letterpress.

For the letterpress, Ackermann tells us that he had hoped 'to provide an historian of each school from the scholars of it'. In the event he only managed to find old boys to write Winchester, Harrow and Rugby, and William Combe, who had originally been assigned only to his old *alma mater*, Eton, found himself 'at a very late period' having to write the remainder as well. He had wanted to write the text for Harrow, claiming surprisingly that he had been a pupil there before going to Eton.

In the event it was given to Henry Drury, a master at the school, whom Combe claimed had 'persuaded A------n to let him have it to puff off the school and the inhabitants of it, so that it does not bear the least conformity to the rest'. Drury, a noted classical scholar and bibliophile, seems to have been more concerned to puff off his personal library, which he footnoted as 'the most splendid collection at present in Harrow ... although inferior in extent to that of Dr. Heath, it is the greatest object of attraction to bibliographers visiting the place'.

It was probably these problems which caused a delay in publication, the appearance of the first part being put back from 1 September 1815 to 1 January 1816. To add to the publisher's troubles, take-up of the subscription was slow – only 337 names were on the list for the usual edition of 1000, and copies remained unsold in 1830. Ever resourceful, Ackermann announced in 1817 that the text and plates of individual schools would be available separately in boards, so that those who lacked the money or inclination to acquire the complete work could purchase the history of their own school for a more modest sum. In the twentieth century the reputation of the Colleges appears to have grown; in 1906 Martin Hardie wrote that their illustration 'equals, if not surpasses, that of the *Oxford* and *Cambridge*' and by 1954, by which time Lord Fairhaven's own collection was well advanced, R.V. Tooley was writing that 'Ackermann's *Schools* is more popular than his *Oxford* and *Cambridge* and occurs less frequently for sale'.

PROVENANCE
Bookseller's description has phone number 'Regent 3610'; with small leather monogrammed ownership label of G.R. N[icolaus].

BINDING
Gilt-tooled red goatskin, signed by Zaehnsdorf, twentieth century.

REFERENCES
Abbey, *Scenery* 438; Ford, pp. 43–4; Hardie, pp. 106–7; Tooley 3; John Ford, 'Ackermann Imprints and Publications' in Robin Myers and Michael Harris (eds), *Maps and Prints* (Oxford: Oxford Polytechnic Press, 1984), pp. 109–22; S.T. Prideaux, *Aquatint Engraving: A Chapter in the History of Book Illustration* (London: Foyle, 1968), pp. 126–7.

WH

28. *Magna Carta* in letters of gold

Magna Carta Regis Johannis
London: J. Whittaker, 1816

This remarkable and rather extraordinary book was published to mark the 600th anniversary of the original issue of *Magna Carta* in 1215. Printed in burnished gold letters by a secret process invented by the bookbinder John Whittaker, copies were priced, according to Lowndes, at from 10 to 250 guineas, depending on the level of decoration and the lavishness of the binding. It was said to be the first book printed in gold and, unsurprisingly, no two copies are exactly alike. Despite the offer of a prize by the Society for the Encouragement of the Arts, Whittaker kept his method of gold printing a secret. It was divulged only after his death, when it was revealed to the Jury of the Great Exhibition of 1851 by John Harris Jr (1791–1873), whose father, the miniaturist John Harris Sr (1767–1832), had carried out much of the decorative painting in *Magna Carta* under the supervision of the Prince Regent's heraldic artist, Thomas Willement (1786–1871):

> The page is composed in moveable type in the usual way; a stereotype-plate is taken. A piece of iron of the size of the page, about half-an-inch in thickness, is made hot, and placed on the table of an ordinary typographical printing-press; the stereotype-plate is then placed on the iron plate, and gets hot, and leaf-gold of an extra thickness, of the size of the plate, is laid very carefully on the surface of the plate; then the paper or vellum is placed on the tympan in the usual way, having previously been sifted over with dried glaze of egg and rosin finely pulverised, which adheres to it in sufficient quantity; the tympan is then turned down, and the pull dwelt on. The degree of heat must be ascertained by practice; if the plate be too hot, the plate is dead and drossy; if too cold, then it appears bright but imperfect.

Many of the Fairhaven books at Anglesey Abbey must have had a personal or sentimental interest for their owner, and this extraordinary *tour de force* is no exception. Following the death of Fairhaven's father, Urban Hanlon Broughton, his widow Cara, Lady Fairhaven and their two sons presented Runnymede to the National Trust, commissioning a memorial from Sir Edwin Lutyens (1869–1944), who designed a sober array of kiosks and piers, one inscribed:

> In these Meads on 15th June 1215 King John at the instance of Deputies from the whole community of the Realm granted the Great Charter the earliest of constitutional documents whereunder ancient and cherished customs were confirmed abuses redressed and the administration of justice facilitated new provisions formulated for the preservation of peace and every individual perpetually secured in the free enjoyment of his life and property.

and the other:

> In perpetual memory of Urban Hanlon Broughton 1857–1929 of Park Close Englefield Green in the county of Surrey Sometime Member of Parliament These meadows of historic interest on 18th December 1929 were gladly offered to the Nation by his widow Cara Lady Fairhaven and his sons Huttleston Lord Fairhaven and Henry Broughton.

PROVENANCE
Purchased at an unknown date, from Charles J. Sawyer, London, presumably by Lord Fairhaven.

BINDING
Gilt- and blind-tooled straight-grained red goatskin, *c.* 1816, with gilt-tooled green watered-silk endleaves and gilt-tooled goatskin doublures. Binder's ticket of [Charles] Hering.

REFERENCES
Dibdin, II, pp. 358–9, 364, 416–7, 526; Lowndes, p. 1450; Wormsley 74; *The Observer*, 22 December 1929, p. 7; Philip J. Weimerskirch, 'John Harris, Sr., 1767–1832: Memoir by his Son John Harris, Jr., 1791–1873', in *The Book Collector*, 42, 2 (Summer 1993), pp. 245–51.

MP

ICH DIEN.

TO
His Royal Highness
The Prince Regent
This
SPECIMEN of ART,
is by Permission
Dedicated
By his most devoted obedient
and humble Servant,
John Whittaker.

29. Coloured aquatints in Rome

Matthew Dubourg, *Views of the Remains of Ancient Buildings in Rome and its Vicinity*
London: printed for J. Taylor by J. Haddon, 1820

With the end of the Napoleonic Wars and the final exile of Napoleon to St Helena after the Hundred Days, British tourists were able to travel freely on the Continent for the first time in a generation. Their Grand Tour predecessors had, of course, been visiting Rome in considerable numbers right through the seventeenth and eighteenth centuries, but the new possibilities of the hand-coloured aquatint offered the opportunity of looking at the Eternal City in new and entrancing ways. For many, the stock mental images of the great monuments of papal and ancient Rome would have been derived from canvases by Grand Tour artists such as Giovanni Paolo Panini (1691–1765), or even from portraits of parents and grandparents painted in Italy against suitably antique backdrops by the likes of Pompeo Batoni (1708–87). But another obvious influence would have been the engravings of Giovanni Battista Piranesi (1720–78), whose *Vedute di Roma* were issued individually and in small groups from the late 1740s onwards.

Piranesi's fellow engraver Matthew Dubourg (*fl.* 1786–1836) depicted many of the same places in his *Views of the Remains of Ancient Buildings in Rome*, originally issued at £7 7s for the 26 aquatints, but the images themselves could not have been more different. The exaggerated perspectives and the dark and gloomy grandeur of Piranesi are replaced with a delicate and airy grace, and above all by the brilliant colours of a Mediterranean summer. The whole point of books like this was that they replicated (or at least claimed to replicate) the colours and tones not just of contemporary watercolours, but of real places which contemporary visitors could, if they wished, experience for themselves. They offered truth, verisimilitude and honesty; or at least a promise of them.

BINDING
Gilt-tooled straight-grained half goatskin, marbled paper boards, twentieth century.

REFERENCES
Abbey, *Travel* 181; BAL 920; Tooley 188.

MP

Plate 17.

TRAJAN'S COLUMN.

Engraved by M. Dubourg

London, Published as the Act directs, 1820.

30. *The Lower Orders of London*

Thomas Lord Busby, *Costume of the Lower Orders of London*
London: published for T.L. Busby by Messrs. Baldwin and Co., [1820]

Books illustrating different fashions of costume became popular in the early decades of the nineteenth century. Many, if not most, merely illustrated contemporary fashions of the local well-to-do, chiefly in serial publications such as *La Belle Assemblée* (1806–37) and Ackermann's *Repository of Arts* (1809–29). Others exploited the interest of the day in foreign travel. Such titles as *The Costume of China* (1800), by G.H. Mason (who also produced a startlingly popular companion work on *The Punishments of China*), and similar works on Russia, Austria, Turkey and elsewhere, complemented the illustrated travel books then in vogue with detailed depictions of the natives in characteristic garb.

It is a little surprising to turn from works like these to T.L. Busby's *Costume of the Lower Orders of London*. Here are the people whom the wealthy book collector could very likely see from the window of his town house, 'painted and engraved from nature', in the words of the title-page, much like specimens in a work of natural history. Each of the 24 plates is accompanied by a leaf of text, in several cases giving the name and biography of the individual depicted, and often soliciting sympathy for their plight. Much of the entry on chimney sweepers is devoted to the then universal practice 'of using boys in this dangerous and cruel employment, the misery of which is often increased by their masters' severity'. The dustman's recycling practices seem by contrast highly enlightened to a twenty-first-century reader: 'At convenient places the ashes [refuse] are sifted, by which

process the bones, rags, nails, &c., are separated, and of course disposed of to the best advantage … Thus we find every part of that which appears rubbish to the house-keeper, is property of no little value to the Dustman.'

As well as that of the costume book, the work fits into the much longer tradition of the illustrated 'Cries of London' – incidentally, a particular enthusiasm of Lord Fairhaven's friend, the architect Sir Albert Richardson (1880–1964). These collections of woodcuts or engravings of itinerant sellers, generally with minimal text, date back as far as the seventeenth century. Small in size and cheaply produced, they were chiefly aimed at a popular or juvenile market. Busby himself produced such a collection in 1823. The present work, though covering much the same ground, appears designed to appeal to a more leisured and thoughtful readership, and one with deeper pockets. An extensively revised edition was published shortly afterwards as *Costume of the Lower Orders of the Metropolis*.

Little is known about Busby, who exhibited as a painter of miniatures at the Royal Academy from 1804 to 1821. His other works include similar books on the lower orders of Paris and *The Fishing Costume and Local Scenery of Hartlepool* (1819), which is also in the Fairhaven collection. A projected work on the *Civil and Military Costume of the City of London* (1824–5) was cut short by the artist's 'indisposition', and was to prove his last work in this form, though he continued to publish etchings and exhibited as late as 1837.

BINDING
Half-goatskin, marbled paper boards with printed label, *c.* 1820.

REFERENCES
Abbey, *Life* 423; Bénézit, III, p. 81; Tooley 123; Karen F. Beall, *Cries and Itinerant Trades* (Hamburg: Hauswedell, 1975) E40; René Colas, *Bibliographie générale du Costume et de la Mode* (Paris: Colas, 1933) 491; Hilaire and Meyer Hiler, *Bibliography of Costume* (New York: H.W. Wilson, 1939), p. 129; Algernon Graves, *A Dictionary of Artists who have Exhibited Works in the Principal London Exhibitions from 1760 to 1893* (3rd edn, London: Graves, 1901); Algernon Graves, *The Royal Academy of Arts* (London: Graves, 1905–6).

W H

DUSTMAN.

Pub.d May 15th 1820 for T.L. Busby by Mess.rs Baldwin & C.o Paternoster Row & at the Artists Depository 21 Charlotte Street Fitzroy Sqre.

PROVENANCE
With the armorial bookplate
of G.R. Nicolaus, 1929; sold,
Sotheby's, 7 June 1944, 'the
Property of a Gentleman'.

BINDING
Brown goatskin with red
watered-silk endleaves and gilt-
tooled doublures, signed by
Zaehnsdorf, twentieth century.

REFERENCES
Abbey, *Travel* 90; Ford, pp.
70–71; Tooley 445; Philip
Mansel, *Louis XVIII* (London:
John Murray, 1981), p. 214.

M P

31. Gothic Revival on the Seine

Jean-Baptiste-Balthazar Sauvan, *A Picturesque Tour of the Seine*
London: published by R. Ackermann, 1821

Just as Napoleon's final defeat and exile focused international attention on the South Atlantic island of St Helena (see no. 25), so the fall of the emperor and the restoration of the Bourbons in 1814 allowed English tourists to explore France for the first time since the short-lived Peace of Amiens of 1802–3. Louis XVIII had been in exile at Hartwell House in Buckinghamshire (now another National Trust property) and was a great Anglophile, but not all of his fellow countrymen shared his feelings, and by the autumn of 1814 the hoards of English visitors and the overbearing behaviour of the British ambassador, the Duke of Wellington, were reportedly beginning to grate on the Parisians. Secret service reports sent to the king revealed it was '*la gloire de Wellington*' that above all else annoyed former Napoleonic loyalists like Marshal Ney, who was to go back to his old master when Napoleon returned for the final gamble of the Hundred Days – only to be shot for treason after the duke's final victory at Waterloo in June 1815.

Louis XVIII was also a great book collector, and he was the dedicatee of this splendid volume of hand-coloured aquatints. Like many such books it was a collaborative effort, published by Ackermann and available from his shop in the Strand, the text by Sauvan, and the yet more crucial plates by the firm's in-house engravers Thomas Sutherland (1785–1838) and Daniel Havell (1785–1826) after original material by John Gendall (1791–1865) – including this plate of medieval Rouen – and the French *emigré* artist Auguste Charles Pugin (1762–1832). Pugin had grown up in pre-revolutionary France and fled the Revolution in 1792, becoming architectural draftsman to John Nash (1752–1835) and contributing many of the illustrations for, among others, Ackermann's books on Oxford (1814), Cambridge (1815; no. 26), and the great public schools (1816; no. 27).

William Gilpin had, of course, published his *Observations on the River Wye*, the founding text of the Picturesque movement, as far back as 1782 (see no. 24), but by 1821 spectacular coloured books on the journeys of rivers – though exciting and novel – were by no means unprecedented. Ackermann had already issued a *Picturesque Tour on the Rhine* (1820), and would go on to produce books on the Thames (1828) and the Meuse (1835), as well as – more exotically – the Ganges and the Jumna (1824), and the Niger (1840). But Gendall and Pugin's illustrations along the Seine would have had a further resonance in the 1820s, and one which would not have been lost on thoughtful contemporaries. Many of the great Gothic buildings of northern France had been badly damaged during the French Revolution, converted into Temples of Reason during the Terror, or otherwise brutalised; the 28 medieval statues of the kings of Israel and Judah on the west front of Notre Dame in Paris – a building which features prominently in Ackermann's illustrations of the French capital – were famously wrecked by the revolutionaries in 1793. By 1821 all this was in the past, and for its authors and purchasers, *A Picturesque Tour on the Seine* was surely as much about the growing veneration of the medieval past and, implicitly, the rejection of the Revolution and all it had stood for, as it was about the sights that were to be seen along the river. Exactly a decade later, Victor Hugo was to publish his famous medievalist novel *Notre-Dame de Paris* (1831), and in 1843 the pioneering Gothicist Eugène-Emmanuel Viollet-le-duc (1814–79) submitted his plans for the restoration of the cathedral. Across the Channel, and at much the same time, Auguste Charles Pugin's son Augustus Welby Northmore Pugin (1812–52) had by then already published *Contrasts* (1836), an impassioned polemic on the depravity of modern life and buildings and the transcendent beauty of the Catholic Middle Ages; he would go on to be the most pungent propagandist of the Gothic Revival in England.

32. Boadicea

Samuel Rush Meyrick and Charles Hamilton Smith,
The Costume of the Original Inhabitants of the British Islands
London: printed by Howlett and Brimmer for T. McLean and E. Williams, 1821

The Costume of the Original Inhabitants of the British Islands represents a different kind of costume book from those dealing with contemporary metropolitan fashions or the exotic garb of other nations. At a time when antiquarians were rediscovering the art and architecture of the ancients, Samuel Rush Meyrick and Charles Hamilton Smith were turning their attention to their dress. The book was originally published in 1815 and followed a similar work by Smith alone, *Selections of the Ancient Costume of Great Britain and Ireland* (1814), which covered the later period from the seventh to the sixteenth centuries.

Its two authors came from very different backgrounds. Meyrick (1783–1848) was a graduate of the Queen's College, Oxford and an active member of the Society of Antiquaries. He practised as an advocate and wrote widely on antiquarian topics, with a particular interest in arms and armour. He assembled a large collection of this, building the lavishly Gothic Goodrich Court in Herefordshire partly to display it (having failed to purchase and rebuild the famous castle on the neighbouring hill). He advised on the arrangement of the armour collection in the Tower of London and was later knighted by William IV in recognition of his similar work at Windsor. His illustrated *Critical Enquiry into Antient Armour* appeared in three volumes in 1824. The Flemish-born Smith (1776–1859), by contrast, was largely self-educated. During a military career which took him to the Low Countries, Jamaica and North America, he amassed volumes of notes and watercolour sketches on topics including topography, natural history and archaeology,

which formed the raw material of his many publications. As well as the two costume books mentioned above, these included works on military history and a number of zoological works illustrated from his own sketchbooks. He became a fellow of both the Royal Society and the Linnaean Society.

In the preface to his *Selections of the Ancient Costume*, Smith had outlined something of a manifesto. He and Meyrick were aiming to demonstrate, to an age still apt indiscriminately to clothe its painted or sculpted images of great men in togas, that 'far from diminishing the impressions intended to be conveyed, an adherence to the costume of the times represented will augment the illusion, and assist to explain the meaning'. Some of the pictures have a slightly theatrical quality, and both men would later act as advisers on historical costume to the leading actor-managers of the day, Smith to William Charles Macready and Edmund and Charles Kean, Meyrick to James Robinson Planché, who was himself to produce a number of works on the subject.

The plates were drawn by Smith and aquatinted by Robert Havell (1769–1832), a member of a dynasty of artists, engravers and publishers who contributed to a large number of illustrated works of the period, most famously Audubon's *Birds of America* (1827–39). The scholarly and well-referenced text was compiled, probably by Meyrick, from 'three large quarto manuscript volumes' of source material in his possession. A third 'improved' edition appeared, undated, some years later, by which time the aquatinting of the plates had in places quite worn away.

BINDING
Gilt- and blind-tooled straight-grained olive goatskin, *c.* 1821.

REFERENCES
ODNB; Tooley 326; René Colas, *Bibliographie générale du Costume et de la Mode* (Paris: Colas, 1933) 2051; Hilaire and Meyer Hiler, *Bibliography of Costume* (New York: H.W. Wilson, 1939), p. 587.

W H

C.H.S. del.

Aquatinted by R. Havell

Boadicea, Queen *of the Iceni.*

33. Repton's *Designs for the Royal Pavilion*

Humphry Repton, *Designs for the Pavilion at Brighton*
London, [1822]

In 1805 Repton visited Carlton House to present a Red Book (see no. 21) for the Brighton Pavilion to the Prince Regent. 'Prinny' was delighted with the designs, exclaiming with evident excitement: 'Mr. Repton I consider the whole of this book as perfect. *I will have every part of it carried into immediate execution.* Not a tittle shall be altered – even you yourself shall not attempt any improvement.' Perhaps unsurprisingly, the designs were never carried through, and Repton's concept remained on paper only, with the original Red Book now in the Royal Library at Windsor. Repton's brief business partnership with the brilliant but wayward architect John Nash (1752–1835) did not long survive. The original conceit of turning a restrained 'Marine Pavillion', built by Henry Holland in 1786–7, into an Indian extravaganza was Repton's – though obviously inspired by the nearby Indian-style Riding House and Stables, built by the architect Henry Porden from 1805, and seen here in the

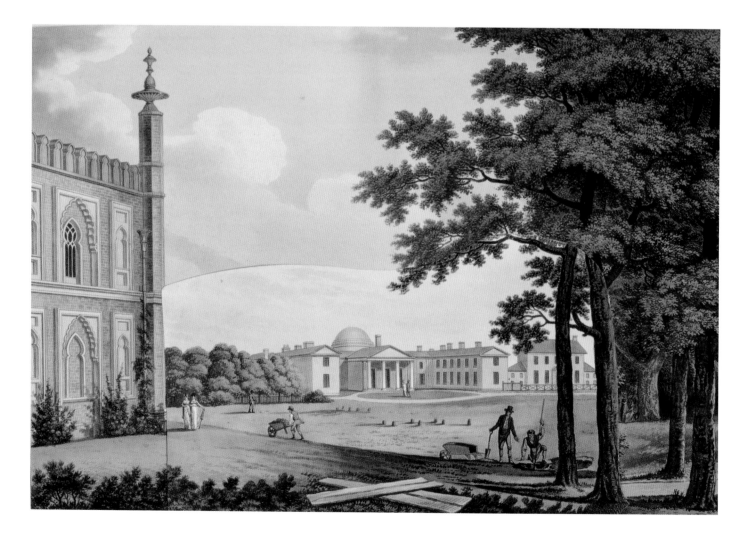

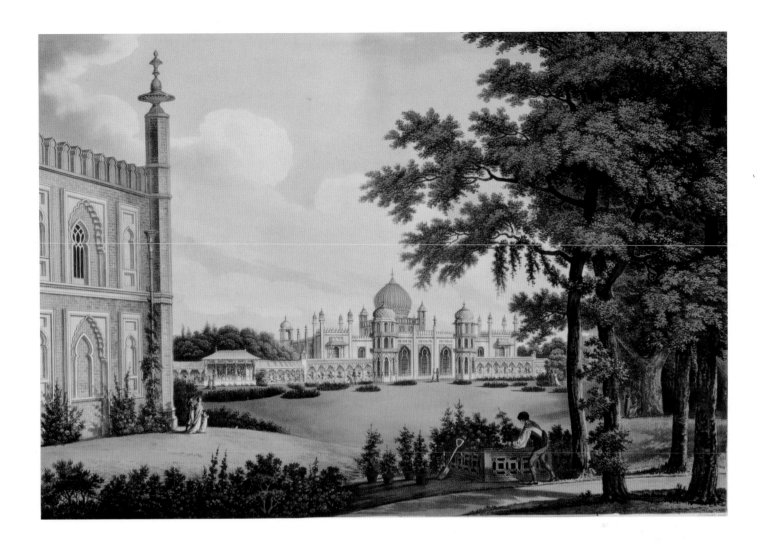

foreground – but the building which eventually emerged was by Nash, and was finished between 1815 and 1822.

The idea of an Indian house was novel, but not without precedent; Porden's master S.P. Cockerell had designed something rather similar for his brother, an Indian 'nabob', at Sezincote in Gloucestershire in 1805. But the fashion for Mughal buildings had already been stoked by two influential colour-plate books, William Hodge's *Views of India* (London, 1786), and William Daniell's magnificent *Views of Oriental Scenery*, issued from 1795. The Fairhaven collection includes an especially splendid copy of the latter, and Repton himself was not far behind Daniell in spotting, in the brief fashion for Indian architecture, a business opportunity for his otherwise wasted designs for Brighton. *Designs for the Pavilion at Brighton* was issued by Repton in partnership with J.C. Stadler in 1805, the project funded on a profit-share basis, but with Stadler agreeing to cover any losses.

It cost six guineas to subscribers, and eight to other purchasers, and included three hand-coloured aquatints, two of them with Repton's characteristic overslips. The work was reissued with the same plates some 17 years later, presumably to coincide with renewed public interest in Brighton on Nash's final completion of the Pavilion in 1822.

BINDING
Half straight-grained goatskin with marbled paper boards, with printed label pasted to front cover as issued, *c.* 1822.

REFERENCES
Abbey, *Scenery* 55; BAL 2730; Tooley 397; John Archer, *The Literature of British Domestic Architecture* (Cambridge, Mass.: MIT Press, 1985) 976; Stephen Daniels, *Humphry Repton: Landscape Gardening and the Geography of Georgian England* (New Haven: Yale, 2000), pp. 203–4; John Morley, *The Making of the Royal Pavilion, Brighton* (London: Sotheby's, 1984), pp. 47–51; Ian Nairn and Nikolaus Pevsner, *The Buildings of England: Sussex* (London: Penguin, 1965), pp. 438–9.

MP

34. Red Coats in Rangoon

Joseph Moore, *Eighteen Views taken at & near Rangoon*
London: Thomas Clay, 1825–6

By the early nineteenth century the British were firmly established as the masters of India and, following Burmese incursions on its north-eastern frontier, the East India Company declared war on Burma in February 1824. While the troops of the Burmese Empire invaded the province of Chittagong, on the eastern shore of the Bay of Bengal, the Company mounted a full-scale sea-borne assault on Rangoon, landing 11,000 men in May 1824 under the command of Major-General Archibald Campbell and Captain Frederick Marryat.

The invaders found the city largely abandoned by its inhabitants, and in the subsequent conflict the Burmese army was crushed by the modern European weapons fielded by the East India Company. After two years of fighting, Burma was defeated and forced both to cede territory and to pay a huge indemnity to the company, beginning the process which would end with the country's annexation by the British Empire in 1889.

This splendid plate book, dedicated to the Court of Directors of the East India Company, was illustrated by Joseph Moore, a lieutenant in the 89th Regiment, which took part in the war. Here, in an improbably calm and orderly scene, a group of red-coated troops marches along the great avenue leading from the sacred Shwedagon Pagoda, whose huge gold-covered *stupa* can be seen in the background. The pagoda, a place of pilgrimage for Burmese Buddhists, was used as a fortress by the British during the Burmese War, and was pillaged and damaged by the occupiers.

PROVENANCE
Bought for £24 by Lord Fairhaven at an unknown date.

BINDING
Half-goatskin, with the original printed wrappers bound in, nineteenth/twentieth century.

REFERENCES
ODNB; Abbey, *Travel* 404; Tooley 334; Thant Myint-U, *The River of Lost Footsteps – Histories of Burma* (London: Faber and Faber, 2007); Win Pe, *Shwe Dagon* (Rangoon: Print and Publishing Corporation, 1972).

MP

35. Wild's *Cathedrals*

Charles Wild, *Twelve Select Examples from the Cathedrals of England*
London, 1828

Pugin's *Contrasts* (1836) is probably the best remembered book of the architectural Gothic Revival, but it came nearer the end than the beginning of the literary history of the movement. Books of architectural patterns based on Gothic forms, most famously Batty Langley's *Gothic Architecture, Improved by Rules and Proportions* (first published under a different title in 1742), had begun to appear a century earlier. The taste these exemplified saw Gothic as a fantastic style, suitable mainly for scenic and decorative purposes. Designs for Gothic temples, summer houses and other eye-catchers abound, and it is hardly surprising that the major architects of the day preferred to work in other styles.

More scholarly attention was devoted to the Gothic style a few years later. Thomas Warton's *Essay on Gothic Architecture* was originally published in the second edition of his *Observations on the Fairy Queen of Spenser* (1762). His fellow-poet Thomas Gray, like Warton a practitioner of the Gothic mode in poetry, advised James Bentham on the similar essay in his *The History and Antiquities of the...Cathedral Church of Ely* (1771), and Horace Walpole on the chapter on architecture in his *Anecdotes of Painting in England* (1762). More substantial works such as Francis Grose's *The Antiquities of England and Wales* (1773–6) and John Carter's *The Ancient Architecture of England* (1795–1814) combined accurate illustrations of early structures with historical commentary; Carter's work, never finished, was intended as a detailed historical survey of the Gothic style.

Books of this kind, expensive and outwardly forbidding, may only have reached a minority readership, but the architectural publications of John Britton (1771–1857), beginning in 1807 with the first volume of *The Architectural Antiquities of Great Britain*, circulated more widely. Subsequent series, of progressively increasing authority and technical achievement, included the unfinished *Cathedral Antiquities of England* (1814–35) and, most significantly, *Specimens of Gothic Architecture* (1820–25), with fine illustrations by the elder Pugin. Britton employed a large number of leading artists for his works, which put high-quality representations of Gothic buildings and individual details within the reach of both amateur and professional.

The publications of Charles Wild (1781–1835) combine an eighteenth-century taste for picturesque detail with nineteenth-century architectural accuracy. Wild was a watercolour painter who specialised in architectural subjects, exhibiting 165 paintings of this kind at the Society of Painters in Water-Colours, of which he was successively treasurer and secretary. An engraver as well as a watercolourist, he also worked in book illustration, contributing to Britton's *Architectural Antiquities* and, most extensively and notably, to W.H. Pyne's *History of the Royal Residences* (1819), arguably the finest book illustrated in aquatint. The *Select Examples from the Cathedrals of England*, consisting of 12 coloured plates without text, comes towards the end of a list of similar collections of works, including illustrations of the cathedrals of Canterbury, Chester and Lichfield. The fact that it includes a fine engraving of the interior of Ely Cathedral, before the Victorian restoration, no doubt recommended it to Lord Fairhaven.

BINDING
Gilt-tooled goatskin, nineteenth century.

REFERENCES
ODNB; Abbey, *Life* 82; Kenneth Clark, *The Gothic Revival* (3rd edn, London: John Murray, 1962); James Macaulay, *The Gothic Revival 1745–1845* (New Haven: Yale University Press, 1987); Michael McCarthy, *The Origins of the Gothic Revival* (Glasgow: Blackie & Son, 1975).

W H

36. A panorama round Regent's Park

Richard Morris, *Panoramic View Round the Regent's Park*
London: printed by R. Ackermann, 1831

In 1787 the Irish-born painter Robert Barker took out a patent for a new type of painting which he called *la nature à coup d'oeil*. His technique for the representation of a 360-degree view of a landscape in correct perspective, mounted on the walls of a circular room, soon acquired the more concise name 'panorama', which in turn came to be used in its modern meaning of an all-round view. Barker's panorama of London, completed in 1792, was a great success with the public, and he swiftly built a huge rotunda in Leicester Square, in which was displayed a changing programme of paintings in a manner which enhanced their *trompe l'oeil* qualities. The opening show of the fleet at Spithead was reputed to be so realistic that it made Queen Caroline seasick, and the panorama was soon established as a popular art form. It appealed to the romantic traveller who ascended towers and mountains in search of picturesque views, to patriots or armchair warriors who wanted to see the scenes of recent battles without risk or exertion, and to anyone who wanted to experience a familiar or unfamiliar view from a new viewpoint.

Small-scale reproductions of panoramas were produced as souvenirs from their earliest days, and the strip panorama soon became an independent genre, though it could never hope to reproduce the overwhelming quality of the full-scale prototypes. These publications, sold concertinaed in folders or rolled in cylinders, had another ancestor in the form of the engraved representation of the triumphal procession, produced as far back as the sixteenth century. The novelty was that the strip panorama generally gave an all-round view, whereas a work such as the *La magnifique Entrée de François d'Anjou en sa Ville d'Anvers* was purely linear. This particular example was produced by the firm of Ackermann (from which Rudolph had now largely retired) in 1831. The drawings were by Richard Morris, a fellow of the Linnean Society of London, otherwise known only for a set of *Essays on Landscape Gardening*, published in 1825. A pleasingly referential touch is the inclusion of the exterior of the Colosseum, which contained one of the most spectacular panoramas of all. This was an aerial view of London sketched from scaffolding atop St Paul's Cathedral in 1823–4 by the surveyor and artist Thomas Hornor (1785–1844) during restoration work. Ackermann had produced a series of aquatints illustrating the Colosseum and its panorama two years earlier, which portrays it as a pleasure dome worthy of Kubla Khan; it was demolished in 1875.

BINDING
In publisher's original case as issued, cloth spine and paper-covered boards with coloured aquatint pasted on front board, 1831.

REFERENCES
Abbey, *Life* 524.

WH

PANORAMIC VIEW ROUND THE REGENT's PARK.

From Drawings taken on the Spot, by Richd. Morris, Author of Essays on Landscape Gardening.

Drawn by R. Morris

Engraved by S.H. Hughes

— PORTLAND PLACE. —

London

PUBLISHED BY R·ACKERMANN, 96, STRAND.

ALSO TO BE HAD OF

R·Ackermann, Junr. 191, Regent Street.

— 1831. —

COLOSSEUM.

CLERGY
ORPHAN SCHOOL ST ANDREWS PLACE. PARK SQUARE EAST. P

369

37. 'One of the largest and most splendid works which the literature and arts of this country has yet produced'

Thomas Lorraine McKenney, *History of the Indian Tribes of North America*
Philadelphia: F. W. Greenough, 1838–[44]

The original edition of McKenney and Hall's *History* was hailed in a contemporary report as 'one of the largest and most splendid works which the literature and arts of this country has yet produced'. The quality of its lithographs was such that it convinced John James Audubon to produce the second edition of *The Birds of America* in the same Philadelphia printshop. But the wealthy, leisured public that formed the market for lavishly illustrated works such as this in Europe barely existed in the US at this time. The two authors made little from their work and the project was beset by difficulties throughout its long gestation, including the bankruptcy of two of its four successive publishers.

Thomas Loraine McKenney was born in Maryland, the son of a Quaker merchant and banker. After service in the war of 1812, during which he appears to have attained the rank of colonel, he turned to a government career, becoming first Superintendent of Indian Trade and then head of the new Bureau of Indian Affairs. Though initially ignorant of the Native Americans, McKenney took an immediate interest in their culture and welfare, entertaining visitors to Washington at his home, encouraging the establishment of mission schools and even taking boys from various tribes into his household to oversee their education. His *Sketches of a Tour to the Lakes* (1827) recorded his visit to the Chippewa on the shore of Lake Superior and included detailed notes on their way of life and beliefs.

Alongside the official duties of his post, McKenney found time to amass a museum of Indian artefacts, including weapons, canoes and an elk. He also commissioned the painter Charles Bird King (1785–1844) to produce portraits of the Indian chiefs who came to Washington for treaty negotiations, expanding the collection with likenesses sent in from the Indian territories. The complete gallery appears to have numbered around 200 pictures, and it soon became an object of curiosity among visitors and controversy among Congressmen, who resented the amount it had cost. More than one visitor suggested that the collection should be published, and in 1829 McKenney formed a partnership with the Philadelphia printer Samuel F. Bradford. One hundred and twenty of the portraits were to be reproduced by lithography, accompanied by a historical introduction and biographical details of each of the subjects. The whole was to be issued in 20 parts, containing six portraits each.

McKenney was sanguine about the likely returns. He claimed there were six English noblemen who would each pay $100,000 for the collection, and considerable profits could be made from simultaneous publication in Europe. Six trial lithographs were produced by the newly established firm of Childs and Inman in 1830, and proofs of the historical introduction were sent to former president John Quincy Adams for correction in 1831. Progress was slow, however, and in late 1832 Samuel Bradford, who as publisher was to bear the full costs of production, went bankrupt. The first number, still incomplete, had cost $1250 to produce in an edition of 400 copies, and as yet there were only 104 subscribers. Bradford's place was taken by Edward C. Biddle and John Key, the latter withdrawing two years later to leave Biddle acting alone. Meanwhile the lithographers Childs and Inman, also in difficulties, had become Childs and Lehman, then Lehman and Duval. Seven years after the launch of the project, nothing had been published.

McKenney needed a partner with means and application, and in 1836 the Cincinnati jurist James Hall joined the project to write the biographies. He was surprised to find how little had been done, the first number still only part written, and materials for the remainder sparse or non-existent. 'My friend the Col.', Hall wrote later, 'was as lazy a man as ever lived, and as unreliable a mortal as ever made big promises.' Under Hall's impetus the

project revived, and numbers finally began to appear in 1837. Critical opinion was laudatory, and the subscription list swelled to 1250. Despite this, the problems continued. Lehman and Duval withdrew after the appearance of the sixth number, to be replaced by J.T. Bowen, who moved his firm to Philadelphia from New York. Biddle stepped down as publisher the following year, to be replaced by Frederick W. Greenough. Then a depression in the late 1830s hit subscriber numbers, and publication ceased after the thirteenth part in 1838. By the time it began again in 1841, Greenough was bankrupt and McKenney was alienated from the project. The remainder of the work, written by Hall alone, appeared under the imprint of Daniel Rice and James G. Clark.

Hall was later to lament that the great cost of the volumes had kept them out of the collections of all but public institutions and the very wealthy. Cheaper reprints followed, but the quality of the lithographs could not match those in the original edition. Since the original Indian portraits were destroyed in a fire at the Smithsonian in 1865, the *History* now stands as what McKenney always intended – a uniquely valuable memorial to a culture now largely disappeared, albeit seen through white American eyes.

BINDING
Half-goatskin, twentieth century.

REFERENCES
Joseph Blanck, *Bibliography of American Literature* (New Haven: Yale, 1955–) 6934; Joseph Sabin, *Bibliotheca Americana* (New York, J. Sabin, 1868–) 43410a; Herman J. Viola, *Thomas L. McKenney* (Chicago: Sage Books, 1974); Nicholas B. Wainwright, *Philadelphia in the Romantic Age of Lithography* (Philadelphia: Historical Society of Pennsylvania, 1958).

W H

38. Early daytrippers to Windsor

William Frederick Taylor, *A Short Description of Windsor Castle,
and a List of Paintings to be Seen in the State Apartments*
Windsor: published by W.F. Taylor, 1847

As Benton Seeley was quick to realise at Stowe (see no. 10), a local tourist attraction could potentially provide a very lucrative source of income for a small-town printer and publisher. This was certainly true of nineteenth-century Windsor, though Seeley's London rivals, the Bickhams, had in fact produced a tourist guide to Hampton Court and Windsor as early as 1742. There are very few copies extant of the Windsor guides issued by William Frederick Taylor, the proprietor of a subscription library in Windsor, who also issued guides to nearby Eton and Virginia Water. As with any very ephemeral publication, most copies must have perished long ago; none of them is cited in the standard bibliography of Windsor published in 1948.

There had been a regular coach service from London to Windsor since at least 1673, though in 1815 the journey still took four hours. The railway only arrived at Windsor in 1849, but from 1842 it was possible to take the train to Slough and pick up a connecting omnibus or carriage on to Windsor. Queen Victoria made the journey for the first time in 1844, covering the distance from Paddington station in about an hour. For her middle-class subjects, day trips from London were feasible for the first time and further improvements were already in sight, with the contract to take the line on to Windsor signed in 1847. Taylor's *Short Description of Windsor Castle* – less grandiose than the massive colour plate-books of the previous generation, but still handsome and attractive – was clearly aimed at this new and expanding market. Like many guidebooks before and since, it rather cleverly filled two niches. The cheaply produced pamphlet mounted on the inside front cover provided the practical information – including the all-important picture list – needed to guide the interested visitor around the sights of the

PROVENANCE
Bought for £50 at an unknown date.

BINDING
Gold- and blind-stamped bookcloth
as issued by the publisher, 1847.

REFERENCES
Maurice Bond, *A Guide to Books
about Windsor Castle and Borough*
([Windsor]: [privately printed],
[1946]); Henry Farrar, *Town and
Castle* (Chichester: Phillimore, 1990),
pp. 51, 98–9; Jane Roberts, *Royal
Landscape: The Gardens and Parks of
Windsor* (New Haven: Yale, 1997);
Jane Roberts, *Views of Windsor*
(London: Merrell Holberton, 1995),
pp. 16–17.

MP

castle. In tandem the 'elaborate panoramic view of the
Castle, six feet long' (an interesting point of comparison
with nos. 36 and 39) and hand-coloured, provided a spec-
tacular souvenir which could be perused and enjoyed at
leisure by the purchaser and his or her friends. Surviving
examples suggest that Taylor operated with some element
of mix-and-match, and that prospective purchasers could
buy the guide with or without the panorama, which is
the only part of the publication to be dated.

The panorama itself shows the south front of the
Upper Ward of the castle, the portion occupied by the
principal royal apartments, with the Round Tower at the
far left, and St George's Chapel and the Lower Ward out
of view. Wyattville's reconstruction for George IV, which
began in 1823, had been completed just seven years previ-
ously, in 1840; like many British traditions, Windsor was,
at least in part, a nineteenth-century invention.

If Lord Fairhaven's collection of Windsor books
is not so well known as the Windsor pictures which
hang on the walls of the Gallery designed for them
by Sir Albert Richardson, it is nonetheless of consider-
able interest. Aside from Ashmole's Order of the
Garter (see no. 6), the earliest book is John Pote's
History and Antiquities of Windsor Castle (Eton, 1749);
other highlights include a magnificent copy of W.H.
Pyne's *History of the Royal Residences* (1819), showing
the Charles II interiors before they were destroyed in
the rebuilding work by Wyattville, an extra-illustrated
copy of James Hakewill's *History of Windsor and its
Neighbourhood* (1813), as well as a wide range of popular
guidebooks and scholarly catalogues of the later
nineteenth and twentieth centuries, including –
appropriately enough – an 1893 catalogue of
bookbindings in the Royal Library.

39. The Iron Duke's funeral procession

Henry Alken Jr, *Funeral Procession of Arthur, Duke of Wellington*
London: published ... by R. Ackermann & Co., 1853

When the Iron Duke died in September 1852, his great age and his iconic status as Victorian England's pre-eminent national hero naturally required a great state funeral. Nelson had lain in state in the Royal Naval Hospital at Greenwich, before being borne to St Paul's for burial (see no. 20). Wellington's lying-in-state was at the Royal Hospital, Chelsea, but because Parliament was not in session when the Duke died, it was more than a month before the architect C.R. Cockerell was ordered to make the arrangements. In parallel, the Lord Chamberlain, Lord Exeter, was instructed to commission a magnificent funeral car, and first approached the architects Owen Jones and Digby Wyatt to request a vehicle which 'should do justice to the immense services of this illustrious individual and at the same time do credit to the taste of the artists of England'. Neither man was able to accept the commission, which was eventually given to administrator and inventor Henry Cole and artist Richard Redgrave, though Redgrave was later to admit that the designs were essentially the work of the great German neoclassical architect Gottfried Semper (1803–76), perhaps best known for the magnificent opera house of 1838–41 in Dresden, but since 1850 a political refugee in London. Drawings survive which suggest that Semper's role was, if anything, even more significant than his English colleagues gave him credit for. The completed car was 5.15m (17ft) high and 8.2m (27ft) long and was drawn by 12 black horses lent by Booth's gin distillery.

The ultimate precedent for a gigantic funeral chariot of the kind designed by Semper was the triumphal car which had carried the body of Alexander the Great from Babylon to Alexandria in 363 BC. Descriptions of this vehicle have survived from antiquity, and there were various attempts made to reconstruct it from the eighteenth century onwards, but there were also English precedents, notably the examples designed for the funerals of military heroes such as Cromwell (1658), Marlborough (1722) and, of course Nelson (1806).

Lord Fairhaven was especially interested in the Napoleonic era, but he was clearly also interested in the funeral obsequies of great men and women. His library includes a number of books on the subject, and the Anglesey Abbey print collection also contains engraved funeral processions of Princess Charlotte (1818) and Frederick, Duke of York (1820), a genre of publication ultimately derived from Renaissance models such as the printed funeral roll of the Emperor Charles V (1559), and the rather similar *Magnifique Entrée de François d'Anjou en sa Ville d'Anvers* (1582), both published in Antwerp by Christophe Plantin. So the Wellington funeral roll was a very late example of an unusual genre of publication with much earlier antecedents, and was in fact the very last thing issued by the Ackermann firm before its final dissolution in 1855. One would expect to find the individual sheets of lithographs jointed together, and the whole procession – over 20m (70ft) long – to be stored rolled up in a cylindrical box, but Fairhaven appears to have purchased the original proofs, which remain separate and are stored flat in the box which was probably made for him.

BINDING
Unbound in purpose-made box, signed 'Robson and Co. Ltd 7 Hanover Street W1'.

REFERENCES
Abbey, *Life* 597; Bunt, p. 43; Ford, pp. 141–6; Leopold

Ettinger, 'The Duke of Wellington's Funeral Car', *Journal of the Warburg and Courtauld Institutes*, III (1939–40), pp. 254–9.

MP

THE FUNERAL CAR DRAWN BY 12 HORSES. IO BANNEROLS BORNE BY OFFICERS.

40. A Royal Wedding at Windsor, 1863

'Windsor – Royal Wedding – 1863'
[spine title]
The Letters of Queen Victoria [First/second series]
London: John Murray, 1907–28 [extra-illustrated copy]

The wedding of the future Edward VII to Princess Alexandra did not pass off entirely smoothly. The princess's carriage was so mobbed by the enthusiastic populace that progress through the streets of London was slow and hazardous, and there was some resentment among the higher ranks of society that the service itself took place away from the capital, in St George's Chapel, Windsor, where there was limited room for invited guests. As with more recent royal weddings, manufac-turers and retailers were eager to exploit the happy event, and the back pages of the newspapers of the day bristled with advertisements for trinkets, prints and songs in honour of the occasion. This set of 20 unsigned coloured lithographs was doubtless intended to appeal to the higher end of the collecting market. It depicts events during 5–10 March 1863, starting with the arrival of the princess in the royal yacht at Margate, followed by the procession, the reception at Eton and Windsor, and the marriage itself. Even at this high point of the Gothic Revival in England, the triumphal arches and decorations have a largely classical air, and the publication takes its place as a late example of the pictorial commemoration of a great national procession, such as the funeral of Wellington (see no. 39) and its Renaissance antecedents.

The practice of adding illustrations to an individual copy of a book from other sources is almost as old as the book itself. Most great libraries have examples of manuscripts enhanced with printed illustrations, while sets of woodcuts, often on religious themes, were issued for the purpose from the earliest days of printing. In the seventeenth century, English booksellers retailed collections of such prints suitable for binding into the rather austere English Bibles of the time. But it was James Granger, with the publication of his *Biographical History of England* in 1769, who inadvertently popularised the practice among book collectors and who contributed his name to the result in the term 'grangerised'.

Granger's *Biographical History* was in fact never intended to be grangerised. The full title describes it as 'an Essay towards reducing our Biography to System, and a Help to the Knowledge of Portraits'. Granger intended it to be used as a directory for the collection of portrait prints, but did not envisage that the prints would be bound into the book itself. It was a contemporary, Richard Bull, who produced the first grangerised Granger by cutting up two copies of the work and mounting the printed text around an extensive collection of portrait prints of the subjects. The practice rapidly caught on, becoming particularly popular for topographical works, the Bible and editions of Shakespeare. Perhaps one of the most remarkable grangerised works was the enormous Macklin Bible, formerly in the library founded in Truro by Henry Philpotts, bishop of Exeter. Originally issued in seven volumes between 1791 and 1824, this had been enlarged to 63 volumes, the whole weighing more than half a ton, by the addition of more than 9,500 prints and drawings.

Windsor Castle. 10th March 1863.

Admit ONE TO THE LOWER COURT.

ENTRANCE AT HENRY VIII. GATE.

NOT LATER THAN
A QUARTER PAST ELEVEN
O'CLOCK

S.t Germans

ROOF OF
NEW GUARD ROOM.

Lord Steward.

Order for admission to Windsor to the marriage of the Prince and Princess of Wales.

BINDING
(Wedding) Half-goatskin
with marbled paper boards,
twentieth century
(*Letters*) Gilt-tooled goatskin,
signed by Sangorski & Sutcliffe,
twentieth century.

REFERENCES
Bunt, p. 106.

W H

Lord Fairhaven's copy of *The Letters of Queen Victoria* is not on such a heroic scale. The six volumes of the first two series (a third series was issued between 1930 and 1932) have merely been doubled to 12. As well as portraits, the additions include a large number of autograph letters from people mentioned in the text, including the politican Thomas Spring-Rice, author Agnes Strickland and statesman Sir Robert Peel. These reflect a fashion for autograph collecting which flourished in parallel with that of grangerising with portraits, reaching a peak in the late nineteenth century. Both crazes attracted severe criticism, portrait collecting because it involved the dismemberment of other volumes to remove the engravings, and autograph collecting because letters were removed from archive collections and scattered far and wide. These volumes were made after the height of the grangerising craze; perhaps most interesting of all their contents to a later generation are the contemporary ephemera, such as menu cards, the announcement of the fall of Sebastopol and the entrance ticket to the Prince of Wales's wedding service.

The volumes have been sumptuously rebound in full blue crushed levant morocco by Sangorski & Sutcliffe (see no. 42) and bear the bookplate of Annie Cowdray (1860–1932), society hostess and supporter of women's suffrage, and wife of the oil magnate Sir Weetman Pearson, who was created Viscount Cowdray in 1917.

41. An autograph manuscript of 'Onward, Christian Soldiers'

Sabine Baring-Gould, 'Onward, Christian Soldiers'
[Autograph manuscript, *c.* 1920]

The need to provide for a family large even by Victorian standards drove Sabine Baring-Gould to write more than 30 novels and a huge quantity of non-fiction, including works of hagiography, church history, archaeology, travel and folklore. But it is by his hymns and carols that the rector of Lew Trenchard in Devon is most widely known today, and at the head of these stands his 'war-song of the Church Militant', 'Onward, Christian Soldiers'.

In later years Baring-Gould claimed that the hymn had been written in haste in 1865 for the children of Horbury Brig Mission to sing on their Whitsun procession to the parish church. Baring-Gould had become curate at Horbury near Wakefield the previous year, and was almost immediately entrusted with establishing a mission at the Brig, a wild and lawless district more noted for dog-fighting and drunkenness than church attendance. Physically commanding and a charismatic preacher, Baring-Gould rented a cottage in the centre of the township, established night-schools, a savings bank and a choir, and held services at which he presided from the fender of the upstairs room, the congregation filling both floors and spilling out into the street. 'Onward, Christian Soldiers' was certainly sung at Horbury, along with other hymns by Baring-Gould, but it had in fact been written the previous year and was first published in the *Church Times* in October 1864.

The hymn was originally sung to a tune adapted from Haydn, but its fame in after years is at least partly owing to the tune 'St Gertrude' which Arthur Sullivan wrote for it in 1871. The result, daringly bringing the tones of a marching band into the church precincts, may be one of the most famous of Victorian hymns, but it has not always been one of the most admired. In Baring-Gould's own time the words 'With the Cross of Jesus / Going on before' suggested popish ceremonial to Low Church worshippers (the tale that the author offered to change the couplet to 'With the Cross of Jesus / Left behind the door' to appease an evangelical bishop is, however, without foundation). Later ages have been repelled by the hymn's warlike imagery, though it is hardly Baring-Gould's fault that his metaphorical army of the Church of God has too easily been confused with the literal armies of Empire and two World Wars. Sullivan cannot have helped matters by tastelessly incorporating the tune into the finale of the *Te Deum* he wrote in 1900 in anticipation of British victory in the Boer War. Baring-Gould seems to have had mixed feelings about his work, writing later to his daughter, concerning a party of Methodists who were due to visit: 'I hope they will not depart singing "We are not divided, all One Body We" for it would be a lie.'

Originally the hymn contained six verses, but when it was included in the 1868 Appendix to *Hymns Ancient and Modern*, the fourth verse, beginning 'What the Saints established / That I hold for true' was omitted; it has rarely been sung since. This manuscript copy also omits that verse and must therefore date from after this period. Baring-Gould's grandson records that late in life the author was offered a dollar by an American dealer for every copy he produced of one of his hymns; this is doubtless one of the copies made then. Similar examples still appear in the salerooms from time to time, and there are copies in various public collections, including the Pierpoint Morgan Library in New York, Syracuse University Library, and Exeter Cathedral Library.

PROVENANCE
Bought from Maggs Bros.,
early 1920s?

BINDING
In a quarter-goatskin slipcase,
twentieth century.

REFERENCES
Barker 113; Bickford H.C.
Dickinson, *Sabine Baring-
Gould: Squarson, Writer and
Folklorist, 1834–1924* (Newton
Abbot: David & Charles, 1970);
William Purcell, *Onward
Christian Soldier: A Life of
Sabine Baring-Gould, Parson,
Squire, Novelist, Antiquary, 1834–
1924* (London: Longmans,
Green, 1957).

WH

42. Mosaic bindings in Wonderland

Lewis Carroll, *Alice's Adventures in Wonderland*
London: Macmillan, 1871
Lewis Carroll, *Through the Looking-Glass*
London: Macmillan, 1878

Francis Sangorski (1875–1912) and George Sutcliffe (1878–1943) met as bookbinding students in London in 1896, at classes taught by Douglas Cockerell, one of the leading craft binders at the turn of the twentieth century. After winning scholarships to continue their training, they were taken on by Cockerell himself, but were laid off in 1901 when a coal strike led to an economic downturn. They decided to establish their own bindery, which soon acquired a reputation for producing high-quality work; by 1905 they were able to set up shop in Southampton Row. In 1911 they famously produced an extravagantly decorated and bejewelled binding on a copy of *The Rubáiyát of Omar Khayyám*, which was lost on the *Titanic*. Sangorski drowned soon afterwards in a separate accident, but the bindery was continued by Sutcliffe and by 1920 it was employing over 80 staff. In 1936, after suffering a stroke, Sutcliffe handed over the running of the business to his nephew Stanley Bray (1907–95), and despite a series of mergers

and realignments the name of the firm survived and it continues to operate today.

The binding on Alberto Sangorski's calligraphic Gray's *Elegy* is described below (see no. 47); the numerous other signed Sangorski & Sutcliffe bindings on Anglesey's shelves include these companion volumes of Lewis Carroll's two well-known classics, *Alice's Adventures in Wonderland* and *Through the Looking-Glass*. They are neither of them first editions, but standard trade editions issued within ten years of first publication, re-bound with their original decorated cloth covers preserved inside. The style is straightforwardly pictorial, using inlaid multicoloured leather to create scenes on the covers that reflect aspects of the stories. In line with the convention common in high-end binderies throughout the nineteenth century and into the twentieth, previous ownership inscriptions were washed out of the leaves as part of the rebinding process, but can be faintly seen still in each volume.

BINDING
Red goatskin, with multi-coloured inlays creating pictorial scenes; watered-silk endleaves. Signed, 'Designed and bound by Sangorski & Sutcliffe London'.

REFERENCES
Nixon and Foot.

DP

43. Two Wagnerian bindings

Richard Wagner, tr. T.W. Rolleston,
Tannhäuser: A Dramatic Poem …
Presented by Willy Pogàny
London: G.G. Harrap, [1911]

Richard Wagner, tr. T.W. Rolleston, *The Tale of*
Lohengrin, Knight of the Swan, after the Drama of
Richard Wagner … Presented by Willy Pogàny
London: G.G. Harrap, 1913

After several decades of struggle against poverty, indifferent audiences and European politics, the composer Richard Wagner finally came into his own in the 1860s, when the new king of Bavaria, Ludwig II, threw him the lifeline he needed. With Ludwig's patronage, Wagner's career blossomed; his operas were performed, his theatre at Bayreuth was built, and by the time he died in 1883 he was something of an international celebrity. In the decades following his death, the Wagner industry continued to expand, with numerous publications devoted to his life and works, including specially illustrated editions

of his operatic texts, by leading book artists of the time. Arthur Rackham's series of pictures for Wagner's *Ring Cycle* is well known; another illustrator who used Wagner depictions to help to make his name was Willy Pogàny (1882–1955), who was born in Hungary and studied in Munich and Paris before coming to London shortly before the First World War. His Art-Nouveau-style illustrated versions of three Wagner operas, *Tannhäuser*, *Parsifal* and *Lohengrin*, published in London between 1911 and 1913, together with a 1910 version of Coleridge's poem *The Rime of the Ancient Mariner*, are often described as his masterpieces. He left England for the USA shortly afterwards and had a successful career as an illustrator for books and magazines and a Hollywood set designer.

Anglesey Abbey Library has copies of *Tannhäuser* and *Lohengrin*, each luxuriously bound. *Tannhäuser* is in red goatskin with an onlaid green border; the covers are gilt-tooled all over with a pattern based on floral and foliage designs, reminiscent of the kind of work inspired by the Arts and Crafts bookbinder Thomas Cobden-Sanderson (compare the similar, but rather more delicate, design on Gray's *Elegy*, see no. 47). *Lohengrin*'s red goatskin is left plain, apart from a busy central design on the front board, made up of multicoloured leather onlays and depicting motifs from the opera – a swan, a chalice, a shield. Both bindings are signed 'Bumpus Ltd, Oxford Street', but were probably the work of one of the major London West End binderies, or possibly Bayntun's of Bath. The Bumpus firm, founded in Clerkenwell around 1790 by Thomas Bumpus (1754–1832), flourished during the nineteenth century as booksellers and publishers, moving first to Holborn and then to Oxford Street, where by the turn of the twentieth century it had become one of the pre-eminent London booksellers, which regularly commissioned binding work from a range of leading contemporary workshops.

BINDING
Red goatskin, gilt-tooled, with pictorial central decoration on front cover made up from gilt-tooled multicoloured goatskin onlays. Watered-silk endleaves, with gilt-tooled goatskin turn-ins.

REFERENCES
Richard Wagner, tr. R. Rolleston, *The Tale of Lohengrin, Knight of the Swan, after the Drama of Richard Wagner ... Presented by Willy Pogàny* (London: G. G. Harrap, 1913).

DP

44. 'I hate bibliophiles'

T.E. Lawrence, *The Seven Pillars of Wisdom*
London: [privately printed], 1926

'I hate bibliophiles', Lawrence claimed in a letter to Edward Garnett, 'and did my best to throw them off the track with the SP, so I did not number my copies, or declare how large the edition was ... or have a standard binding, or signatures, or index, or anything posh.' A surprising declaration from someone who, as an undergraduate, had hatched grandly romantic schemes for producing editions of the classics bound in dyed vellum, to be printed on a handpress sited in a windmill built on a headland washed by the sea.

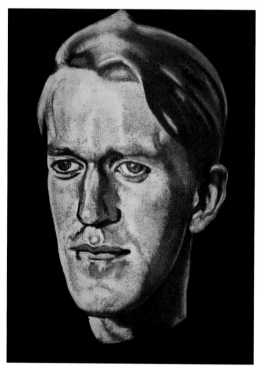

Lawrence's epic narrative of his war career in the Middle East was a long time coming to print. The first draft dated from 1919, but was allegedly lost on Reading station. Lawrence re-wrote it in great haste, mainly in rooms belonging to the architect Sir Herbert Baker. The new text came to some 400,000 words; Lawrence re-wrote it again over nearly two years, reducing it by around 70,000 words and completing it in May 1922. Eight copies of this version were then set in type on the presses of *The Oxford Times* for circulation among friends.

Insecure about his abilities as a writer, and aware that the memoirs were likely to prove controversial, Lawrence decided in late 1923 on publication in a high-priced limited edition. He claimed, 'I'm aiming at a public that will pay but not read ... and from what one hears the plutocrats should be of that sort.' He had retained his interest in fine printing, and after the war had come close to establishing a press with his friend Vyvyan Richards

at Pole Hill in Essex. To him Lawrence had expressed his ambition to produce 'the best book in modern times', and to some extent he set out to realise this ambition in *The Seven Pillars*.

The process of printing took two years, Lawrence cutting and altering his text as it progressed to produce a printed page that accorded with his particular views on book design. He had engaged the artist Eric Kennington to provide illustrations as early as 1920; the finished book was to include work by 18 different artists, ranging from the society portraitist John Singer Sargent to the Vorticist William Roberts. When printing was finally finished in summer 1926, all 170 copies of the complete edition were bound differently by a variety of different binders, supposedly to make it impossible to distinguish earlier from later issues.

Obfuscatory steps such as this only served to increase the mystique and desirability of the book. The subscribers' price was high for the time, at 30 guineas, but a year after publication a copy fetched £570 at auction. Not everyone was pleased with the result; Herbert Baker called the edition 'an expensive parade of eccentricity and bad taste'. The huge project cost £13,000 and an abridged edition, re-titled *Revolt in the Desert*, was issued to pay off the costs. The complete work was not re-published until July 1935, shortly after Lawrence's death, in a slightly edited form. Such was its author's celebrity that it had sold 100,000 by December of that year.

PROVENANCE
Purchased from Charles
Sawyer, January 1945, for £220.

BINDING
Gilt- and blind-tooled brown
goatskin, by Sangorski &
Sutcliffe, 1926.

REFERENCES
Barker 121; T. German-Reed,
*Bibliographical Notes on T.E.
Lawrence's* Seven Pillars of
Wisdom (London: Foyle, 1928);
Lawrence James, *The Golden
Warrior: The Life and Legend of
Lawrence of Arabia* (rev. edn,
London: Abacus, 1995); Philip
M. O'Brien, *T.E. Lawrence: a
Bibliography* (2nd edn, New
Castle: Oak Knoll, 2000),
A040); Philip M. O'Brien, *T.E.
Lawrence and Fine Printing*
(Buffalo: Hillside Press, 1980);
Jeremy Wilson, 'Seven Pillars of
Wisdom: triumph and tragedy',
T.E. Lawrence Studies [online],
2006 <telawrencestudies.org>;
Jeremy Wilson, *Lawrence of
Arabia: The Authorised
Biography of T. E. Lawrence*
(London: Heinemann, 1989).

WH

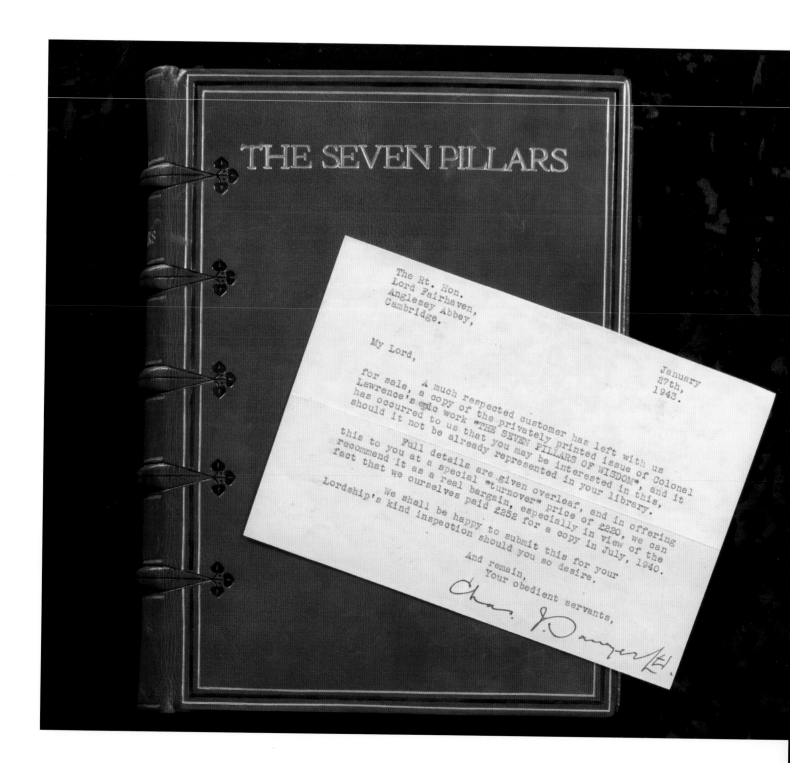

45. A jewelled binding by Zaehnsdorf

The Life Guards: Historical Records, Battle Honours and Poetical Tributes
[Calligraphic manuscript on vellum, written and illuminated by Alberto Sangorski, 1922]

The name Zaehnsdorf came to be associated with luxury bookbinding in Britain in the middle of the nineteenth century. Joseph Zaehnsdorf (1814–86) was born in Pest, Hungary, and learned the binder's trade there before travelling across Europe and working with binders in Vienna, Zürich, Paris and elsewhere. He ended his journey in London in 1837, where he soon established a binding workshop of his own in Covent Garden. He married an Englishwoman, steadily built a reputation and a clientele, and by the 1860s was winning medals at international exhibitions and styling himself 'bookbinder to the King of Hanover'.

After his death, the business was carried on by his son, Joseph William Zaehnsdorf (1853–1930), who expanded it and assured its place as one of the top West End firms of the early twentieth century. The firm

held a royal warrant as bookbinders to both Edward VII and George V, and their customer base extended beyond England to Europe and the USA. The younger Zaehnsdorf took advantage of the growing interest in hand-binding fostered by Thomas Cobden-Sanderson and the Arts and Crafts movement, by advertising courses in bookbinding and by publishing a manual on *The Art of Bookbinding*, first issued in 1880 and regularly reprinted. The dynastic succession continued in 1920, when Joseph William handed over the running of the business to his son Ernest Zaehnsdorf (1879–1970). After his retirement in 1947, it passed through various hands and in 1998 was combined with Sangorski & Sutcliffe.

The book shown here, signed 'specially bound by Zaehnsdorf 1922', is one of the most imposing – and weighty – modern bindings on the Anglesey Abbey shelves; it also seems to have been one of Lord Fairhaven's earlier acquisitions, and was certainly in his library by 1925. It covers another of Alberto Sangorski's specially handwritten and illuminated calligraphic manuscripts, on vellum, telling the history of the Life Guards (see also nos. 42 and 47). The book has thick wooden boards, covered in red goatskin with inlays, gilt-tooled with a simple design including crowns and Tudor roses, and with a central oval panel on the front, into which is sunk a gilt and enamel medallion of the regimental badge. Lord Fairhaven served in the Life Guards from 1916 to 1924, and it is clear that his association with the regiment was something special to him; his portrait in full-dress uniform, commissioned in 1925, hangs at Anglesey today. The Life Guards is the senior regiment of the British Army, dating its origins back to troops raised by Charles II in the 1650s and 1660s. Organised as two regiments between the late eighteenth century and the First World War, they were formally amalgamated into one regiment in 1922 and are now part of the Household Cavalry.

An Incident at the Battle of Waterloo.

CAPTAIN KELLY of the 1st Life Guards encountered the Colonel of the 1st Regiment of Cuirassiers, and killing him, stripped the epaulettes off the body carrying them off as a trophy. This officer had been previously wounded in the first charge, when he was nearly taken prisoner. He, however, survived the battle, exchanging into the 3rd Light Dragoons, and went as aide-de-camp to Lord Combermere in India, where he died of fever at the siege of Bhurtpore in 1828.

BINDING
Red goatskin over wooden
boards, with blue and black
goatskin inlays, gilt-tooled;
enamel medallion sunk into
central oval panel of front
board. Watered-silk endleaves,
with gilt-tooled goatskin
turn-ins.

REFERENCES
Frank Broomhead, *The
Zaehnsdorfs (1842–1947): Craft
Bookbinders* (Pinner: Private
Libraries Association, 1986);
Huttleston Broughton, 1st Lord
Fairhaven, *The Dress of the First
Regiment of Life Guards in Three
Centuries* (London: Hatton &
Truscott Scott, 1925), p. 36.

DP

46. Two Cosway bindings

William Henry Ireland, *The Life of Napoleon Bonaparte*
London: printed and published
by John Fairburn, 1823

G.H. Wheeler (ed.), *Letters of Sir Thomas Bodley to Thomas James*
Oxford: Clarendon Press, 1926

A 'Cosway binding' is the name given to a distinctive style of bookbinding, created around the turn of the twentieth century, devised to appeal to wealthy collectors who wished to indulge in some ostentatious luxury. These bindings were made of the best materials and elaborately gilt-tooled, with the defining finishing touch of a hand-painted miniature inlaid at the centre of the front cover. The miniatures were individually made for each book, and typically depicted the subject or author.

The style was invented and named by the London bookselling firm of Sotheran's, and numerous examples were offered for sale in their catalogues during the first four decades of the twentieth century. The earliest known one dates from 1902, and by 1930 it was claimed that over 900 such bindings had been made. The name was inspired by the English artist Richard Cosway (1740–1821), who was famous for his portrait miniatures. Sotheran's commissioned the bindings from several top firms of the day, including George Bayntun, Sangorski & Sutcliffe, and Robert Rivière & Son, and the miniatures, painted on ivory, were the work of Miss C.B. Currie, who also specialised in adding fore-edge paintings to

bindings. Prices typically varied between £20 and £60, depending on the elaborateness of the binding.

To modern eyes, these bindings seem aesthetically clumsy, the triumph of ingenuity (and expense) over good taste, but they had a following at the time. According to Sotheran's catalogue 812 (1928), they 'take a long time to produce, but they sell very quickly'. Lord Fairhaven was evidently taken by them, as there are 15 on the shelves at Anglesey Abbey today. The two illustrated here are representative examples. The *Letters of Sir Thomas Bodley* has a miniature portrait of Bodley inset within boards which are heavily gilt, but to a simple pattern, and overall seems one of the more successful designs achieved with Cosway bindings. *The Life of Napoleon* belongs at the other end of the scale; each volume has a different miniature, copied from famous paintings of scenes from Napoleon's life, set within a frame edged with pearls. Coupled with the elaborate floral design round the outer border, the effect is one of saccharine extravagance. Whether we like them or not, however, they are beautifully preserved examples of this particular slice of early twentieth-century bookbinding history.

BINDING
(*Bonaparte*) Gilt-tooled blue goatskin with red goatskin and jewelled inlays and central inlaid miniature of Napoleon on his warhorse, watered-silk endleaves. Signed by Bayntun. (*Bodley*) Gilt-tooled blue goatskin with inlaid miniature of Sir Thomas Bodley on front board, blue watered-silk endleaves, *c.* 1926. Signed by Rivière.

REFERENCES
Nixon and Foot, p. 112, fig. 124; H.M. Nixon, 'Cosway Binding, *c.* 1928', no. 100 in H.M. Nixon, *Five Centuries of English Bookbinding* (Aldershot: Scolar Press, 1978).

DP

THE LIFE
OF
NAPOLEON

EXCELLMANNS

VOL. III

EXTRA ILLUSTRATED
1828

47. A floral binding by Sangorski & Sutcliffe

Thomas Gray, *Elegy written in a Country Churchyard*
[Calligraphic manuscript on vellum, written and
illuminated by Alberto Sangorski, *c.* 1925]

Bookbinding, like all other aspects of the book trade, was transformed during the nineteenth century through mechanisation and the introduction of new techniques. What used to be a handcrafted process, carried out in small workshops, came to be undertaken on a more industrial scale, with prefabricated cloth binding cases made in great quantities for ever-growing edition sizes. These new types of binding developed a lively decorative culture of their own, with some striking designs made for blocking onto binders' cloth, while the traditional skills in tooling leather-covered bindings suffered something of a decline, continuing to be carried out, but without much flair.

The man who is widely acknowledged as having regenerated bookbinding in Britain at the end of the nineteenth century, and set in train the modern rediscovery of binding as an art form, is Thomas Cobden-Sanderson (1840–1922). After some rather unhappy years spent as a lawyer, he was inspired by William Morris's wife, Jane, to take up bookbinding, and after training with a professional firm in 1884 he began working independently. The bindings he produced himself, or which were made to his designs at the Doves bindery which he founded, have been admired and collected ever since. Exquisitely crafted, they typically incorporate intricate but delicate patterns, inspired by roses or similar foliage, covering the boards with intertwining stems reminiscent of a summer garden in full bloom.

Lord Fairhaven did not own any bindings by Cobden-Sanderson, but many of his fine modern bindings grew out of the tradition thus re-established for beautifully produced, handmade, leather bindings. The example here is the one from Anglesey's shelves which is perhaps most reminiscent of a Cobden-Sanderson design; its intense floral pattern, achieved by the meticulous placing of small gilt tools and multi-coloured leather onlays, is simple, naturalistic and spectacular. It was made by the firm of Sangorski & Sutcliffe, one of the leading London West End binderies of the early twentieth century (see no. 42). The binding here is very much a family production, as it covers a manuscript copy of Gray's *Elegy* (see also no. 11) written and illuminated by Francis Sangorski's elder brother Alberto (1862–1932), who specialised in this kind of high-end calligraphy. Lord Fairhaven paid the very considerable sum of £150 for this book.

BINDING
Blue goatskin, with white, red and green goatskin onlays, elaborately gilt-tooled. Watered-silk endleaves, with gilt-tooled goatskin turn-ins. The lower board is decorated to a simpler pattern.

REFERENCES
Wormsley 91–2; Roy Harley Lewis, *Fine Bookbinding in the Twentieth Century* (Newton Abbot: David & Charles, 1984), pp. 20–4.

DP

The spine reads:

ELEGY WRITTEN IN A COUNTRY CHURCH-YARD

BY THOMAS GRAY

48. An armorial binding for Lord Fairhaven

Clive Bigham, 2nd Viscount Mersey, *The Kings of England 1066–1901*
London: John Murray, 1929

Coats of arms and other armorial devices are familiar to us from letterheads and various kinds of public signage, but heraldry is taken less seriously today than was the case in the past; corporate logos have taken over as the ubiquitous graphic badges of identity. In earlier times, quite apart from the medieval usefulness of painted arms for distinguishing enemies on a battlefield, heraldry came to be eagerly pursued as a means of demonstrating social status. Throughout the early modern period, a family coat of arms and the right to display it was a mark of gentry or noble rank, in a society which cared about such things. Seventeenth-century antiquaries spent many hours researching their ancestors, so as to demonstrate their entitlement to complex and impressive coats of arms, while the College of Arms in London, as the central regulating body, sent heralds around the country on visitations to check that arms were being used legitimately.

It followed that gentlemen were eager to display their arms wherever they could, around their property and on domestic objects. Books provided good opportunities for this, as armorial bearings could be used to good effect both on bookplates and on bindings. The idea of decorating the outside of a book with its owner's coat of arms can be traced back to medieval times and grew in popularity during the sixteenth century. The earliest English examples are mostly royal ones, with the royal arms found on books intended for the libraries of

Henry VIII or Edward VI, but the practice spread to the aristocracy and gentry during the second half of the sixteenth century. By 1600, armorial binding stamps were increasingly being used by book owners, and the practice remained popular for as long as books were being made and bound as a handcrafted process. The introduction of mechanisation and the mass production of publishers' bindings during the nineteenth century led to the declining use of personal armorial stamps, and armorial bindings from that time and later are more typically found on school prizes.

Lord Fairhaven is quite unusual, therefore, as a twentieth-century collector who commissioned and used a personal armorial binding stamp for his books. The modern books at Anglesey are variously found in publishers' bindings, as issued, or in more handsome full- or half-leather bindings, added to enhance the luxury of the library shelves. Some of these leather bindings are further decorated with a large oval stamp, applied in gold, featuring Fairhaven's arms (in the language of heraldic blazon, *Argent two bars in dexter chief a saltire couped gules; supporters, two winged bulls gorged with chains the arms of Broughton hanging from them; coronet of a Baron*). The stamp seems to have been used quite sparingly, and is found selectively on early-twentieth-century full-leather bindings, particularly on books which were presentation copies to Fairhaven.

PROVENANCE
Presentation copy from the author to Lord Fairhaven.

BINDING
Red goatskin, gilt-tooled, by Robson & Co., incorporating the central gilt armorial stamp of Lord Fairhaven, early twentieth century.

DP

49. The Gregynog *Eros and Psyche*

Robert Bridges, *Eros and Psyche*
Gregynog Press, 1935

The Gregynog Press was founded in 1922 at Gregynog Hall, a mock-Tudor mansion in Montgomeryshire. The Hall had been bought two years earlier by Gwendoline and Margaret Davies, two sisters whose considerable wealth had come from their grandfather's work in railways and coal mines. Their plan was a high-minded one, typical of the time: the Hall was to become a craft centre for ex-servicemen and others affected by the First World War; there was to be weaving and pottery, printing and music. In the event the pottery and weaving were never established and Gregynog became almost exclusively a centre for book-making, with music festivals in the summer at which Ralph Vaughan Williams conducted and for which Gustav Holst composed music.

The press was unusual among private presses, in that its owners took no direct hand in its operation but governed it through a board of directors. This frequently resulted in friction with the artists and craftsmen who were employed to do the actual printing and decoration of the books. Towards the end of the press's period of operation, in 1940, Thomas Jones, Cabinet Secretary and chairman of the board, lamented that they had managed to part on good terms with only one of their senior staff. By the mid-1930s the press was on its third 'controller', the American Loyd Haberly (1896–1981).

Haberly was the only one of the Gregynog controllers with previous experience of printing. He had previously built and run the Seven Acres Press at Long Crendon in Buckinghamshire, on which he had printed volumes of his own verse. As a young man he had met Robert Bridges and the veteran poet, some of whose early works had been printed by the private Daniel Press in Oxford, had expressed the hope that his *Eros and Psyche* (1885) would one day be printed with the woodcuts which Edward Burne-Jones had devised for William Morris's *The Earthly Paradise*.

Morris had conceived the scheme for his long poem around 1865. It was to be printed in a large folio volume with high-quality typography and Burne-Jones's illustrations. The artist made designs for the 'Cupid and Psyche' episode of the poem, founding his style on woodcuts in early printed books, and Morris and others cut woodblocks from them. Prototype pages, however, were unsatisfactory. It was a quarter of a century before Morris founded the Kelmscott Press, and even the best typography of the period could not produce a good effect with the robust lines of the woodcuts that Burne-Jones and Morris had produced. When *The Earthly Paradise* was published between 1868 and 1870, it was in a conventionally produced edition without illustrations.

When Haberly was appointed controller at Gregynog, he decided to produce a book in which the Burne-Jones woodcuts would be combined with Bridges's verse as the poet had proposed. The original woodblocks were not available, so new ones had to be made from tracings held by the Ruskin School of Drawing in Oxford. For the type Haberly went back much further, selecting one modelled on that used in the 1472 Foligno edition of Dante's *La divina commedia*. This, the only type devised for Gregynog, was designed by the calligrapher Graily Hewitt (1864–1952), who also provided the initials used in the book. The result was not generally well received; the type was thought eccentric and too heavy for the illustrations, which themselves seemed somewhat anaemic compared to the originals. We can imagine, however, that their discreet eroticism might have appealed to a collector of Etty nudes such as Lord Fairhaven. Morris's woodblocks were bequeathed to the Society of Antiquaries of London by May Morris in 1940, and were finally used to print an edition of Morris's *Cupid and Psyche* by the Rampant Lions Press in 1974, when they found their perfect match in Morris's own Troy type.

EROS AND PSYCHE

A POEM IN XII MEASURES
BY ROBERT BRIDGES : WITH
WOOD-CUTS FROM DESIGNS
BY EDWARD BURNE-JONES
GREGYNOG
MCMXXXV

BINDING
Gilt-tooled white pigskin, 1935,
by the Gregynog bindery, with
finishing by John Ewart Bowen
(1915–2004).

REFERENCES
Steven A. Bakker and Erik J.
Warmenhoven, *The Miss
Margaret Sydney Davies
Collection of Special Gregynog
Bindings* (Antwerp: De
Zilverdistel Rare Books, 1995)
33; Roderick Cave, *The Private
Press* (2nd edn, New York &
London: R.R. Bowker, 1983);
Colin Franklin, *The Private
Presses* (2nd edn, Aldershot:
Scolar Press, 1991); Dorothy
A. Harrop, *A History of the
Gregynog Press* (Pinner: Private
Libraries Association, 1980) 33;
Thomas Jones, *The Gregynog
Press: A Paper Read to the Double
Crown Club* (Oxford: Oxford
University Press, 1954) 33;
William Morris, *The Story of
Cupid and Psyche* (London:
Clover Hill Editions, 1974);
Will Ransom, *Selective Check
Lists of Press Books* (New York:
C.P. Duschnes, 1963), p. 157, 33.

W H

OCTOBER

50. *You Only Live Twice*

Ian Fleming, *You Only Live Twice*
London: Jonathan Cape, 1964

1964 was a good year for James Bond. Fleming's hero had had his profile raised by the American president John F. Kennedy, who cited *From Russia with Love* as one of his favourite books, and by the success of *Dr No* (1962) and *From Russia with Love* (1963), the first two of the unstoppable sequence of Bond films. In 1964 Bond returned to the screen in *Goldfinger*, regarded as one of the best of the series, and which has an unexpected connection with Anglesey Abbey. Two years previously, Lord Fairhaven had sold his 1937 Rolls Royce Phantom III; it was bought by EON Films, and appears in the film in the role of Auric Goldfinger's car. A celebrated sequence shows the Rolls being stripped of its bodywork, which turns out to be made of smuggled gold bullion.

The same year saw the last of the Bond novels to be published in Fleming's lifetime. Written by a man who had not long to live, *You Only Live Twice* has an elegiac tone. Grieving for the loss of his wife at the hands of Ernst Stavro Blofeld, Bond goes undercover in Japan to find the identity of the mysterious Dr Shatterhand who runs a 'Garden of Death' offering a variety of means for the suicidal to end it all. The villain turns out to be none other than Blofeld, whom Bond finally kills with his bare hands. The novel ends with Bond, now stricken with amnesia, leaving the Japanese island where he has been living in seclusion, in search of his true identity.

Fleming held that the appearance of his books was an important part of their appeal, and laid down strict instructions as to what was to appear on the jackets. Since 1957 these had largely been drawn by the artist Richard Chopping (1917–2008), whom Fleming described as 'the finest *trompe l'oeil* artist working today'. Fleming had met Chopping through his wife Ann, who had been to a joint exhibition Chopping had given with Francis Bacon; at her suggestion, he was engaged to produce the cover of *From Russia with Love* for 50 guineas. By 1964 his fee had increased to 300 guineas, partly met out of Fleming's own pocket. The cover for *You Only Live Twice* depicts a chrysanthemum, a dragonfly and a toad, toad sweat being, according to Fleming, a traditional Japanese aphrodisiac.

Ian Fleming himself amassed a noteworthy collection of books in collaboration with the bookseller Percy Muir, with whom he was to found the journal *The Book Collector* in 1952. In the early 1930s he instructed Muir to find him first editions of post-1800 scientific and technical works: 'books that marked milestones of progress – books that had started something'. The resulting collection formed the nucleus of the famous *Printing and the Mind of Man* exhibition in 1963 and was ultimately sold to the Lilly Library at Indiana University.

PROVENANCE
Bookseller's ticket of Bowes and Bowes; bought by Lord Fairhaven in April 1964.

BINDING
Gilt-tooled black bookcloth, publisher's binding, with dust jacket, as issued.

REFERENCES
Iain Campbell, *Ian Fleming: A Catalogue of a Collection* (Liverpool: Iain Campbell, 1978), 12007A1; Lilly Library, The Ian Fleming collection of 19th–20th Century Source Material Concerning Western Civilization ([Bloomington: Lilly Library, 1971]); P.H. Muir, 'Ian Fleming: a personal memoir', *The Book Collector*, v. 14, 1 (Spring 1965), pp. 24–33.

W H

YOU ONLY LIVE TWICE

When Ernst Stavro Blofeld blasted into
eternity the girl whom James Bond had
married only hours before, the heart, the
zest for life, went out of Bond. Incredibly,
from being a top agent of the Secret
Service, he had gone to pieces, was even
on the verge of becoming a security risk.
M is persuaded to give him one last
chance – an impossible mission far re-
moved from his usual duties – and Bond
leaves for Japan.

There, coming under the orders of the
formidable 'Tiger' Tanaka, Head of the
Japanese Secret Service, the Kōan-Chōsa-
Kyōku, he is indeed subjected to the
shock treatment his condition demanded.

Shock treatment? The reader will also
be subjected to it in full measure in this,
perhaps the most bizarre and doom-
fraught of all James Bond's adventures.

二度だけの生命

IAN
FLEMING

FLEMING

YOU ONLY LIVE TWICE

YOU ONLY LIVE TWICE

Bibliography

Standard abbreviations

ABBEY, LIFE J.R. Abbey, *Life in England in Aquatint and Lithography, 1770–1860: Architecture, Drawing Books, Art Collections, Magazines, Navy and Army, Panoramas, etc., from the Library of J. R. Abbey* (London: privately printed at the Curwen Press, 1953)

ABBEY, SCENERY J.R. Abbey, *Scenery of Great Britain and Ireland in Aquatint and Lithography, 1770–1860, from the Library of J.R. Abbey* (London: privately printed at the Curwen Press, 1952)

ABBEY, TRAVEL J.R. Abbey, *Travel in Aquatint and Lithography, 1770–1840, from the Library of J.R. Abbey* (London: privately printed at the Curwen Press, 1956–57)

BAL Nicholas Savage and Paul Nash, *Early Printed Books, 1478–1840: Catalogue of the British Architectural Library Early Imprints Collection* (London: Bowker-Saur, 1994–2003)

BARKER Nicolas Barker, *Treasures from the Libraries of National Trust Country Houses* (New York: Royal Oak Foundation, 1999)

BÉNÉZIT Emmanuel Bénézit, *Dictionnaire Critique et Documentaire des Peintres, Sculpteurs, Dessinateurs et Graveurs de Tous les Temps et de Tous les Pays* (new edn, Paris: Gründ, 1999)

BERLIN CATALOGUE *Katalog der Ornamentstich-Sammlung der Staatlichen Kunstbibliothek Berlin* (Berlin: Verlag für Kunst-wissenschaft, 1936–39)

BUNT Cyril G.E. Bunt, *Windsor Castle through Three Centuries: A Description and Catalogue of the Windsor Collection formed by Lord Fairhaven, F.S.A., Anglesey Abbey, Cambridgeshire* (Leigh-on-Sea: F. Lewis, 1949)

DBF J. Balteau, A. Rastoul and M. Prévost (eds), *Dictionnaire de Biographie Française* (Paris: Letouzey et Ané, 1932–)

DIBDIN Thomas Frognall Dibdin, *The Bibliographical Decameron* (London: for the author, 1817)

ESTC *English Short Title Catalogue Online* <estc.bl.uk>

FORD John Ford, *Ackermann, 1783–1983: The Business of Art* (London: Ackermann, 1983)

HARDIE Martin Hardie, *English Coloured Books* (London: Fitzhouse, 1990)

LOWNDES W.T. Lowndes, *The Bibliographer's Manual of English Literature* (London: Bohn, Bell & Daldy, 1858–65)

NISSEN BBI Claus Nissen, *Die botanische Buchillustration. 2. Aufl.* (Stuttgart : Hiersemann, 1966)

NIXON AND FOOT H.M. Nixon and M.M. Foot, *The History of Decorated Bookbinding in England* (Oxford: Clarendon Press, 1992)

ODNB *Oxford Dictionary of National Biography* (Oxford: Oxford University Press, 2004)

PRITZEL Georg August Pritzel, *Thesaurus Botanicae Omnium Gentium* (Leipzig: Brockhaus, 1851)

STC Alfred W. Pollard, *A Short Title Catalogue of Books Printed in England, Scotland & Ireland and of English Books Printed Abroad 1475–1640* (2nd edn, London: Bibliographical Society, 1991)

TOOLEY R.V. Tooley, *English Books with Coloured Plates, 1790 to 1860: A Bibliographical Account of the Most Important Books Illustrated by English Artists in Colour Aquatint and Colour Lithography* (London: Batsford, 1954)

WING Donald Wing, *Wing Short-Title Catalogue 1641–1700* [CD-rom]: *Short-Title Catalogue of Books Printed in England, Scotland, Ireland, Wales and British America and of English Books Published in Other Countries* (Cambridge: Chadwyck-Healey, 1996)

WORMSLEY *The Wormsley Library: A Personal Selection by Sir Paul Getty* (2nd edn London: Maggs Bros., 2007)

Primary sources

Anglesey Abbey, Huttleston Broughton, 1st Lord Fairhaven, [Manuscript Travel Diary] 1925 (unreferenced)

Anglesey Abbey, Huttleston Broughton, 1st Lord Fairhaven, [Manuscript Travel Diary], 'U.H.R.B. S.Y. *Sapphire* 1925–' (unreferenced)

Anglesey Abbey, Guest Files, [Typescript] 'List of Activities' (undated)

Anglesey Abbey, Guest Lists (undated, unreferenced)

Anglesey Abbey, 'Henry H. Rogers', scrapbook of press clippings, 1909 (unreferenced)

Anglesey Abbey, Architectural Drawings by Wratten & Godfrey and Sidney Parvin (inv. no. 514015–17)

London, British Library, National Sound Archive C1168/156/01–02, 159, 165, 174, 180, 557.01 (recordings from the National Trust Sound Archive, comprising interviews with the 3rd Lord Fairhaven, the 11th Duke of Grafton, and with former Anglesey Abbey staff)

London, British Library, National Sound Archive, C1168/557/01

London, National Archives, WO 372/3 579327/4374

Swindon, National Trust Archives, Box 106:34, Box 110:23; Box 106:34

Printed literature

Cleveland Amory, *Who Killed Society?* (New York: Harper & Brothers, 1960)

John Archer, *The Literature of British Domestic Architecture* (Cambridge, Mass.: MIT Press, 1985)

J.B. Atkins, *Further Memorials of the Royal Yacht Squadron (1901–1938)* (London: Geoffrey Bles, 1939)

Consuelo Vanderbilt Balsan, *The Glitter and the Gold* (Maidstone: George Mann, 1973)

Nicholas A. Basbanes, *A Gentle Madness: Bibliophiles, Bibliomaniacs, and the Eternal Passion for Books* (New York: Henry Holt, 1995)

Lucius Bebee, *The Big Spenders* (London: Hutchinson, 1967)

C. Berthezène, 'Archives: Ashridge College, 1929–54' *Contemporary British History* vol. 19, issue 1, pp. 79–83

Maurice Bond, *A Guide to Books about Windsor Castle and Borough* ([Windsor]: [privately printed], [1946])

Ruth Brandon, *The Dollar Princesses* (London: Weidenfeld & Nicolson, 1980)

Cara Broughton, Lady Fairhaven, *Second Cruise of S.Y. Sapphire, R.Y.S., December 11, 1925 – May 15, 1926* (privately printed, 1926)

Huttleston Broughton, 1st Lord Fairhaven, *The Dress of the First Regiment of Life Guards in Three Centuries* (London: Hatton & Truscott Smith, 1925)

Urban H. Broughton, *The British Empire at War* (London, 1916)

Urban H. Broughton, 'The Shone Hydro-Pneumatic System of Sewerage', *Transactions of the American Society of Civil Engineers*, XXVII, December 1892, pp. 659–74

Urban H. Broughton, *A Winter Cruise and Some Mental Ramblings* ([Edinburgh]: Printed for Private Circulation, 1922)

James Bryce, *The American Commonwealth* (London: Macmillan, 1888)

Alan Burns, 4th Baron Inverclude, *Porpoises and People* (London: Hatton & Truscott Smith, 1925)

Jamie Camplin, *The Rise of the Plutocrats* (London: Constable, 1978)

David Cannadine, *The Decline and Fall of the British Aristocracy* (London: Yale, 1990)

John Carter, *Taste and Technique in Book Collecting* (Cambridge: Cambridge University Press, 1948)

Barbara Cartland, *The Isthmus Years* (London: Hutchinson, 1942)

Catalogue of the Library at Leybourne Grange (London: Ellis and White, [c. 1875])

The Chicago Blue Book of Selected Names of Chicago and Suburban Towns (9th edn, Chicago: Chicago Directory Company, [1899?])

Reginald Crabtree, *The Luxury Yacht from Steam to Diesel* (Newton Abbot: David & Charles, 1973)

J. Mordaunt Crook, *The Rise of the Nouveaux Riches: Style and Status in Victorian and Edwardian Architecture* (London: John Murray, 1999)

Earl J. Dias, *Henry Huttleston Rogers: Portrait of 'A Capitalist'* (Fairhaven: Millicent Library, 1974)

A. H. Dodd, *A History of Wrexham* ([Wrexham]: Wrexham Borough Council, 1957)

Henry Farrar, *Town and Castle* (Chichester: Phillimore, 1990)

Robin Fedden, *Anglesey Abbey: A Guide* (London: National Trust, 1968)

John T. Flynn, *God's Gold: The Story of Rockefeller and His Times* (London: George G. Harrap, 1933)

The Folger Shakespeare Library, Washington ([Washington]: Published for the Trustees of Amherst College, 1933)

E.H.H. Green, *Ideologies of Conservatism: Conservative Political Ideas in the Twentieth Century* (Oxford: Oxford University Press, 2002)

Alexis Gregory, *Families of Fortune: The Gilded Age* (New York: Vendome Press, 1993)

Edward Hailstone, *The History and Antiquities of the Parish of Bottisham and the Priory of Anglesey in Cambridgeshire* (Cambridge: Cambridge Antiquarian Society, 1873)

John Hays Hammond, *The Autobiography of John Hays Hammond* (New York: Farrar & Rinehart, 1935)

George Harvey, *Henry Clay Frick: The Man* (New York: Charles Scribner's Sons, 1928)

Ralph W. Hidy and Muriel E. Hidy, *Pioneering in Big Business, 1882–1911: History of the Standard Oil Company, New Jersey* (New York: Harper & Brothers, 1955)

Hilaire and Meyer Hiler, *Bibliography of Costume* (New York: H.W. Wilson, 1939)

Simon Houfe, 'More than Just a Pretty Face', *Country Life*, 21 June 1990, pp. 118–21

Simon Houfe, *Sir Albert Richardson: The Professor* (Luton: White Crescent Press, 1980)

Tristram Hunt, *Building Jerusalem: The Rise and Fall of the Victorian City* (London: Weidenfeld & Nicolson, 2004)

Helen Keller, *The Story of My Life* (London: Hodder & Stoughton, 1959)

Mrs John King van Rensselaer, *The Social Ladder* (London: Eveleigh Nash & Grigson, [1925])

Alastair Laing, *In Trust for the Nation: Paintings from National Trust Houses* (London: National Trust, 1995)

Thomas Wilson Lawson, *Frenzied Finance: The Crime of Amalgamated* (London: W. Heinemann, 1906)

James Lees-Milne, *Diaries 1942–1945* (London: John Murray, 1995)

James Lees-Milne, *Diaries, 1946–1949* (London: John Murray, 1996)

Peter Messent, *Mark Twain and Male Friendship: The Twichell, Howells and Rogers Friendships* (Oxford: Oxford University Press, 2009)

Ross Miller, *American Apocalypse: The Great Fire and the Myth of Chicago* (Chicago: University of Chicago, 1990)

Ian Nairn and Nikolaus Pevsner, *The Buildings of England: Surrey* (London: Penguin, 1971)

Allan Nevins, *John D. Rockefeller: The Heroic Age of American Enterprise* (New York: Charles Scribner's Sons, 1940)

John Newman, *The Buildings of England: West Kent and the Weald* (London: Penguin, 1980)

Nigel Nicolson, *Mary Curzon: A Biography* (London: Weidenfeld & Nicolson, 1977)

Arthur Oswald, 'Anglesey Abbey, Cambridge', *Country Life*, 27 December 1930, pp. 832–8

Park Close, Englefield Green, Surrey ... For Sale by Auction, July 5th 1917 (London: Mobbett & Edge [auctioneers], [1917])

Sara Paston-Williams, *Fish: Recipes from a Busy Island* (London: National Trust, 2005)

David Pearson (ed.), *For the Love of the Binding: Studies in Bookbinding History Presented to Mirjam Foot* (London: British Library, 2000)

Nikolaus Pevsner and Elizabeth Williamson, *The Buildings of England: Buckinghamshire* (London: Penguin, 1994)

S.T. Prideaux, *Aquatint Engraving: A Chapter in the History of Book Illustration* (London: Foyle, 1968)

Jane Roberts, *Royal Landscape: The Gardens and Parks of Windsor* (New Haven: Yale, 1997)

Jane Roberts, *Views of Windsor* (London: Merrell Holberton, 1995)

Lanning Roper, *The Gardens of Anglesey Abbey, Cambridgeshire: The House of Lord Fairhaven* (London: Faber and Faber, 1964)

W. D. Rubenstein, 'The Evolution of the British Honours System Since the Mid-Nineteenth Century', in *Elites and the Wealthy in Modern British History: Essays in Social and Economic History* (Brighton: Harvester, 1987)

Nicholas Savage and Paul Nash, *Early Printed Books, 1478–1840: Catalogue of the British Architectural Library Early Imprints Collection* (London: Bowker-Saur, 1994–2003)

Geoffrey Scott, *The Architecture of Humanism* (London: Constable, 1914)

F.H.W. Sheppard, ed., *Survey of London*, vol. XXXIX: *The Grosvenor Estate in Mayfair* (London: Greater London Council, 1977)

Isaac Shone, *The Main Drainage of the Houses of Parliament, on the Shone Hydro-Pneumatic System* (London: E. & F.N. Spon, 1887)

Michael Stenton and Stephen Lees, *Who's Who of British Members of Parliament*, vol. 2, *1886–1918* (Hassocks: Harvester, 1978)

Amanda Mackenzie Stuart, *Consuelo and Alva Vanderbilt: The Story of a Daughter and a Mother in the Gilded Age* (New York: Harper Perennial, 2006)

Herbert L. Sutterlee, *J. Pierpont Morgan: An Intimate Portrait* (New York: Macmillan, 1939)

Mark Twain's Correspondence with Henry Huttleston Rogers, 1893–1909 (Berkeley: University of California Press, 1969)

'Mark Twain's Millionaire Friend', *Review of Reviews*, 32, 188 (August 1905), p. 179.

Merlin Waterson, *The National Trust: The First Hundred Years* (London: BCA, 1994)

Edith Wharton, *The Decoration of Period Rooms* (London: Batsford, 1898)

Edith Wharton and Ogden Codman, *The Decoration of Houses* (London: Batsford, 1898)

Notes

1 London, British Library, National Sound Archive, C1168/159.
2 Simon Houfe, *Sir Albert Richardson: The Professor* (Luton: White Crescent Press, 1980), pp. 147–8.
3 National Sound Archive, C1168/159; C1168/174; Cara Broughton, Lady Fairhaven, *Second Cruise of S.Y. Sapphire, R.Y.S., December 11, 1925 – May 15, 1926* (privately printed, 1926), p. 116; James Lees-Milne, *Diaries, 1946–1949* (London: John Murray, 1996), p. 10.
4 Lees-Milne, *Diaries, 1946–1949*, p. 10.
5 James Lees-Milne, *Diaries 1942–1945* (London: John Murray, 1995), p. 215.
6 Sara Paston-Williams, *Fish: Recipes from a Busy Island* (London: National Trust, 2005), p. 87.
7 National Sound Archive, C1168/159; C1168/174; C1168/180.
8 National Sound Archive, C1168/174.
9 *The New York Times*, 21 August 1966, p. 92; National Sound Archive, C1168/159.
10 *The Times*, 27 August 1966, p. 10.
11 National Sound Archive, C1168/174; C1168/156/01–02.
12 National Sound Archive, C1168/180; C1168/174.
13 Barbara Cartland, *The Isthmus Years* (London: Hutchinson, 1942), p. 52.
14 National Sound Archive, C1168/174; Broughton, *Second Cruise of S.Y. Sapphire*, p. 9.
15 Houfe, *Sir Albert Richardson*, p. 232; Anglesey Abbey, Guest Lists (unreferenced).
16 Anglesey Abbey, Guest Files, Typescript 'List of Activities' (undated).
17 *The Times*, 10 April 1937, p. 17; *The Times*, 10 November 1930, p. 7; *The Scotsman*, 17 February 1949, p. 4.
18 Houfe, *Sir Albert Richardson*, p. 158.
19 Swindon, National Trust Archives, Box 106:34.
20 *The Times*, 10 November 1930, p. 7; National Sound Archive, C1168/174.
21 *The Scotsman*, 26 May 1939, p. 15; *The Manchester Guardian*, 9 July 1940, p. 9.
22 National Trust Archives, Box 106:34.
23 National Trust Archives, Box 110:23; Box 110:23; Box 106:34; Box 106:34.
24 National Sound Archive, C1168/174; C1168/156/01–02.
25 Huttleston Broughton, 1st Lord Fairhaven, *The Dress of the First Regiment of Life Guards in Three Centuries* (London: Hatton & Truscott Smith, 1925), p. 16.
26 National Trust Archives, Box 106:34.
27 Broughton, *Second Cruise of S.Y. Sapphire*, p. 151.
28 *Berrow's Worcester Journal*, 16 November 1895, p. 5; *The Scotsman*, 12 August 1898, p. 8; *Belfast Newsletter*, 15 October 1863; *The York Herald*, 26 August 1875, p. 3.
29 *Mark Twain's Correspondence with Henry Huttleston Rogers*, pp. 517–18.
30 Broughton, *A Winter Cruise*, pp. 70–72.
31 Isaac Shone, *The Main Drainage of the Houses of Parliament, on the Shone Hydro-Pneumatic System* (London: E. & F.N. Spon, 1887); Tristam Hunt, *Building Jerusalem: The Rise and Fall of the Victorian City* (London: Weidenfeld & Nicolson, 2004), pp. 260–1.
32 *The New-York Tribune*, 18 September 1907, p. 2; Broughton, *A Winter Cruise*, pp. 53, 74; Urban H. Broughton, *The British Empire at War* (London, 1916), p. 3.
33 Ross Miller, *American Apocalypse: The Great Fire and the Myth of Chicago* (Chicago: University of Chicago, 1990), pp. 22–3; Urban H. Broughton, 'The Shone Hydro-Pneumatic System of Sewerage', *Transactions of the American Society of Civil Engineers*, XXVII, December 1892, pp. 659–74.
34 Broughton, *A Winter Cruise*, pp. 53–4; Alexis Gregory, *Families of Fortune: The Gilded Age* (New York: Vendome Press, 1993), p. 14.
35 *The New-York Tribune*, 19 January 1908, p. 2.
36 *The British Architect*, 11 August 1905, p. 94.
37 Earl J. Dias, *Henry Huttleston Rogers: Portrait of 'A Capitalist'* (Fairhaven: Millicent Library, 1974), pp. 20–2, 43–6, 60; Gregory, *Families of Fortune*, p. 59.
38 *The New-York Tribune*, 18 September 1907, p. 2; Broughton, *A Winter Cruise*, pp. 53, 74; Urban H. Broughton, *The British Empire at War* (London, 1916), p. 3.
39 Ralph W. Hidy and Muriel E. Hidy, *Pioneering in Big Business, 1882–1911: History of the Standard Oil Company, New Jersey* (New York: Harper & Brothers, 1955), p. 591; *The New York Times*, 20 May 1909, p. 1; Gregory, *Families of Fortune*, pp. 12, 99.
40 *Mark Twain's Correspondence with Henry Huttleston Rogers*, pp. 69, 201, 468.
41 *Mark Twain's Correspondence with Henry Huttleston Rogers*, p. 20.
42 *Mark Twain's Correspondence with Henry Huttleston Rogers*, p. 102, 157; Dias, *Henry Huttleston Rogers*, pp. 115, 178.
43 Dias, *Henry Huttleston Rogers*, pp. 40–1, 65, 78.
44 Thomas Wilson Lawson, *Frenzied Finance: The Crime of Amalgamated* (London: W. Heinemann, 1906), p. vii.
45 Herbert L. Sutterlee, *J. Pierpont Morgan: An Intimate Portrait* (New York: Macmillan, 1939), pp. 437–8.
46 Hidy, *Pioneering in Big Business, 1882–1911*, p. 668; John Hays Hammond, *The Autobiography of John Hays Hammond* (New York: Farrar & Rinchart, 1935), II, p. 524.
47 Allan Nevins, *John D. Rockefeller: The Heroic Age of American Enterprise* (New York: Charles Scribner's Sons, 1940), I, p. 343 (n. 9).
48 Nevins, *John D. Rockefeller*, I, pp. 343, 507–8.
49 Lucius Bebee, *The Big Spenders* (London: Hutchinson, 1967), p. 346.
50 Helen Keller, *The Story of My Life* (London: Hodder & Stoughton, 1959), p. 173; 'Mark Twain's Millionaire Friend', *Review of Reviews*, 32, 188 (August 1905), p. 179.
51 Dias, *Henry Huttleston Rogers*, pp. 108–9.
52 Hidy, *Pioneering in Big Business, 1882–1911*, p. 59; *The Folger Shakespeare Library, Washington* ([Washington]: Published for the Trustees of Amherst College, 1933), pp. vii–x.
53 Dias, *Henry Huttleston Rogers*, pp. 36, 39, 100, 111, 174–5.
54 Edith Wharton and Ogden Codman, *The Decoration of Houses* (London: Batsford, 1898), p. 151.
55 *Mark Twain's Correspondence with Henry Huttleston Rogers*, p. 63; Broughton, *A Winter Cruise*, pp. 45–6.
56 *The New-York Tribune*, 20 May 1909, p. 3.
57 *Mark Twain's Correspondence with Henry Huttleston Rogers*, pp. 148, 190.
58 Nigel Nicolson, *Mary Curzon: A Biography* (London: Weidenfeld & Nicolson, 1977), pp. 75–6.
59 Consuelo Vanderbilt Balsan, *The Glitter and the Gold* (Maidstone: George Mann, 1973), pp. 38–43; Amanda Mackenzie Stuart, *Consuelo and Alva Vanderbilt: The Story of a Daughter and a Mother in the Gilded Age* (New York: Harper Perennial, 2006), p. 135.
60 *Berrow's Worcester Journal*, 16 November 1895, p. 5.
61 Brandon, *The Dollar Princesses*, p. 1.
62 *Mark Twain's Correspondence with Henry Huttleston Rogers*, p. 626; Alan Burns, 4th Baron Inverclude, *Porpoises and People* (London: Hatton & Truscott Smith), pp. 3, 174.
63 *The Chicago Blue Book of Selected Names of Chicago and Suburban Towns* (9th edn, Chicago: Chicago Directory Company, [1899?]), pp. 262, 353, 406, 426.
64 *The New-York Tribune*, 18 September 1907, p. 2.
65 Broughton, *A Winter Cruise*, pp. 30, 37, 75–6.
66 Broughton, *A Winter Cruise*, pp. 30, 38.
67 Dias, *Henry Huttleston Rogers*, p. 239.
68 Dias, *Henry Huttleston Rogers*, pp. 214, 248, 313.
69 *The New York Times*, 29 May 1909, p. 5.
70 Dias, *Henry Huttleston Rogers*, pp. 167–8, 115.
71 Stuart, *Consuelo and Alva Vanderbilt*, p. 135; Gregory, *Families of Fortune*, p. 10.
72 *Los Angeles Herald*, 21 May 1909, p. 5.
73 *Mark Twain's Correspondence with Henry Huttleston Rogers*, p. 58.
74 John T. Flynn, *God's Gold: The Story of Rockefeller and His Times* (London: George G. Harrap, 1933), p. 361.
75 J.B. Atkins, *Further Memorials of the Royal Yacht Squadron (1901–1938)* (London: Geoffrey Bles, 1939), p. 155; J. Mordaunt Crook, *The Rise of the Nouveaux Riches: Style and Status in Victorian and Edwardian Architecture* (London: John Murray, 1999), p. 377.
76 Nicholas A. Basbanes, *A Gentle Madness: Bibliophiles, Bibliomaniacs, and the Eternal Passion for Books* (New York: Henry Holt, 1995), pp. 185–7.
77 *The New-York Tribune*, 21 April 1912, p. 9.

78 Gregory, *Families of Fortune* p. 71; Jamie Camplin, *The Rise of the Plutocrats* (London: Constables, 1978), p. 184–5; John Newman, *The Buildings of England: West Kent and the Weald* (London: Penguin, 1980), p. 325; Nikolaus Pevsner and Elizabeth Williamson, *The Buildings of England: Buckinghamshire* (London: Penguin, 1994), p. 255.

79 Theo Barker, 'Albert Henry Stanley, Lord Ashfield (1874–1948)', *Oxford Dictionary of National Biography* (Oxford: Oxford University Press, 2004), LII, pp. 162–3.

80 Anglesey Abbey, Huttleston Broughton, 1st Lord Fairhaven, [Manuscript Travel Diary] 1925.

81 London, National Archives, WO 372/3 579327/4374.

82 Crook, *The Rise of the Nouveaux Riches*, pp. 260–2.

83 Cleveland Amory, *Who Killed Society?* (New York: Harper & Brothers, 1960), p. 319; Brandon, *The Dollar Princesses*, pp. 13–15.

84 Mrs John King van Rensselaer, *The Social Ladder* (London: Eveleigh Nash & Grigson, [1925]), p. 172; Camplin, *The Rise of the Plutocrats*, p. 171.

85 James Bryce, *The American Commonwealth* (London: Macmillan, 1888), II, p. 815.

86 Quoted in Camplin, *The Rise of the Plutocrats*, p. 180.

87 The best impression of the interiors is to be found in a photograph album now at Anglesey Abbey.

88 Crook, *The Rise of the Nouveaux Riches*, pp. 172–3.

89 *Park Close, Englefield Green, Surrey … For Sale by Auction, July 5th 1917* (London: Mobbett & Edge [auctioneers], [1917]); Ian Nairn and Nikolaus Pevsner, *The Buildings of England: Surrey* (London: Penguin, 1971), p. 213.

90 Broughton, *A Winter Cruise*, pp. 27, 49–50; *The Scotsman*, 6 July 1916, p. 4; W.D. Rubenstein, 'The Evolution of the British Honours System Since the Mid-Nineteenth Century', in *Elites and the Wealthy in Modern British History: Essays in Social and Economic History* (Brighton: Harvester, 1987), pp. 222–61 (pp. 223, 240–1).

91 Broughton, *A Winter Cruise*, p. 50.

92 E.H.H. Green, *Ideologies of Conservatism: Conservative Political Ideas in the Twentieth Century* (Oxford: Oxford University Press, 2002), p. 135.

93 *The Scotsman*, 14 August 1928, p. 8; Inverclyde, *Porpoises and People*, p. 10; *The Sun*, 28 May 1902, p. 4.

94 Broughton, *A Winter Cruise*, p. 67.

95 Broughton, *A Winter Cruise*, p. 63.

96 Rubenstein, 'The Evolution of the British Honours System', pp. 242–3; David Cannadine, *The Decline and Fall of the British Aristocracy* (London: Yale, 1990), pp. 316–23; *The Observer*, 21 August 1966, p. 3.

97 *Saturday Review*, 5 March 1934, p. 229.

98 Crook, *The Rise of the Nouveaux Riches*, pp. 272–3.

99 Robin Fedden, *Anglesey Abbey: A Guide* (London: National Trust, 1968), p. 6; National Sound Archive, C1168/174.

100 Simon Houfe, 'More than Just a Pretty Face', *Country Life*, 21 June 1990, pp. 118–21.

101 National Sound Archive, C1168/174; Broughton, *A Winter Cruise*, p. 8.

102 Burns, *Porpoises and People*, pp. 8–10; Cyril G.E. Bunt, *Windsor Castle through Three Centuries: A Description and Catalogue of the Windsor Collection formed by Lord Fairhaven, F.S.A., Anglesey Abbey, Cambridgeshire* (Leigh-on-Sea: F. Lewis, 1949), p. 16.

103 London, National Sound Archive, C1168/156/01–02; Burns, *Porpoises and People*, pp. 125, 138, 173; Houfe, 'More than Just a Pretty Face', p. 118.

104 London, National Sound Archive, C1168/156/01–02; Anglesey Abbey, Huttleston Broughton, 1st Lord Fairhaven [Manuscript Travel Diary]: 'U.H.R.B. S.Y. *Sapphire* 1925–1926'; Houfe, *Sir Albert Richardson*, p. 152.

105 Lees-Milne, *Diaries 1942–1945*, p. 214; Lees-Milne, *Diaries 1946–1949*, p. 10.

106 Fedden, *Anglesey Abbey*, p. 6.

107 Broughton, *Second Cruise of S.Y. Sapphire*, pp. 11, 137–40, 156–7, 162.

108 Reginald Crabtree, *The Luxury Yacht from Steam to Diesel* (Newton Abbot: David & Charles, 1973), pp. 48–9; Atkins, *Further Memorials of the Royal Yacht Squadron (1901–1938)*, pp. 7, 92–3, 125; Burns, *Porpoises and People*, p. 13; *The Observer*, 29 June 1934, p. 9; 1 August 1937; *The New York Times*, 22 March 1931, p. N5 [sic].

109 National Sound Archive, C1168/159; C1168/165.

110 *The Manchester Guardian*, 22 June 1939, p. 12.

111 For the earlier history, see Edward Hailstone, *The History and Antiquities of the Parish of Bottisham and the Priory of Anglesey in Cambridgeshire* (Cambridge: Cambridge Antiquarian Society, 1873).

112 Arthur Oswald, 'Anglesey Abbey, Cambridge. The Seat of Lord Fairhaven and Capt. The Hon. Henry Broughton', *Country Life*, 27 December 1930, pp. 832–8.

113 F.H.W. Sheppard ed., *Survey of London*, vol. XXXIX: *The Grosvenor Estate in Mayfair* (London: Greater London Council, 1977), p.153.

114 Oswald, 'Anglesey Abbey, Cambridge', pp. 832–8; National Sound Archive, C1168/159.

115 C. Berthezène, 'Archives: Ashridge College, 1929–54', *Contemporary British History* vol. 19, issue 1, pp. 79–83, n. 8.

116 *The Manchester Guardian*, 1 March 1929, p. 11; Lanning Roper, *The Gardens of Anglesey Abbey, Cambridgeshire: The House of Lord Fairhaven* (London: Faber and Faber, 1964), pp. 21–22.

117 Anglesey Abbey, inventory no. 514015–17; for Wratten and Godrey, see Sir John Summerson, 'Walter Hindes Godfrey (1881–1961)', *Oxford Dictionary of National Biography*, XXII, pp. 572–3.

118 London, National Sound Archive, C1168/159.

119 *The Times*, 4 February 1948, p. 2.

120 The remaining contents of Park Close, 37 Park Street, and the S.Y. *Sapphire* were sold at Philips, 7–8 November 1946 (copy retained in library desk at Anglesey Abbey).

121 Etty, preface; Lees-Milne, *Diaries, 1942–1945*, p. 215.

122 Bunt, *Windsor Castle through Three Centuries*, pp. 11–14.

123 Somewhat unaccountably on long-term loan from the National Trust to the Fitzwilliam Museum, Cambridge.

124 Lees-Milne, *Diaries, 1942–1945*, p. 215.

125 Merlin Waterson, *The National Trust: The First Hundred Years* (London: BCA, 1994), p. 149; National Sound Archive, C1168/557/01.

126 Geoffrey Scott, *The Architecture of Humanism* (London: Constable, 1914), pp. 38–42.

127 Waterson, *The National Trust: The First Hundred Years*, p. 158; Crook, *The Rise of the Nouveaux Riches*, p. 5.

128 Alastair Laing, *In Trust for the Nation: Paintings from National Trust Houses* (London: National Trust, 1995), p. 224.

129 Edith Wharton, *The Decoration of Period Rooms* (London: Batsford, 1898), pp. 147–51.

130 National Sound Archive, C1168/174.

131 I am grateful to Nicholas Poole-Wilson, Robyn Myers and John Saumarez Smith for their memories (and, from the last, for the information that he believes that the 3rd Lord Fairhaven was probably mistaken in thinking that his uncle was a regular customer of Heywood Hill Ltd in Curzon Street: this was true of Henry Broughton, but the first Lord Fairhaven generally shopped elsewhere).

132 John Carter, *Taste and Technique in Book Collecting* (Cambridge: Cambridge University Press, 1948), pp. 72–3.

133 *The Wormsley Library: A Personal Selection by Sir Paul Getty, K.B.E.* (2nd edn, London: Maggs Bros., 2007).

134 Nicolas Barker, *Treasures from the Libraries of National Trust Country Houses* (New York: Royal Oak Foundation, 1999), p. 39.

Index

Figures in *italics* indicate captions.
'LF' indicates Huttleston
Broughton, 1st Lord Fairhaven.

Abbey, Major J.R. 35, 37
Académie des Sciences 66
Ackermann (firm) 114
Ackermann, Rudolph 30, 74,
 81, 88, 102, 105, 114
 History of the Colleges 94, 96–7
 The Microcosm of London 88–9, 94
Adam, Robert 69, 74
Adams, John Quincy 119
Ainslie, Sir Robert 80
Aldeburgh, Suffolk 10, 24
Aldine Catullus 34
Alexander the Great 124
Alexandra, Princess (later
 Queen) 128
Alken, Henry, Jr: *Funeral Procession
 of Arthur, Duke of Wellington*
 124–7
Allard 19, 26
Altieri family 28
Amalgamated Copper Company 13
Anaconda Mining Company 17, 18
Anglesey Abbey, Cambridgeshire
 bought by LF and brother
 Henry 23
 garden 11, 24, 25, 63
 gifted to National Trust 10
 history of 25
 Library 6, 26–7, 32–8, *32*
 location 23
 Lower Gallery 28
 meals 7–8
 Picture Gallery 26
 provenance of books 38
 Sitting Room 26
 staff 6–7, 25, 27
 Tapestry Hall 26, 27, *27*
 three-phase transformation 26
 Upper Picture Gallery *10*, 28, *29*
 Windsor Corridor 28
Anglo-American Oil 19
Arnold, Spencer *13*
Artaria 73
Arundel, Thomas Howard, 2nd
 Earl of 54
Arundel House, London 54
Ashburnham House, London 64
Ashfield, Albert Henry Stanley,
 Lord 19, 20
Ashmole, Elias: *Institution, Laws
 and Ceremonies of the Order of the
 Garter* 30, 34, 54–5, 125
Ashridge, Hertfordshire (later
 Ashridge Bonar Law Memorial
 College) 22, 23, 26
Astor, John Jacob 13, 19
Astor, William Waldorf 19
Astor family 14
Audubon, John James 106, 119
Avalos y Aragon, Alphonso
 Felice d' 42

Bacon, Francis 150
Baker, Sir Herbert 136
Baldinucci, Filippo 42

Bambridge, Elsie 9
Bank of England, London 37
Baring-Gould, Sabine: 'Onward,
 Christian Soldiers' 130–1
Barker, Nicolas 37–8
Barker, Robert 114
Barraban, Jacques 86
Barri, Giacomo 91
Barry, Charles 12
Bartolozzi, Francesco 74
Barton, Suffolk 23
Batoni, Pompeo 100
Bayntun, George 141
Bayntun's of Bath 134
Bayreuth 134
Bazalgette, Joseph 12
BBC 8
Beaumont, Jean-François
 Albanis 91
Beaverbrook, Max Aitken, Lord 19
Beckford, William 28, *745*
Bedford, Francis 54
Behrens, Balthasar Friedrich 32
Belgentier, Provence 50
Bell, George, Bishop of
 Chichester 44, 46
Bellasis, George Hutchins:
 Views of Saint Helena 28, 92–3
Benjamin, Henry Rogers 9
Benjamin, William Evarts 15
Bensley, Thomas 74
Bentham, James 112
Bentley, Richard 64
 *Designs by Mr. R. Bentley for
 Six Poems by Mr. T. Gray* 64–5
Bentley, Dr Richard 64
Berwind family 14
Bickham, George 62, 122
 *The Beauties of Stow, or a
 Description of the Most Noble
 House, Gardens & Magnificent
 Buildings therein, of the Right
 Honble Earl Temple* 62–3
Bickham, George, Junior 62, 122
Biddle, Edward C. 119, 120
Bigham, Clive, 2nd Viscount
 Mersey: *The Kings of England
 1066–1901* 146–7
Biltmore, North Carolina:
 Library *33*, 37
Birkenhead, Frederick Edwin
 Smith, Lord 20, 21, 34
Birley, Sir Oswald *12*
 *Portrait of Huttleston Broughton,
 1st Lord Fairhaven* 23, 24, 73
Blagdon, Francis William 83
Blenheim Palace, Woodstock,
 Oxfordshire 16, 18
Bloemart, Abraham 48
Bodley, Sir Thomas 141–2
Bodoni press 69
Bolsover Castle, Derbyshire 51
Bonington, Richard Parkes:
 Coastal Scene of Northern France 28
Book of Common Prayer, The 60–1
Bouquet, Louis 86
Bowen, J.T. 120
Boydell, Alderman 76
Bradford, Samuel F. 119
Bray, Stanley 133
Bridges, Robert: *Eros and Psyche*
 34, 148–51
Brigham, Charles 13

Brighton Pavilion 108–9
Brisson, Mathurin 66
British Architectural Library,
 London 84
British Museum, London 70
British Red Cross 9, 10, 24
Britton, John 112
Brooks's Club, London 10
Broughton, John (LF's paternal
 grandfather) 11
Broughton, Mai 19
Broughton, Urban Hanlon
 (LF's father) 10, 11–13, *12*, 16–23,
 17, 24–5, 98
 The British Empire at War 21
Broughton Castle, Oxfordshire 20
Broughton family 6, 9, 18, 20, 21, 22
Brown's Hotel, Mayfair 19
Bryant, Sir Arthur 8, 9
Bryce, James 20
Buchanan, Handasyde 76
Buchel, Aernout van 50
Buc'hoz, Pierre-Joseph 66
 *Le Jardin d'Eden, le Paradis
 Terrestre renouvellé dans le Jardin
 de la Reine à Trianon* 66–7
Buffon, George Louis Leclerc,
 le comte de 66
Bull, Richard 128
Bumpus, Thomas 134
Bumpus Ltd 134
Bunt, Cyril 54
Burghley, William Cecil, Lord 44
Burmese War (1824–6) 110
Burne-Jones, Edward 148
Burrell, Sir Peter 84
Busby, Thomas Lord: *Costume of
 the Lower Orders of London* 102–3

Caius, John 40, 79
 *De Antiquitate Cantabrigiensis
 Academie Libri Duo* 40–1
Cambridge 9
Cambridge Arts Theatre 9
Cambridge, University of 9, 10, 40
Campbell, Major-General
 Archibald 110
Canadian Pacific Railroad 12
Carlton House, London 108
Carnegie, Andrew 15, 20
Caroline, Queen 74, 114
Carroll, Lewis
 *Alice's Adventures in
 Wonderland* 132–3
 Through the Looking-Glass 132–3
Carter, John 37, 112
Cartland, Barbara 8–9
Cassel, Sir Ernest 21
Catesby, Mark 70
Catherine the Great 80
Catullus 34
Cavendish, Charles 51
Charles II, King 51, 60, 123, 138
Charles V, Emperor 124
Charlotte, Princess 124
Charlotte, Queen 76
Chicago 12, 17, 18, 20
 World Fair (1892) 12
Chichester Cathedral 44, 46
Childs and Inman (later Childs
 and Lehman, then Lehman and
 Duval) 119, 120
Chopping, Richard 150

Christie's auctioneers 10
Clark, James G. 120
Clarke, Canon Basil Lowther 44
Claude Lorrain
 'Altieri Claudes' 28, *29*, 30, 31, 37
 *The Landing of Aeneas at
 Palanteum 29*
Cliveden, Buckinghamshire 19
Cobden-Sanderson, Thomas 35,
 134, 138, 144
Cobham, Richard Temple, Lord 62
Cockerell, C.R. 124
Cockerell, Douglas 133
Coe, Mai Rogers 11
Coe, William R. 9
Cole, Henry 124
Coleridge, Samuel Taylor 74, 134
Collaert, Adriaen 42
Collaert, Hans, I 42
College of Arms, London 147
Colnaghi, Paul 74
Combe, William 88
 *A History of the University of
 Cambridge* 94–5
Conservative Central Office 22
Consolidated Gas Company 13
Constable, John: *Embarkation
 of George IV from Whitehall: The
 Opening of Waterloo Bridge 1817*
 27, 32
Constantinople 80
Cosway, Richard 30, 35, 141
Cosway bindings 30, 35, 141
Cotton, Sir Robert 64
Council for the Care of Churches 9
Cowdray, Annie 129
Cowes, Isle of Wight *24*, 25
Cromwell, Oliver 124
Currie, Miss C.B. 141
Curtis, William 74, 79
Curzon, George Nathaniel,
 Lord 16, *17*
Curzon, Mary (née Leiter) 16

Danckerts, Hendrick 55
Dante Alighieri 148
Davies, Gwendoline and
 Margaret 148
Dickson, R.W. 79
Diepenbeeck, Abraham van 52
Dodsley, Robert 64
Doves bindery 144
Dresden opera house 124
Drury, Henry 97
Dubourg, Matthew 98
 *Views of the Remains of Ancient
 Buildings in Rome and its Vicinity*
 100–1
Duff, Bradford F. 16
Dugdale, William 54
Duncan-Jones, Dean Arthur 44, 46

East India Company 92, 110
East India Railway, Bengal 11
Edema, Gerard 55
Edward VI, King 55
Edward VII, King 20, 21, 128, 138
Edwards, George 70
Edwards, Sydenham 76, 79
 *Cynographia Britannica:
 Consisting of Coloured Engravings
 of the Various Breeds of Dogs* 76–7
Edwards, William 69

Edwards of Halifax 69
Elizabeth I, Queen 42
Emmanuel College, Cambridge 44
EON Films 150
Esher, Lord 11
Eton, Berkshire 38, 128
Etty, William 28, 30, 148
 The Standard Bearer 30
Exeter, Lord 124

Fairhaven, Ailwyn Henry George
 Broughton, 3rd Lord 8, 38
Fairhaven, Henry Broughton
 (LF's brother), 2nd Lord 6, *18*, 23,
 25, 26, 36, 76, 98
Fairhaven, Huttleston
 Broughton, 1st Lord 7, *9*, *18*, *25*
 appearance 16, 24
 assembles library at Anglesey
 Abbey 6
 birth (31 August 1896) 18
 born and raised in United
 States 6
 education 9–10
 interest in the Napoleonic era 124
 moves to London 6
 peerage 22, 23, 25
 personality 8, 24
 preoccupations 24
 serves in the Life Guards 20, 54,
 73, 138
 shopping for his collection
 30–1, 38
 *The Dress of the First Regiment
 of Life Guards in Three Centuries*
 10, 73
Fairhaven, Lady (Cara Leland
 Broughton; LF's mother) 7–8, 11,
 16–19, *17*, *18*, 21–5, *25*, 27, *28*, 32, 98
Fairhaven, Massachusetts 12–16,
 14, 18, 25
Fairhaven crest 33
Farington, Joseph 10
Fedden, Robin 38
Felixstowe, Suffolk 12
Fell, John 57
First World War 21, 24, 28, 138, 148
Fitzwilliam Museum, Cambridge
 10, 27, 36
Flaxman, John: *Shield of Achilles* 28
Fleming, Ann (née Charteris) 150
Fleming, Ian: *You Only Live Twice*
 33, 152–3
Folger, Henry Clay 15, 37
Frederick, Duke of York 124
Frederick II of Denmark 55
French Revolution 88, 105
Frick, Henry Clay 13, 15, 17
Frost, Henry Harvey 88
Fuseli, Henry 74

Gainsborough, Thomas 74
Galle, Philips 42
Gendall, John 105
Geometrical Compartment Binder
 30, 60–1
George IV, King 28, 30, 108, 125
George V, King 20, 138
Georgian Group 31
Getty, Sir Paul 37
Gilbert, Alfred 32
Gilpin, William 62, 91, 105
Gloucester, Duke of 94

Goltzius, Hendrick 42
Gonville and Caius College,
 Cambridge 40
Goodrich Court, Herefordshire 106
Gordon, Huntly 21
Gould, Howard 13
Grafton, Hugh FitzRoy, 11th
 Duke of 31
Granger, James 128
Gray, Thomas 64–5, 112
 *Elegy written in a Country
 Churchyard* 133, 134, 144–5
Gray's bookbinders, Cambridge 33
Great Neck, Long Island 18, 21
Greenough, Frederick W. 120
Greenwich Hospital 83
Gregory, Maundy 22
Gregynog Hall,
 Montgomeryshire 148
Gregynog Press 34, 148–51
Gribelin, Simon 58
Grignion, Charles 65
Grigson, Geoffrey 76
Grolier Club, New York 38
Grosvenor estate, London 21
Grove House 23
Guggenheim, Solomon R. 15

Haberly, Loyd 148
Hakewill, James 123
Hall, James 119, 120
Hamilton, Emma, Lady 83
Hamilton, William 74
Hampton Court Palace, Middlesex
 62, 122
Harris, John, Jr 98
Harris, John, Sr 98
Harrow School 10, 20
Hartwell House, Buckinghamshire
 105
Harvard University Library 19
Havell, Daniel 105
Havell, Robert 106
Havemeyer, Henry Osborne 13–14
Haydn, Franz Joseph 130
 Die Jahreszeiten 74
Heath, William 73
Heffers bookshop, Cambridge 33
Heinze, F. Augustus 15
Henderson, Peter 76
Henry VII, King 30, 55
Henry VIII, King 32, 147
Herrenhausen summer palace,
 Germany 32
Herstmonceux Castle 27
Hever Castle 19
Hewitt, Graily 148
Highcliffe 74
Highmore, Joseph 28
Hiler, Hilaire and Meyer 73
Hill, Heywood 76
Hobson, G.D. 35
Hodgson, Edward 70
Holland, Henry 108
Hollar, Wenceslaus 30, 54–5
Holst, Gustav 148
Holy Bible, The 60–1, 128
Hondius, William 57
Horbury, near Wakefield 130
Hornor, Thomas 114
Houghton Hall, Norfolk 32
House of Commons 21
House of Lords 6, 19, 21

Household Cavalry 138
Houses of Parliament, London 12
Hugo, Victor 105
Hunt, Richard Morris 12, 33
Huth, Henry 70
Huth, Henry Alfred 70
Huttleston, Mary Eldridge
 (LF's great-grandmother) 18, 23

Imperial College, London 11
Imprimerie royale 57
Inverclyde, Lord 8–9
Ireland, William Henry: *The Life
 of Napoleon Bonaparte* 140–1, 143

James, Henry 6, 20
Janszoon., Jan 48
Jenyns, Anne 9
Jenyns, Soane 9
Jockey Club 24
John, Don 42
Jones, Owen 124
Jones, Thomas 148

Kean, Charles 106
Kean, Edmund 106
Kedleston Hall, Derbyshire 16, 74
Keller, Helen 15
Kelmscott Press 148
Kennedy, John F. 150
Kennington, Eric 136
Kent, George, Duke of 28
Kent, William 32, 74
Key, John 119
King, Charles Bird 119
King van Rensselaer, Mrs 20
King's School, Ely 9
Kininger, Vincenz Georg 73
Kipling, Rudyard 9
Kirtling Tower, Cambridgeshire 19
Knight, Richard Payne 84

Langley, Batty 112
Langley Park, Beckenham, Kent 84
Larousse, Pierre 66
Latham, Sir Paul 27
Lawrence, T.E.: *The Seven Pillars
 of Wisdom* 34, 136–7
Lawson, Thomas W. 14
Le Vaillant, François 86
 *Histoire Naturelle des Oiseaux de
 Paradis* 86–7
Lees-Milne, James 7, 10, 11, 24,
 28, 30
Leighton, Frederic, Lord 32
Leiter, Levi Z. 17
Lewin, William: *The Birds of
 Great-Britain, with their Eggs,
 Accurately Figured* 70–1
Life Guards 20, *23*, 24, 54, 73, 138
Lilly Library, Indiana
 University 150
Linnaean Gallery, London, Dr
 Thornton's 74, 76
Linnaeus, Carl 70
Lloyd George, David 21, 22
Lode, Cambridgeshire 10, 26
Loggan, David 57
 Cantabrigia Illustrata 34, 56–7
London 20
London Colosseum 114
London Underground 19
Long Island 6, 11, 18

Lord Baldwin's Fund for
 Refugees 10
Lory, Gabriel Ludwig 91
Lory, Mathias Gabriel 91
Louis XVIII, King of France 105
Lowndes, William Thomas 98
Ludwig II, King of Bavaria 134
Lutyens, Sir Edwin 25, 98

McAllister, Ward 20
McKenney, Thomas Loraine:
 *History of the Indian Tribes of
 North America* 118–21
Macklin, Thomas 74
Macklin Bible 128
Macready, William Charles 106
Maggs Bros. 37
Magna Carta Regis Johannis 98–9
Mansfeld, Josef Georg:
 *Abbildung der Neuen Adjustirung
 der K.K. Armee* 72–3
Manuzio, Aldo 34
Marble House, Newport 33
Marcel, Guillaume 58
Marlborough, Charles Spencer-
 Churchill, 9th Duke of 16, 20
Marlborough, Consuela Vanderbilt,
 Duchess of 16, 18, 20
Marlborough, John Churchill,
 1st Duke of 124
Marlow, William: *Windsor Castle* 29
Marryat, Captain Frederick 110
Marsh and Tatham 32
Maximilian, Emperor 30, 55
Mayer, Luigi 80
 *Views in Egypt from the Original
 Drawings in the Possession of Sir
 Robert Ainslie, Taken During his
 Embassy to Constantinople* 80
Meerburgh, Nicolaas 66
Melville, Herman 12
Metropolitan Board of Works 12
Metropolitan Museum of Art,
 New York 33
Meyrick, Samuel Rush and Smith,
 Charles Hamilton: *The Costume of
 the Original Inhabitants of the
 British Islands* 106–7
Mollo, Tranquillo 73
Moore, Sir Jonas 34
Moore, Joseph: *Eighteen Views
 taken at & near Rangoon* 110–11
Moreelse, Paulus 48
Morgan, J.P. 13, 15, 21, 37
Morris, Jane 144
Morris, May 148
Morris, Richard: *Panoramic View
 Round the Regent's Park* 114–17
Morris, William 35, 144, 148
Moulton Paddocks 23
Muir, Percy 150
Müller, Johann Sebastian 65
Munnings, Sir Alfred 28

Napoleon Bonaparte 28, 88, 91,
 92, 100, 105, 140–1, 143
Nash, John 105, 108
National Trust 7, 9, 10, 11, 22, 24,
 27, 31, 32, 34, 37, 38, 57, 98, 105
Nelson, Admiral Lord Horatio
 82–3, 88, 124
New York City 11, 13, 15, 18, 19,
 20, 22, 25, 26, 33

New York Yacht Club 19
Newcastle, Margaret, Duchess of 52
Newcastle, William Cavendish,
 Marquess of: *Methode et Invention
 Nouvelle de Dresser les Chevaux*
 51–3
Newport, Rhode Island 14, 19, 26
Ney, Marshal 105
Nixon, Howard 60
Notre Dame, Paris 105
Nutting, Joseph 58

Orme, Edward 83
*Orme's Graphic History of the Life,
 Exploits, and Death of Horatio
 Nelson* 82–3
Ortelius, Abraham 44
Orwell Park, Suffolk 12
Ostervald, Jean-Frédéric d':
 *Voyage Pittoresque de Genève à
 Milan par le Simplon* 90–1
Owst, G.R. 44
Oxford University 57

Palace House, Newmarket 23
Palazzo Te, Mantua 42
Palm Beach, Florida 7
Panini, Giovanni Paolo 100
Park Close, Englefield Green,
 Windsor 21, 24, 54, 98
Park Grove School, Wrexham 11
Parsons, William: *A New Book
 of Cyphers* 58–9
Parvin, Sidney 26, 32, 33
Passe, Crispijn de, the Elder 48
Passe, Crispijn de, the Younger
 48, 50, 57
 Hortus Floridus 48–50
Passe, Magdalena de 48
Passe, Simon de 48
Passe, Willem de 48
Pauncefote, Audrey 9
Pearson, David 35
Pearson, Sir Weetman (later
 Viscount Cowdray) 129
Peel, Sir Robert 129
Peiresc, Nicolas-Claude Fabri de 50
Pepys, Samuel 60
Pether, Abraham 76
Petit Trianon, Versailles 66
Philpotts, Henry, bishop of
 Exeter 128
Pine, John 28, 30
Piranesi, Giovanni Battista 74, 100
Planché, James Robinson 106
Plantin, Christophe 124
Plantin Press 57
Planting Fields, Oyster Bay,
 Long Island 11
Pluvinel, Antoine de 50
Pogány, Willy 134–5
Pole Hill, Essex 136
Porden, Henry 108
Pote, John 125
Poussin, Nicolas 57
Prêtre, Jean-Gabriel 86
Price, Sir Uvedale 84
Pugin, Auguste Charles 88, 105, 112
Pugin, Augustus Welby
 Northmore 105, 112
Pyne, W.H. 88, 112, 125

Queen's Binder B 57

Rackham, Arthur 134
Rampant Lions Press 148
Redgrave, Richard 124
Redouté, Pierre-Joseph 86
Rees, Abraham 79
Reinagle, Philip 76
Rennie, John 32
Repton, Humphry 84
 *Observations on the Theory and
 Practice of Landscape Gardening*
 84
 'Red Books' 84, 108
Rice, Daniel 120
Richards, Vyvyan 136
Richardson, Sir Albert 6, 9, 24,
 26, 27, 31, 37, 102, 125
Robert Rivière & Son 141
Roberts, William 136
Rockefeller, John D. 13, *14*
Rockefeller family 20
Rogers, Henry (Harry), Jr 16, 18
Rogers, Henry Huttleston
 (LF's maternal grandfather) 6, 10,
 13–18, *13, 14*, 19, 25, 38
Rogers, Rowland 13
Rogers family 16
Rome 100
Roosevelt, Franklin D. 14–15
Roper, Lanning 9
Rothschild, Leopold de 23
Rousseau, Jean-Jacques 86
Rowlandson, Thomas 88, 94
Roxburghe Club 70, 74
Royal Library, Windsor 108, 123
Royal Yacht Squadron 20
Rubens, Peter Paul 42, 51, 52, 57
Runnymede 24–5, 98
Ruskin School of Drawing,
 Oxford 148

St Antoine, M. de 51
St George's Chapel, Windsor
 123, 128
St Helena 92–3, 100, 105
St Paul's Cathedral, London
 54–5, 114, 124
St Paul's School, Concord,
 New Hampshire 10
Saint-Non, Jean-Claude
 Richard de 91
Saltram House, Devon 57
Sangorski, Alberto 133, 144
 *The Life Guards: Historical
 Records, Battle Honours and
 Poetical Tributes* 138–9
Sangorski, Francis 133, 144
Sangorski & Sutcliffe *34*, 129,
 133, 138, 141, 144–5
Sapphire 7, 11, 22, 24, *24*, 25, 33
Sargent, John Singer 136
Sauvan, Jean-Baptiste-Balthazar:
 A Picturesque Tour of the Seine
 104–5
Sawyer, Charles 36
Saxton, Christopher: *Atlas of the
 Counties of England and Wales*
 44–7
Saye and Sele, Lord 20
Scott, George: *Architecture of
 Humanism* 31
Seckford, Thomas 44
Second World War 10, 24
Seeley, Benton 62–3, 122

Sefton Lodge 23
Semper, Gottfried 124
Seven Acres Press, Long Crendon,
 Buckinghamshire 148
Shakespeare, William 15, 128
 First Folios 15, 37
Shoberl, Frederick 91
Shone, Isaac 12
Shone company 12, 17
Siddons, Sarah 74
Smith, Charles Hamilton 106
Smythson, John 51
Soane, Sir John 37
Society for the Encouragement of
 the Arts 98
Society for the Protection of
 Ancient Buildings 31
Society of Antiquaries 148
Society of Painters in
 Water-Colours 112
Sotheby's auctioneers 70
Sotheran's, London 141
Spring-Rice, Thomas 129
Staggermeier and Welcher 74
Standard Oil Company 13, 18
Stanislas I, King of Poland 66
Stephen, Sir George 12
Stowe 62, 122
Straet, Jan van der 42
 *Equile Ioannis Austriaci Caroli V
 Imp.F.* 42–3
Strawberry Hill, Twickenham,
 Middlesex 64, 65
Strickland, Agnes 129
Stuart, James ('Athenian') 69
Sullivan, Sir Arthur:
 'St Gertrude' 130
Sutcliffe, George 133
Sutherland, Thomas 105

Tauvel, Michel 58
Taylor, William Frederick:
 *A Short Description of Windsor
 Castle, and a List of Paintings to be
 Seen in the State Apartments* 122–3
Thomson, James: *The Seasons* 74–5
Thorney Abbey House,
 Cambridgeshire 10
Thornton, Burrell 76
Thornton, Robert John: *New
 Illustration of the Sexual System of
 Carolus von Linnaeus... The Temple
 of Flora, or Garden of Nature* 76–7
Tomkins, Peltro William 74
Tooley, R.V. 88, 94
Tower of London 106
Trew, Christoph Jakob 66
Trinity College Library,
 Cambridge 57
Turner, J.M.W. 74
Twain, Mark 15, 16, 18

Vanderbilt, Alva 16
Vanderbilt, Commodore Cornelius
 16, 25
Vanderbilt, George Washington 37
Vanderbilt, William Kissam 16, 18
Vanderbilt family 14, 33, *33*
Vasari, Giorgio 42
Vaughan Williams, Ralph 148
Veblen, Thorstein 38
Velázquez, Diego 42
Vertue, George 32

Victoria, Queen 21, 122
 The Letters of Queen Victoria
 128–9
Viollet-le-duc, Eugène-
 Emmanuel 105
Virginian Railway 13, 18

W. Turner Lord & Co. 26
Wagner, Richard
 *The Tale of Lohengrin, Knight of
 the Swan, after the Drama of
 Richard Wagner ... Presented by
 Willy Pogány* 134–5
 *Tannhaüser: A Dramatic Poem ...
 Presented by Willy Pogány* 134–5
Walpole, Horace 64, 65, 112
 The Castle of Otranto 68–9
Walpole, Sir Robert 32
Warton, Thomas 112
Washington, Booker T. 15
Washington Park Club 17
Waterloo Bridge, London 32
Welbeck Abbey, Nottinghamshire
 51
Wellesley, Richard 70
Wellington, Arthur Wellesley,
 Duke of 28, 30, 70, 92, 124–7, 128
Wharton, Edith 6, 15, 33
Wheeler, G.H., ed.: *Letters of Sir
 Thomas Bodley to Thomas James*
 141–2
White, Gilbert 74
Whittaker, John 98
Whole Book of Psalms, The 60–1
Widener, Harry Elkins 19
Wierix, Hieronymus 42
Wijck, Jan 55
Wild, Charles 112
 *Twelve Select Examples from the
 Cathedrals of England* 112–13
Willement, Thomas 98
William IV, King 106
Wimpole Hall, Cambridgeshire 9
Windsor, Berkshire 28, 34, 54, 55, 62
Windsor Castle 28, *29*, 30, 122–3
Windsor collection 31, 125
Winona, Minnesota 12
Woolavington, James Buchanan,
 Lord 23
Worcester, Massachusetts 11, 12, 16
Wordsworth, William 74
Wormsley library, Buckinghamshire
 37
Wratten and Godfrey 27
Wren, Sir Christopher 57
Wrexham 11, 12, 20
Wyatt, Digby 124
Wyatt, James 22
Wyatville, Sir Jeffry 125

Zaehnsdorf, Ernest 138
Zaehnsdorf, Joseph 138
Zaehnsdorf, Joseph William 138